NOTTINGHAM FRE

VOLUME 53 NUMBER 2 SUMMER 2014

Photography in Contemporary French and Francophone Cultures

Edited by Kathrin Yacavone

This publication is available as a book (ISBN 978-0-7486-9366-5) or as a single issue or part of a subscription to *Nottingham French Studies*, Volume 53 (ISSN: 0029-4586). Please visit www.euppublishing.com/journal/nfs for more information.

Subscription rates for 2014

Three issues per year, published in March, July, and December

		Tier	UK	RoW	N. America
Institutions	Print & online	1	£99.00	£108.00	$178.00
		2	£123.50	£132.50	$218.50
		3	£154.50	£163.50	$270.00
		4	£185.50	£194.50	$321.00
		5	£210.00	£219.00	$361.50
Premium	Print & online	1	£123.50	£132.50	$218.50
		2	£155.00	£164.00	$270.50
		3	£193.50	£202.50	$334.00
		4	£232.50	£241.50	$398.50
		5	£263.00	£272.00	$449.00
Institutional	Online	1	£84.00	£84.00	$139.00
		2	£105.00	£105.00	$173.00
		3	£131.50	£131.50	$217.00
		4	£157.50	£157.50	$260.00
		5	£178.00	£178.00	$294.00
Premium	Online	1	£108.50	£108.50	$179.00
		2	£136.50	£136.50	$225.00
		3	£170.50	£170.50	$281.00
		4	£204.50	£204.50	$337.00
		5	£231.00	£231.00	$382.00
	Additional print volumes		£96.45	£95.45	$162.50
	Single issues		£45.50	£48.50	$82.50
Individuals	Print		£46.50	£55.50	$92.00
	Online		£46.50	£46.50	$81.00
	Print & online		£57.50	£66.50	$115.00
	Premium online		£60.50	£60.50	$105.50
	Premium print & online		£71.50	£80.50	$139.50
	Back issues/single copies		£17.00	£20.00	$33.50

How to order

Subscriptions can be accepted for complete volumes only. Print prices include packing and airmail for subscribers in North America and surface postage for subscribers in the Rest of the World. Volumes back to the year 2000 are included in online prices. Print back volumes/single issues will be charged at the print rates stated above (vol. 51 onwards). Enquiries concerning back volumes/issues up to vol. 50 inclusive should be addressed to Mrs Sue Ruszczynski, Secretary to the Board of *Nottingham French Studies*, Department of French and Francophone Studies, School of Cultures, Languages and Area Studies, University of Nottingham, Nottingham NG7 2RD; email: sue.ruszczynski@nottingham.ac.uk

All orders must be accompanied by the correct payment. You can pay by cheque in Pounds Sterling or US Dollars, bank transfer, Direct Debit or Credit/Debit Card. The individual rate applies only when a subscription is paid for with a personal cheque or credit card. Please make your cheques payable to Edinburgh University Press Ltd. Sterling cheques must be drawn on a UK bank account.

Orders for subscriptions and back issues can be placed by telephone, on +44(0)131 650 4196, by fax on +44(0)131 662 3286, using your Visa or Mastercard credit cards, or by email on journals@eup.ed.ac.uk. Don't forget to include the expiry date of your card, and the address that the card is registered to. Alternatively, you can use the online order form at www.euppublishing.com/page/nfs/subscribe.

Requests for sample copies, subscription enquiries, and changes of address should be sent to Journals Department, Edinburgh University Press, The Tun – Holyrood Road, Edinburgh EH8 8PJ; email: journals@eup.ed.ac.uk

MIX
Paper from
responsible sources
FSC™ C013985

NOTTINGHAM FRENCH STUDIES

VOLUME 53 NUMBER 2 SUMMER 2014

CONTENTS

Special Issues of *Nottingham French Studies*

Pierre Reverdy: 1889–1989
edited by Bernard McGuirk
28: 2 (Autumn 1989)

The Abbé Prévost 1697–1763
edited by R A Francis
29: 2 (Autumn 1990)

Arthurian Romance
edited by Roger Middleton
30: 2 (Autumn 1991)

Culture and Class in France in the 1930s
edited by Rosemary Chapman
31: 2 (Autumn 1992)

French Cinema
edited by Russell King
32: 1 (Spring 1993)

Molière
edited by Stephen Bamforth
33: 1 (Spring 1994)

Hervé Guibert
edited by Jean-Pierre Boulé
34: 1 (Spring 1995)

Ionesco
edited by Steve Smith
35: 1 (Spring 1996)

Roland Barthes
edited by Diana Knight
36: 1 (Spring 1997)

French Erotic Fiction: Ideologies of Desire
edited by Jean Mainil
37: 1 (Spring 1998)

Fortune and Women in Medieval Literature
edited by Katie Attwood
38: 2 (Autumn 1999)

Errances Urbaines
edited by Jean-Xavier Ridon
39: 1 (Spring 2000)

Gender and Francophone Writing
edited by Nicki Hitchcott
40: 1 (Spring 2001)

French Fiction in the 1990s
edited by Margaret-Anne Hutton
41: 1 (Spring 2002)

Thinking in Dialogue: The role of the interview in post-war French thought
edited by Christopher Johnson
42: 1 (Spring 2003)

Jazz Adventures in French Culture
edited by Jacqueline Dutton and Colin Nettelbeck
43: 1 (Spring 2004)

Irreconcilable differences? Centre, periphery and the space between in French history
edited by Paul Smith
44: 1 (Spring 2005)

France, America and the Modern
edited by Jackie Clarke and Carole Sweeney
44: 3 (Autumn 2005)

Focalizing the Body: Recent Women's Writing and Filmmaking in France
edited by Gill Rye and Carrie Tarr
45: 3 (Autumn 2006)

Sociolinguistic Variation and Change in France
edited by David Hornsby and Mikaël Jamin
46: 2 (Summer 2007)

Terror and Psychoanalysis
edited by Lynsey Russell-Watts with Lisa Walsh
46: 3 (Autumn 2007)

'Mythologies' at 50: Barthes and Popular Culture
edited by Douglas Smith
47: 2 (Summer 2008)

Identification before Freud: French Perspectives
edited by Joseph Harris
47: 3 (Autumn 2008)

Annie Ernaux: Socio-Ethnographer of Contemporary France
edited by Alison S. Fell and Edward Welch
48: 2 (Spring 2009)

Enlightenment and Narrative: essays in honour of Richard A. Francis by colleagues and friends
edited by Philip Robinson
48: 3 (Autumn 2009)

Nottingham French Studies 53.2 (2014): 115–121
DOI: 10.3366/nfs.2014.0079
© University of Nottingham
www.euppublishing.com/nfs

INTRODUCTION:
MAPPING PHOTOGRAPHY IN FRENCH
AND FRANCOPHONE CULTURES

KATHRIN YACAVONE

Photography is the product of scientific advances in the fields of optics and chemistry converging in the mid-nineteenth century. A combination of the optical device of the portable *camera obscura*[1] and the chemical substances (iodine, bromine, etc.) that served first to sensitize a treated plate and later fix the image obtained to protect it against vanishing, by the end of the nineteenth century this new image production technology had become the first visual mass-medium. Shortly after the public announcement of its invention in 1839, photography was put to a myriad of uses in a number of fields, ranging from criminology and medicine to portraiture and anthropology; from landscape and amateur family photography to war photography and photojournalism. The dominant form of commercial advertising throughout the twentieth century, in the hands of the European avant-garde movements of the 1920s and early 1930s, it was simultaneously a distinctly modern or modernist means of artistic expression. Today, of course, an individual may well encounter hundreds of photographically derived images every day, most of these the product of digital cameras, not least in the virtual world of the Internet and social media.

Against the background of the technological development, multifarious uses and sheer ubiquity of the medium, the history and theory of photography has always struggled to find a secure disciplinary home, with selected aspects of it taken up in art history, media studies, cultural studies and national area studies. The present special issue of *Nottingham French Studies* foregrounds yet another question of belonging, namely the national, cultural and social place of photography in France and the wider francophone world. At first sight, photography may not be as readily associable with French culture as is cinema, for example, one of its closest neighbours in the visual media and arts. In itself a mute medium – even if the photographic image is often surrounded by written

1. The *camera obscura* is a sealed box with a pinhole opening holding a lens which allows for bundled light to enter and then hit a light-sensitive plate, thus registering an upside-down image (unless reversed by a mirror).

text or verbal language[2] – photography *per se* lacks discursive language and narrativity, two of the most significant vehicles by which national cultures and traditions are created, identified and institutionalized. Given this fact, what exactly has been (or may yet be) the role of photography in these processes in a French and francophone context? Furthermore, how might the relatively neglected place of photography within French studies be mapped, described or debated? The overarching purpose of this special issue is to begin to tackle these and related questions.

Although photography is perhaps not immediately identified with what is or may be characteristically French and francophone (in the cultural sphere), the French contribution to the medium has been profound. The emergence of photography in the mid-nineteenth century was marked by fertile trans-national experimentation and intense rivalry between France and England,[3] yet it is often seen, with some justification, as a French invention. Moreover, from Baudelaire to Barthes, to name but two of the most frequently cited writers in the history and theory of photography, there is a long-standing French-language tradition of critical, historical and theoretical reflection on the medium as a socio-cultural and artistic phenomenon. Such reflection occurred in the wider context of photography's centrality to the ongoing project of understanding the processes of modernity in Europe. In this connection, one need only look at Walter Benjamin's unfinished *Arcades-Project*, in which the German philosopher attempted both to trace and establish an Ur-history of modernity in the light of nineteenth-century Parisian culture, a history in which photography plays an integral part. In practice, rather than theory, photography has often served as a vehicle for the exploration of identity and belonging on the part of French and francophone photographers, artists and writers; this has taken a number of distinct forms, from bodies of photographic work to autobiographical projects combining photographic images and text (photobiography), and also includes so-called photographic writing which emerged in the early twentieth century. This richness speaks in itself to the significance of a reciprocal relationship between photography and other cultural forms of expression.

2. For a wide-ranging discussion of photography's relation to language, see Clive Scott, *The Spoken Image. Photography and Language* (London: Reaktion, 1999). Similarly related to word-and-image studies, Andy Stafford's *Photo-texts: Contemporary French Writing of the Photographic Image* (Liverpool: Liverpool University Press, 2010) looks at a number of collaborative projects involving photographers and writers in a specifically French-speaking context. Already in the1960s, the semiotic work on photography by Roland Barthes began to problematize these issues; see 'Rhétorique de l'image', in *Œuvres complètes*, ed. by Éric Marty, 5 vols. (Paris: Seuil, 2002), vol. 2, pp. 573–88.

3. See the recent account of the early period of photographic history by Helen Rappaport and Roger Watson, *Capturing the Light. The Birth of Photography: A True Story of Genius and Rivalry* (London: Macmillan, 2013).

As part of the oft-cited 'pictorial turn' of the 1990s, so-called French theory has (re-) entered the centre stage of theoretical and critical debate on the visual.[4] In this context, photography is often absorbed into discourses on 'visual culture', with the attendant danger of losing sight of its specificity from technological, historical and artistic points of view. Although it cannot be denied that theories of visual culture and of 'the image' dovetail with changes that photography and other visual media have been undergoing for at least the last twenty-five years owing to digitization – resulting in a notable blurring of strictly medium-defined boundaries – these developments by no means obviate the need for historical and theoretical discourses that are specific to photography (ones which do not, however, adopt an uncritical so-called medium-specificity thesis). In short, just as theories of visual culture do not challenge, but rather co-exist and productively intersect with, traditional, medium-specific art history and criticism, so too do theories of photography properly sit alongside and in dialogue with wider trans-media trends in French theory and philosophy.

Especially considering this theoretical turn towards the visual (with all it may entail), together with the increasingly inter-disciplinary, area and cultural studies orientation of French studies in recent years,[5] inclusion of photography in the canon of subjects studied as part of French and francophone cultures appears timely, and indeed overdue. Although there is a brief entry on photography in the 1998 *Encyclopedia of Contemporary French Culture*,[6] the recent landmark publication *French Studies in and for the Twenty-first Century*, which claims to 'offer a picture of French Studies today, an analysis – from the inside – of what the discipline has become and where it might and, indeed, must go in the future',[7] makes no reference to photography at all. The uses of the medium, it

4. See Martin Jay's important study *Downcast Eyes: The Denigration of Vision in Twentieth-Century French Thought* (Berkeley: University of California Press, 1993) and the more recent collection of essays by Nigel Saint and Andy Stafford (eds.), *Modern French Visual Theory. A Critical Reader* (Manchester and New York: Manchester University Press, 2013).

5. See the brief historical overview by Diana Holmes, 'A Short History of French Studies in the UK', in *French Studies in and for the Twenty-first Century*, ed. by Philippe Lane and Michael Worton (Liverpool: Liverpool University Press, 2011), pp. 12–24.

6. Michael Worton, 'Photography', in *Encyclopedia of Contemporary French Culture*, ed. by Alex Hughes and Keith Reader (London and New York: Routledge, 1998), pp. 421–3. Kidd and Reynolds take this relative neglect of photography, and visual culture more generally, in the *Encyclopedia*, as further confirmation that, in 2000, these aspects of French culture 'were not at present sufficiently prominent nationally or well enough documented to warrant special chapters', *Contemporary French Cultural Studies*, ed. by William Kidd and Siân Reynolds (London: Arnold, 2000), p. 8.

7. Philippe Lane and Michael Worton (eds.), *French Studies in and for the Twenty-first Century* (Liverpool: Liverpool University Press, 2011), p. 3.

seems, fall into the gap between discussion of cinema, popular culture and word-and-image studies, on the one hand, and area studies and literary or cultural studies, on the other, each of which is separately addressed in the volume. Given the aforementioned distinct historical, artistic and scholarly ties between photography and French society and culture, this lack of engagement with the medium in a seemingly discipline-defining reference work may well seem odd. Yet it accurately reflects the symptomatic invisibility of photography in the established university curriculum of French and francophone studies. While it has been addressed by scholars in French studies for a number of years, if not decades (albeit often from a more traditional literary studies perspective, in relation to autobiographical writing, for example[8]), French studies as an institutionalized discipline – in the UK, at least – has largely neglected any more direct and expansive engagement with photography as a form of socio-cultural expression in its own right. Nevertheless, as demonstrated by the contributions to this volume, photography is at the centre of much current research, often inter-disciplinary, that aptly reflects the rich tradition of photography in historical, cultural and artistic French and francophone contexts.

This collection of articles partially draws on papers first presented at a study day on the topic of photography in contemporary France at the University of Nottingham in June 2012.[9] While the conference was focused on the period from the 1990s to the present day, covering the two decades following the major shift from analogue to digital image making and viewing, it quickly became clear that in order better to understand these contemporary developments, it is necessary to move further back in time, to the 1970s: a decade of great importance in the wider cultural and institutional recognition of the medium as valuable in its own right, above and beyond its more utilitarian purposes. For this reason, the essays presented here cover a broader time-frame, without losing sight of the central focus on contemporary debates and developments. The volume has been organised not according to any particular chronology or hierarchy, but rather so as to allow four interrelated themes to emerge; namely: the wider institutional, political and art-historical debates surrounding photography in France; the contemporary practice of French photographers working in an urban context; the role of photography in processes of creating, reflecting on and questioning French

8. For instance, Natalie Edwards, Amy L. Hubbell and Ann Miller (eds.), *Textual and Visual Selves: Photography, Film, and Comic Art in French Autobiography* (Lincoln: The University of Nebraska Press, 2011). See also the contributions by Arribert-Narce and Kawakami in this volume.

9. Participants in this conference included Fabien Arribert-Narce, Shirley Jordan, Akane Kawakami, Joseph McGonagle, Olga Smith and Andy Stafford. I wish to thank my colleagues at Nottingham, the Society for French Studies and the School of Cultures, Languages and Area Studies at the University of Nottingham for supporting both this event and the present publication.

and francophone identities; and finally, the impact of photography on different forms and genres of literary writing.

Accordingly, my own article, which opens the volume, looks at the current landscape of photographic institutions in France through the lens of the complex history of photography's cultural institutionalization from the 1970s onwards. The aim of my text is to show that the place of photography in contemporary French culture is not a default position, as it were, but one that has been actively promoted and fought for by pioneering individuals and institutions alike. The more centralized and co-ordinated cultural politics of photography which emerged in the early 1980s must be understood as a response to changes in photographic practice that had been happening on an individual, local and regional level, rather than as a consequence of national and political initiative as such. Although photography's present visibility in French culture owes much to the activities of fine art museums and galleries, its promotion by key institutions such as the Maison européenne de la photographie and the Bibliothèque nationale de France speaks to a broader cultural recognition beyond the realm of fine art and at the level of national institutions and policies. The second article in the present collection, an interview with the founder and director of the Maison européenne de la photographie, Jean-Luc Monterosso, provides a valuable first-hand account of the cultural institutionalization of photography, especially in a Parisian context. However, and as Monterosso maintains, photography naturally lends itself to international cultural exchange in a way that defies institutional as well as geographical boundaries, just as digitization has challenged more traditional modes of photographic production and dissemination. Magali Nachtergael's contribution moves on from this wider overview of the connection between a new understanding of photography as art and the founding and running of photographic institutions, and focuses on a specific theoretical discourse emerging in the 1980s and 1990s concerning photographic practices that were then novel in France. Taking as her central point of reference the notion of 'photographie plasticienne', coined by Dominique Baqué, Nachtergael analyses the theoretical and historical tensions and convergences which mark the complex debate between certain modernist positions, that emphasize the aesthetic quality of the photographic image and the autonomy of the medium, and post-modernist ones, which stress media hybridity (or plasticity) in contemporary photographic practice coming in the wake of the conceptual-art challenge to such autonomy.

Nachtergael's discussion of Jean-François Chevrier's concept of *photo-tableau* as an acknowledgement (in theoretical discourse) of photography's arrival in the wider sphere of the fine arts relates to Olga Smith's investigation of this category in more detail in relation to the photographic work of Valérie Jouve. Through analysis of Jouve's urban photography, Smith explains the multi-layered significance of 'containment', as applied, respectively, to the relation between the human body and its social as well as architectural

environment, the topographical relation between the centre of Paris and the *banlieue*, and finally, drawing on Chevrier's concept of *tableau*, to the framing of the photographic space as representation. This latter, she suggests, speaks to the reflexive aspect of Jouve's urban portraits in which the sitters' and the viewers' contemplative attitudes mirror each other, thus creating a distinct documentary aesthetic. The photograph's potential as both document and art is a theme also central to Shirley Jordan's discussion of Stéphane Couturier's urban photography. Jordan demonstrates how Couturier's photographs, in visual dialogue with nineteenth- and twentieth-century predecessors in photography and painting, create visual palimpsests of rapid urban transformation in France and elsewhere. She argues that through subject matter, composition, colour and size, these images ceaselessly oscillate between 'the archive' and the collapse of memory, creating indeterminacy in the viewer's reaction to the photographs, rooted in his or her equally being caught between past and future as a reflection of the transience of urban change.

Whereas Smith and Jordan analyse photography concerned with the city in an explicit and self-reflexive art photography context, the following two contributions consider wider territorial changes in relation to French and francophone identities, expanding the discussion of photography to include its role in (co-)shaping and expressing the relation between Paris and the *provinces*, and between metropolitan France and Algeria. Taking as its starting point Michel Houellebecq's 2010 novel *La Carte et le territoire* Edward Welch's article investigates the impact of visual imagery and photography on the understanding of national territory and identity in contemporary France in particular, with as central point of reference Raymond Depardon's photographic œuvre of the first decade of the twenty-first century. Unlike the state-funded, centralized land surveillance projects such as those commissioned by the Délégation à l'aménagement du territoire et à l'action régionale (DATAR) in the 1980s, Depardon's photographs of rural France, Welch argues, offer a more engaged and decentred (self-) reflection on provincial life, while at the same time reaffirming the traditional use of photography as a paradigmatic means of charting identity and spatial territory in the context of the modernization of post-war France. A potentially uneasy relationship between official, state-led representation and more personal, artistic endeavours to capture one's individual as well as one's national identity is addressed in more overtly post-colonial terms in Amanda Crawley Jackson's article. Against the backdrop of the Algerian 'guerre sans images' of the 1990s, she analyses Bruno Boudjelal's body of photographic work, which, like his written commentary upon it, was built up in the course of a number of journeys he made to Algeria in order to trace both his personal family history and the recent collective history of the country. Crawley Jackson demonstrates how the photographic medium helps Boudjelal to capture and express these histories in a non-linear fashion, and how his images self-reflexively

question notions of documentary authenticity in the same way as his journeys to Algeria problematize a fixed cultural and self-identity.

The final two articles by Fabien Arribert-Narce and Akane Kawakami turn to an even more directly subject-centred exploration of identity and selfhood in the form of autobiographical narratives – or the predominantly French phenomenon of *autofiction* and *photobiographie* – that include or refer to photographic images (real or imaginary). In this context, Arribert-Narce proposes a two-pronged taxonomy of photobiographical texts in French from the 1970s to the present day. He distinguishes between a notational type of photobiography, on the one hand, and a fictionalizing type, on the other, the former based on the largely documentary function of the photographic image and its apparent referentiality, whereas the latter presents these same properties as an obstacle to imaginary self-exploration and reflection. Evaluating works by a number of key writers/photographers along these lines (from Roland Barthes, J.M.G. Le Clézio and Denis Roche to Hervé Guibert, Marguerite Duras and Sophie Calle), Arribert-Narce reflects on a wide range of photobiographical writing. Kawakami, on the other hand, focuses on writings by Annie Ernaux which are preoccupied with photography in its multifaceted relation to life writing. Concentrating on 1989 as a particularly prolific year in Ernaux's diary writing, Kawakami demonstrates how the author's auto-ethnological œuvre produces a multi-perspectival self-reflection. Through an analysis of the ability of Ernaux's snapshot-like diaries to register and fix past life experiences from the standpoint of the present, as well as photographic metaphors present in Ernaux's texts, Kawakami's article concludes this volume on a meta-level, as it were, suggesting that Ernaux's writings create a multi-layered 'photograph' of the author.

Overall, and despite its broad and inclusive remit, this special issue does not propose to be a comprehensive survey of contemporary manifestations of photography in French and francophone cultures; instead it marks a beginning, I would hope, of a more visible engagement with photography as a distinct form of cultural expression in the French-speaking world. In addition to the presence of photographic metaphors, tropes and analogies in French-speaking literature, the actual practices and cultural and historical dynamics of photography as a visual medium offer in themselves a new and fascinating subject for scholarly explorations of what 'Frenchness' is or may be, as the contributions here assembled aim to demonstrate.

Nottingham French Studies 53.2 (2014): 122–135
DOI: 10.3366/nfs.2014.0080
© University of Nottingham
www.euppublishing.com/nfs

THE CULTURAL INSTITUTIONALIZATION OF PHOTOGRAPHY IN FRANCE: A BRIEF HISTORY

KATHRIN YACAVONE

On 19 August 1839, the physicist, astronomer and politician François Arago delivered a powerful *rapport* before the Parisian Académie des Sciences, in which he announced and vividly described the invention of the photographic process by Nicéphore Niépce and Louis Daguerre. After outlining the great potential of photography for the arts and sciences due to its detailed image capturing, Arago concluded on a patriotic note, alluding to the fact that the French government had recently acquired the rights to the invention: 'Cette découverte [the daguerreotype process], la France l'a adoptée; dès le premier moment, elle s'est montrée fière de pouvoir en doter libéralement le monde entier'.[1] This act, and its announcement, represented the first step in the French government's appropriation of the then new image reproduction technology presented as a distinctly French contribution to world culture.

However, if the French state 'adopted' photography so as to bequeath it to the rest of the world, according to Arago's hyperbolic rhetoric, surprisingly it would take no less than a century and a half before what might be called an active and coordinated cultural politics of photography was pursued. And this is despite a strong tradition of state involvement in cultural and artistic affairs, ranging from the fine arts to music, theatre and, later, cinema (very early on in its history), all of which were fully institutionalized at the beginning of the Fifth Republic in the form of a Ministry of Culture.[2] France's first culture minister, the novelist, essayist and art theorist André Malraux, was of course no stranger to photography. Published in 1947, his *Musée imaginaire* famously celebrates the profoundly new understanding and appreciation of paintings, sculptures and other art works from different periods and cultures when juxtaposed with one another in the form of photographic images and thus made available to an exponentially larger public. However, and perhaps reflecting the largely instrumental role granted to photography in his concept and practice of the 'museum without walls' – in

1. François Arago, *Le Daguerréotype* (Paris: L'Échoppe, 2003), p. 23.
2. For an overview of France's cultural politics from the mid-nineteenth century onwards, see Philippe Poirrier, *L'État et la culture en France au XX^e siècle* (Paris: Le Livre de Poche, 2009).

which the medium served merely as the practical vehicle for traditional artistic representation and expression – as minister, Malraux did little to reverse the tradition of failing to make a space for photography as an officially promoted and financially supported French artistic and cultural practice (as distinct from its officially supported historical/archival and scientific applications).[3] Malraux's lack of initiative in this respect was most likely also a reflection of the widely held view, in some quarters persisting as late as the 1960s, that photography was not an art form in its own right, in the way that painting and cinema were, for instance, even if it could be harnessed for artistic purposes (as in Malraux's work). Such a position can be traced back to nineteenth-century debates concerning the status of photography as art, and, specifically, to Charles Baudelaire's famous critique of the 1859 Salon, in which photography was exhibited alongside traditional fine art for the first time.

In the section of his Salon review entitled 'Le public moderne et la photographie', Baudelaire accuses the contemporary populous of accepting and celebrating a positivistic 'goût exclusif du Vrai', which photography fuelled.[4] Beginning with the 1854 invention of the *carte-de-visite* process, which allowed for relatively inexpensive mass-production of photographic portraits, photography, for Baudelaire, had become an 'industrie' as opposed to an art, and must now wholly accept its role as 'la servante des sciences et des arts, mais la très-humble servante'.[5] Baudelaire's assessment not only helped to entrench dichotomies with which photography was subsequently yoked – art versus technology, fiction versus document, subjectivity versus objectivity, illusion versus reality etc. – but also helped to shape the French public and governmental discourse on photography right up until the latter third of the twentieth century.

It was in the 1970s and 1980s that photography is generally considered to have been fully embraced by French cultural and political institutions, both in parallel with, but also in direct response to, its widespread recognition as a fully-fledged fine art by the international artistic establishment. It must be stressed, however, that the official move towards a centralized and cogent cultural politics of the medium was preceded by a number of pioneering initiatives by individual enthusiasts engaged in valorising photography as an in-itself valuable artistic (or otherwise culturally significant) activity, a valorisation which took the form of events, gallery exhibitions and editorial projects, for example. In fact, looking more closely at the historical specifics of photography's cultural

3. Cf. Michel Frizot, 'Politique de la photographie', in *Dictionnaire des politiques culturelles de la France depuis 1959*, ed. by Emmanuel de Waresquiel (Paris: Larousse, 2001), pp. 495–9 (p. 496).

4. Charles Baudelaire, 'Salon de 1859', in *Œuvres complètes*, ed. by Yves-Gérard Le Dantec (Paris: Gallimard/Bibliothèque de la Pléiade, 1954), pp. 761–80 (p. 769).

5. Ibid., p. 771.

institutionalization from the 1970s onwards,[6] it is clear that in many respects, rather than lead the way in prospective fashion, an official cultural politics of photography began to emerge in a relatively uncoordinated and piecemeal fashion in the wake of grass-roots changes, seen to include changes in archival and exhibition practices in French libraries and art museums, and the creation of dedicated photography museums.

Individual Enthusiasts and Early Initiatives
Despite the increasingly ubiquitous presence of photographic images in the visual landscape of mid-twentieth-century life, and the medium becoming a subject of academic study (including in the seminal semiotic and sociological writings of Roland Barthes and Pierre Bourdieu, respectively[7]), the 1950s and 1960s saw no significant public initiatives related to the multifaceted cultural and artistic nature and potential of photography, nor to the history of the medium. Indeed, it can be argued, following Christian Gattinoni, that up until the mid-1970s, most activity in this direction was initiated by individual enthusiasts on a notably regional rather than national basis.[8] These included, for example, amateur photographers Jean and André Fage who, in 1960, founded the Musée français de la photographie in Bièvres (located close to Paris in the Essonne department), which specializes in the early history of photographic technology. Apart from establishing permanent exhibition spaces and museums, such private initiatives also encompassed the creation of festivals, conferences, marketplaces and temporary exhibitions.

Another important milestone was the formation of the Rencontres internationales de la photographie in Arles in 1970.[9] Led by a diverse group of photography enthusiasts, including the photographer Lucien Clergue, Jean-Claude Lemagny (director of what was then still called the Cabinet des Estampes of the Bibliothèque nationale de France), Maurice Rouquette and the writer Michel Tournier, the Rencontres established an influential photography community in the south, one which continues to the present day in the form of

6. While the institutional history of photography is relatively well documented in a French-language context, as evident from the sources this article draws on, there is no comparable overview in English.

7. See especially, 'Le Message photographique' (1961) and 'Rhétorique de l'image' (1964) by Roland Barthes, in Œuvres complètes, ed. by Éric Marty, 5 vols. (Paris: Seuil, 2002), vol. 1, pp. 1120–33; vol. 2, pp. 573–88; and Un Art moyen: essai sur les usages sociaux de la photographie, ed. by Pierre Bourdieu (Paris: Minuit, 1965).

8. Christian Gattinoni, La Photographie en France, 1970–2005 (Paris: Panoramas/CulturesFrance, 2006), p. 30.

9. For a concise overview of the history of the Rencontres, see Michel Frizot's entry 'Rencontres internationales de la photographie (RIP)', in Dictionnaire des politiques culturelles, pp. 548–9.

public debates and events, supplementing exhibitions that frequently showcase the bodies of work of individual photographers. The innovative nature of the Rencontres in the 1970s (under the directorship of Lucien Clergue) was typified by the presentation of the work of seminal French photographers, including Brassaï, Robert Doisneau and Henri Cartier-Bresson; but also American photography by Ansel Adams, for example, hitherto little seen by the French public. Although critics have sometimes pointed to a lack of coherent vision and orientation, to which the rather short tenure of its directors has perhaps contributed,[10] the Rencontres have nonetheless remained a significant annual occasion for viewing and discussing past and present photographic work.

Against the background of the *provinces* having their signature photography event, in the form of the Rencontres, a number of individuals attempted to interest local authorities in the French capital in similar initiatives.[11] Prominent among these was Jean-Luc Monterosso who, together with Henry Chapier, Marcel Landowski and Francis Balagna, established the association Paris Audiovisuel in 1978 in order to promote the creation and dissemination of artistic photography in Paris.[12] The fact that they managed to secure public funding from the Hôtel de Ville in order to support cultural initiatives with regards to a medium that had hitherto received little political attention (national or regional) may in itself speak to an emerging politicization of photography. In 1977 Jacques Chirac was elected Mayor of Paris, an office which had been in a century-long abeyance. Given Chirac's national political ambitions and in the context of rivalry between the liberal national government of Valéry Giscard d'Estaing and the Parisian municipal authorities, in cultural affairs and beyond, promotion of photography fell on fruitful ground, so to speak, as it provided an apparently democratic medium fit for Chirac's political programme of urban and cultural innovation in France's capital.

With funding from the municipal authorities, Paris Audiovisuel henceforth provided the administrative structure for the emerging Mois de la Photo, a biannual event initiated by Monterosso in 1980. Combining exhibitions of photography from France and elsewhere with conferences and colloquia, and a photography auction, the aim was to transform Paris 'en une formidable cimaise où chacun pourra trouver son parcours', as Monterosso declared in a press statement in 1980.[13] The immediate success of this eclectic format led to a quick succession of Mois de la Photo outside of France, including European cities such

10. See ibid.
11. Cf. Gattinoni, *La Photographie en France*, p. 30.
12. See also the interview with Monterosso in this volume.
13. *Interphotothèque. Actualités*, 18 (1982), p. 5. This bulletin, published between 1977 and 1991 by the Documentation française, was intended to communicate publicly funded developments and news in relation to photography.

as Barcelona and Rotterdam, as well as North American ones, such as Montreal and Houston (the latter being more commercially oriented).[14] Since 1998 the Parisian version has been affiliated to the Paris Photo salon, an international photography fair (which first took place in 1997),[15] and since then has also been closely aligned with the Maison européenne de la photographie (MEP), a major photographic institution.

In 1996, one year after Chirac's departure from his office as Mayor of Paris, the MEP was opened by the Hôtel de Ville in the restored Hôtel de Cantobre in the Marais quarter, in close proximity to the Galerie Agathe Gaillard, the first Parisian gallery devoted to photography,[16] and the Hôtel de Sully, which houses the Centre des monuments nationaux, France's cultural heritage administration.[17] A more permanent home for exhibitions and activities surrounding photography than its direct predecessor, the Espace Photo du Forum des Halles (1986–96), the MEP has since organized eight to ten photography exhibitions per year, under the directorship of Monterosso. As Gaëlle Morel has emphasized, with its multiple gallery spaces, a specialist library and *médiathèque*, an auditorium and the more recent installation of a restoration laboratory, the MEP is 'un lieu culturel dédié à la photographie, et non un simple musée'.[18] The MEP's originality – alongside the aforementioned photography museum in Bièvres and the Musée Nicéphore Niépce in Chalon-sur-Saône (which was opened in 1974) – is not confined to its being a space explicitly dedicated to photography,[19] but also owes to the fact that it has assembled its own collection. With an emphasis on photography from the 1950s onwards, it includes post-war French and Japanese photography, the work

14. Stuart Alexander, 'L'Institution et les pratiques photographiques', in *Nouvelle histoire de la photographie*, ed. by Michel Frizot (Paris: Éditions Adam Biro/Larousse, 2001), pp. 695–707 (p. 704).

15. Gaëlle Morel, 'Entre art et culture: politique institutionnelle et photographie en France, 1976–1996', *Études photographiques*, 16 (2005), 32–40 (p. 38).

16. The gallery opened in 1975 and its owner, Agathe Gaillard, must be counted among the true pioneers in elevating the cultural and artistic status of photography in France. Her recently published memoir is a vivid account of the history of her gallery and of the difficulties of promoting photography as art in the mid-1970s and its later success. Agathe Gaillard, *Mémoires d'une galerie* (Paris: Gallimard, 2013).

17. Frizot points out that there were plans to establish a Galerie nationale de la photographie in the Hôtel de Sully, before the founding of the MEP, which have, however, never been realized, 'Politique de la photographie', p. 499.

18. Morel, 'Entre art et culture', p. 37.

19. Sylvain Maresca usefully distinguishes between fine art collections which comprise photography and institutions which pursue an exclusively photographic programme, see 'Puisque c'est un art désormais', in *Une Aventure contemporaine: la photographie 1955–1995* (Paris: MEP/Paris Audiovisuel, 1996), pp. 91–9 (pp. 94–5).

of important American street photographers, such as William Klein and Robert Frank, as well as contemporary photographic work from around the world.[20]

Photography and Fine Art Collections

As already noted, since its invention, photography, the result of mid-nineteenth-century scientific and technological advances, struggled to receive institutional and political recognition as art (broadly defined) as distinct from only technical craft (to evoke Immanuel Kant's evaluative distinction). In France, this battle has been particularly pronounced owing to the traditionally strong concept of *beaux arts* and the clear normative demarcation between so-called high and low art, or, non-art,[21] with writers such as Baudelaire using photography (associated with the latter) as the very basis for the loaded dichotomy. While the use of photography for artistic purposes was 'en voie de légitimation' during the 1960s, as Bourdieu suggests,[22] the subsequent decade is most commonly considered to mark the decisive turning point in the institutional acknowledgement of photography as fine art in Europe, the USA and beyond.[23] In a French context, this took the form of a paradigm shift in collection and acquisition policies of major national fine art museums, from an almost entire neglect of photography,[24] to a range of influential acquisition and exhibition policies, reflecting a larger transition from a more narrow definition of *beaux arts* (confined to non-mechanically produced art) to a more technologically inclusive one of *arts plastiques*.[25] This shift has also been described as a move from considering photography primarily as a historical and archival document to viewing photographs through the lens of their rarity as physical objects and a certain 'desinterestedness' and autonomy (as associated with art and the aesthetic since the eighteenth century).[26] Two major museums, the Musée national d'art moderne housed in the Centre Georges-Pompidou and the Musée d'Orsay, both of which were conceived during the height of this transition, were also instrumental in it.

20. I take this information from < http://www.mep-fr.org/la-maison/la-collection/le-fonds-photographique/> [accessed 1 August 2013].
21. Maresca makes this point in 'Puisque c'est un art désormais', p. 98–9. Frizot similarly argues that the elitist notion of art in France was detrimental to the integration of photography into established fine art institutions, 'Politique de la photographie', p. 496.
22. Bourdieu (ed.), *Un Art moyen*, pp. 136–7.
23. For an in-depth art-historical treatment of this question, see Michael Fried, *Why Photography Matters as Art as Never Before* (New Haven: Yale University Press, 2008).
24. See *La Photographie: dix ans d'enrichissement des collections publiques*, ed. by Philippe Néagu (Paris: Réunions des musées nationaux, 1992), p. 19.
25. See Maresca, 'Puisque c'est un art désormais', p. 93.
26. Ibid., pp. 91–2.

The initial creation of a photography collection in these national museums was consciously modelled on the Museum of Modern Art in New York, as the world-leading institution in this respect.[27] The MoMA has been pursuing an active policy of photography acquisition and exhibition since the 1930s (under the egis of Beaumont Newhall, its first curator of photography, whose *History of Photography*, first published in 1949, remains a classic in the field). In France, while the very first photographic works entered the collection of the Musée national d'art moderne in the form of donations in the early 1970s, the first official acquisitions date from 1976, one year before its opening to the public.[28] Meanwhile, the nineteenth-century photography collection of the Musée d'Orsay, with its focus on the work of artists born in or before 1870, started from scratch in 1979 and, by the time of its opening in 1986, was the first *beaux-arts* museum in France to feature a dedicated photography section.[29] Three years later, and the year of the 150th anniversary of the first public launch of photography, two landmark exhibitions took place at the Musée d'Orsay and the Musée national d'art moderne: *L'Invention d'un regard* and *L'Invention d'un art*, respectively, which are justly seen to mark the 'sommet de reconnaissance institutionnelle' of photography,[30] and its permanent place in French art collections, comparable in their significance with respect to photography's cultural institutionalization to a series of seminal exhibitions at New York's MoMA in the 1930s.[31]

Photography in the Bibliothèque nationale de France

Although photography became an increasingly prominent feature of public art museums as a result of the above-noted shift concerning the fine art status (or potential) of the medium, photographic images had always been a part of history museum collections in France – including that of the Musée Carnavalet, for example – on the basis of their archival-historical

27. See Quentin Bajac, 'Stratégies de légitimation: la photographie dans les collections du musée national d'art moderne et du musée d'Orsay', *Études photographiques*, 16 (2005), 222–33 (p. 226).

28. Ibid., pp. 224–5.

29. See < http://www.musee-orsay.fr/fr/collections/histoire-des-collections/photographie> [accessed 1 August 2013]. However, it is difficult to disagree with Gattinoni who remarks that the museum does not allocate the appropriate exhibition space to photography that its impact on nineteenth-century society and culture would deserve, *La Photographie en France*, p. 38.

30. Gattinoni, *La Photographie en France*, p. 38.

31. However, as Christopher Phillips has argued, these photography exhibitions at the MoMA failed to impact significantly on the wider art-world at the time; see 'The Judgement Seat of Photography', in *The Contest of Meaning: Critical Histories of Photography*, ed. by Richard Bolton (Cambridge, MA and London: MIT Press, 1996), pp. 14–47 (p. 23).

interest.[32] The same is true of libraries, as Quentin Bajac has pointed out,[33] and the most important example is the photography collection of the Bibliothèque nationale de France (BnF).

The history of the photography collection of the BnF can aptly be described as a part of 'l'histoire de la photographie elle-même',[34] due to the fact that from 1851 onwards many photographers donated their work to the library and to the requirement of the *dépôt légal* of photography since 1925, which entails obligatory submission to the library of printed documents which include photographic reproductions (ranging from posters and postcards to photographic albums and catalogues). Over the years, this collection has expanded thanks to significant donations and targeted acquisitions of major photographic œuvres, and it is now one of the largest collections of photography in France, especially of nineteenth-century and early twentieth-century images, including the bulk of the work of Nadar and Atget, to name but the most famous French photographers of these periods.[35] Together with an acquisitions policy, dating back to the post-war years, which is explicitly governed by the idea of centralizing the French *patrimoine* with respect to photographic images, the BnF's photography collection was also expanded and reclassified – tellingly according to photographers' names rather than subject matter – as a result of photography's new-found fine art status in the 1970s. In 1976, the Cabinet des estampes was transformed into the Département des estampes et de la photographie, and, under its dynamic director Jean-Claude Lemagny (who co-founded the Rencontres in Arles), saw a number of initiatives, notably the creation of a permanent exhibition space entirely dedicated to photography (the Galerie Mansart at the historic site on the Rue Vivienne). Since the opening of the new site of the BnF on the Quai François-Mauriac in 1996, a better infrastructure and larger exhibition spaces have allowed for more sizable and regular photography exhibitions.[36] These are often held in conjunction with the Mois de la Photo (such as *La Photographie en 100 chefs-d'œuvre* in 2012), drawing on the library's extensive collection. In sum, and paralleling the situation in other countries (including the United States), the widespread recognition of photography as an art form and a vital cultural force on

32. For a comprehensive list of these institutions and the focus of their collections, see *La Photographie: État et culture* (Paris: La Documentation française, 1992), pp. 45–52.

33. Bajac, 'Stratégies de légitimation', p. 224.

34. Sylvie Aubenas, '"Magique circonstancielle": le fonds de photographies du XIX^e siècle au département des estampes et de la photographie de la BnF', *Études photographiques*, 16 (2005), 210–21 (p. 211).

35. Since 1993, the BnF also houses the collections of the Société française de photographie. Founded in 1854, it is the oldest active photography society and possesses its own photography and book collection.

36. Aubenas, '"Magique circonstancielle"', p. 213.

a par with traditional arts and cinema, for instance, which took place during the 1970s, has not only had a major impact on photography's place in French fine art museums, but also on other institutions collecting and preserving photographic images.[37]

The Cultural Politics of Photography

Considering the exceptional involvement of the French government at the moment of the medium's inception, it may come as a surprise that an active cultural politics of photography is relatively recent, as Frizot has remarked.[38] Perhaps inspired by Arago's suggestion as to photography's archaeological potential (with reference to the monuments of ancient Egypt, and the deciphering of hieroglyphs specifically),[39] the Interior Ministry established the Commission des monuments historiques, which, in 1851, commissioned five photographers with the *Mission héliographique*, an innovative project with the aim of photographically documenting the state of France's historic buildings. This truly 'monumental' project was the first state-funded photography project in France's history.

Although the official organ of the French government and administration, La Documentation française, describes 1975 as a 'date-charnière' in the history of photography's cultural institutionalization,[40] the governmental initiatives under Giscard d'Estaing remained rather tentative. However, this year did see the launch by the culture minister, Michel Guy, of a Service de la photographie, a primarily administrative body whose function was mainly to coordinate (and harmonize) all photography-related cultural activities.[41] The leadership of this Service was undertaken by Agnès de Gouvion Saint-Cyr, who has since played a key role in the cultural politics of photography for over thirty years, earning her the description, by Claude Nori, as the 'véritable mémoire de la photographie française'.[42] In 1978, the year of the foundation of Paris Audiovisuel by the Parisian Hôtel de Ville, a Fondation nationale de la photographie was established, with Pierre de Fenoyl as its director. It was housed in the Château Lumière in Lyon, reinforcing the connection between still photography and cinema, already apparent in the financing of the Service de la photographie, which was, initially at

37. See Douglas Crimp's discussion of the changing conception, and re-categorization, of the photography collection of the New York Public Library, 'The Museum's Old, the Library's New Subject', in *The Contest of Meaning*, pp. 3–12 (pp. 6–8).
38. Frizot, 'Politique de la photographie', p. 495.
39. Arago, *Le Daguerréotype*, p. 15.
40. *La Photographie: État et culture*, p. 40.
41. *Interphotothèque. Actualités*, 2 (1978), pp. 1–2.
42. Claude Nori, *La Photographie en France: des origines à nos jours* (Paris: Flammarion, 2008), p. 312.

least, taken from the budget for the Centre national de la cinématographie.[43] With these new organizations in place, the French government hoped to take a decisive step in the direction of a cultural institutionalization of the medium and, in a statement harking back to the moment of the invention of photography, declared that '[l]a photographie devrait ainsi progressivement retrouver par la politique culturelle menée en France le prestige dont elle bénéficiait lors de sa découverte'.[44] Together with emphasizing the prestige of photography in nineteenth-century French culture, this official statement also, and for the first time, implicitly acknowledged a long period of governmental neglect. Such neglect would be greatly rectified under the leadership of Jack Lang, who it must be said reacted to local and regional activities, including those already mentioned, which he sought to frame, a posteriori, and centralize in political and institutional terms.

Apart from Malraux himself, no other culture minister has influenced the cultural landscape of twentieth-century France to a greater extent than Lang, as has often been noted. Arriving at the rue de Valois under the socialist government of François Mitterrand in 1981 (within which he stayed, with only one two-year interruption, until 1993), Lang presided over the most intense period of governmental activity with respect to the promotion of photography. In the wake of the constitution of the Délégation aux arts plastiques in the early 1980s, the Mission pour la photographie became henceforth the overarching administrative unit (under the continued leadership of de Gouvion Saint-Cyr) which supervises all photography-related activities as well as the distribution of funds and the dissemination of France's photographic heritage. Beginning with a doubling of the national budget for culture under Lang,[45] the Mission has had the Fonds national d'art contemporain (FNAC) at its disposal, which includes a fund specifically dedicated to the acquisition of photography.

In 1982, the primary photography organization of the Ministry of Culture became the Centre national de la photographie (CNP). In his speech in July of that year on the new governmental directions and initiatives with respect to photography, Lang described the current *zeitgeist* as a desire for the recognition of 'la place de la photographie dans la grande famille des arts plastiques' and called for more extensive political action in this respect, while simultaneously acknowledging that

> un pays comme la France, inventeur et berceau de la photographie, n'a peut-être pas donné à la photographie, à l'art de la photographie, à l'enseignement de la

43. Morel, 'Entre art et culture', p. 34. The foundation in Lyon closed in 1993 to make space for the Institut Lumière.

44. *Interphotothèque. Actualités*, 2 (1978), p. 3.

45. Poirrier, *L'État et la culture*, pp. 160–1.

photographie, à la diffusion de la photographie, la place pleine et entière qu'elle mérite.[46]

The actions that followed this speech demonstrate that Lang was indeed committed to remedying this situation – even if photography was already gaining a more visible place in French culture, without the support he mentioned. The creation of the CNP was Lang's major institutional contribution in this context.

Modelled, like the Musée national d'art moderne and the Musée d'Orsay, as Lang acknowledges,[47] on a New York-based predecessor, the International Centre of Photography, the CNP was directed by Robert Delpire,[48] a household name on the French photography scene since the 1950s, when he first began to exhibit photography in his gallery and to edit innovative monographs of the work of French and American photographers (such as Brassaï, Cartier-Bresson, Doisneau and Jacques-Henri Lartigue, as well as Robert Frank) under the label Éditions Delpire. The main task of the CNP was to disseminate photography and to fulfil an educational function, or to 'sensibiliser à la photographie le public le plus large possible',[49] for which touring exhibitions as well as the vast exhibition space in the Palais de Tokyo (from 1984 to 1993), provided the key means. The CNP also initiated a major publication programme, the distinctively black coloured *Photo Poche* series, with each small-format volume dedicated to the work of one photographer (the first in the series was on Nadar), or specific themes, such as the history of the medium, or specific genres of photography. The inauguration of the Jeu de Paume as the key national museum of photography on the Place de la Concorde in 2004 marks the end or, perhaps better put, latest metamorphosis of the CNP, with the Jeu de Paume taking over the latter's collection and mission. Dedicated from the start to photographic imagery broadly defined, 'dans une approche ouverte et transversale sur le plan chronologique du XIXe siècle à nos jours, comme sur le plan des différentes pratiques d'images (photo, cinéma, vidéo, installations…)', since 2007 the Jeu de Paume has also showcased virtual projects specifically designed for the Internet.[50] The opening of this museum can be seen as a reflection of continued political commitment to the evolving institutionalization of photography, which in the 1980s peaked a second time, on the occasion of the medium's 150th anniversary.

46. Jack Lang, 'Photographie: les nouvelles orientations', *Interphotothèque. Actualités*, 18 (1982), 1–5 (p. 1).

47. Ibid., p. 2.

48. For a concise summary of the history of the CNP, see Michel Frizot 'Centre national de photographie', in *Dictionnaire des politiques culturelles*, pp. 110–11.

49. Lang, 'Photographie', p. 3.

50. Nori, *La Photographie en France*, p. 312.

Given the projects and initiatives of the early 1980s, during a press conference on 1 June 1989, Lang could look back at a number of years of increased funding and public activity in relation to photography and assert, with some justification at least, that the decisive political action he inaugurated had paid off:

> Aujourd'hui, on voit se dessiner les effets d'une politique qui a eu pour objet d'intégrer la photographie dans tous les domaines de la pensée culturelle [...] au ministère de la Culture, chaque direction a désormais une préoccupation et une action en la matière.[51]

The publically funded events of 1989 ranged from scholarly and more popular publication projects (the proceedings of a conference on *Les Multiples inventions de la photographie* at Cerisy and the world history of photography *Histoire de voir* by Frizot and Delpire),[52] to the creation of prizes and competitions, with over sixty exhibitions all over the country, as well as educational initiatives. These latter were an extension of the already existing École nationale de la photographie in Arles (opened in 1982 and recognized as an École nationale supérieure in 2003) and the inauguration in 1990 of a chair of photography history at the prestigious École du Louvre.

Since the 1980s, governmental initiatives concerning photography as spearheaded by the Ministry of Culture have been divided into four major categories, corresponding roughly to the four traditional areas of cultural policy in France: education and training, conservation of the national heritage, democratization and the promotion of cultural creation.[53] More specifically, these entail the teaching of the history of photography in a wider educational context manifested not only in the aforementioned Grandes Écoles, but also in more targeted 'Ateliers de photographie' in *lycées* and *collèges*, or the integration of photography in university degrees, such as at Paris VII and Aix-Marseille I. There have also been attempts, not entirely successful, to institute legislation clarifying copyright laws, including a major amendment of the 1957 copyright law which extended artistic copyright to photography. The third and final areas of involvement, the constitution and protection of the photographic heritage and the creation and dissemination of photographic work, are the most visible and dynamic ones. Whereas the activities of the Mission pour la photographie are the main vehicle for the coordination of the heritage, the CNP (and since 2004 the Jeu

51. Jack Lang, 'Conférence de presse sur la photographie', *Interphotothèque. Actualités*, 42 (1989), 14–16 (p. 14).

52. See Gattinoni, *La Photographie en France*, pp. 38–9.

53. The breakdown of activity described in this paragraph is taken from *La Photographie: État et culture*, pp. 54–97.

de Paume) is charged with delivering on political rhetoric with regards to major support for the creation and dissemination of photography. The latter goes beyond the traditional means of exhibitions and includes three further priorities: the development of more decentralized activities and institutions (of which the creation of branches of the Centre Pompidou in Metz, in 2010, and the Jeu de Paume in Tours, in the same year, are but some of the latest manifestations); a better coordinated editorial politics, which includes the administration of research funds; and activities that target the dissemination of France's photographic collections, heritage and events abroad.

In spite of this ambitious cultural politics with respect to photography, overall the governmental initiatives under Mitterrand and his culture minister Lang were still rather reactive rather than proactive in comparison to the numerous private endeavours already underway in the 1970s. It should also be noted that in terms of photographic theory, history and criticism, by the early 1980s the medium was already a significant part of French intellectual discourse, not least through the highly influential theoretical works of Roland Barthes (*La Chambre claire: note sur la photographie*, 1980); Philippe Dubois (*L'Acte photographique*, 1983); Jean-Marie Schaeffer (*L'Image précaire: du dispositif photographique*, 1987); and the lesser-known *Philosophie de la photographie* by Henri Van Lier (1983). A number of small publishing houses devoted to reproducing photographic work emerged during this period,[54] and in terms of mass media, France's major daily newspapers *Le Monde*, *Libération* and *Le Figaro* started photography columns in their cultural sections. Such scholarly and journalistic interest in photography continues to the present day in greatly expanded form and in various media.

By way of conclusion, it can be said that the complex and multifaceted landscape of photography in contemporary France has emerged out of a fruitful combination of the activity of individual enthusiasts as well as private enterprises, together with a slowly growing (if comparatively late) state commitment to photography. The latter arose in part as a reaction to internal cultural developments as well as to photography's increasing institutionalization as fine art outside of France. In contrast to the proactive foresight which underpinned the legal appropriation of the new invention of photography by the French government in 1839, in the late twentieth century, Mitterrand and his culture minister Lang reacted on hindsight to new cultural and artistic practices surrounding photography. Thus, while photography, in a twenty-first-century context, and in its now predominantly digital guise, is very clearly part of the

54. Nori's chronology provides a good overview of this perhaps under-acknowledged field, *La Photographie en France*, pp. 295–305. As the founder of the gallery and publishing house Contrejour in the 1970s, Nori is, of course, himself an important figure in this aspect of the history of photography in France.

officially recognized and supported French pantheon of the arts, and of culturally significant media more generally, as this brief overview has shown, this place has been hard won. In addition to the specifically French and cultural-political circumstances which have been traced, no doubt this is partly owing to the apparently contradictory or competing aspects of a fascinating medium with a bewildering variety of uses, functions and values.[55]

55. I wish to thank Sheila Perry and Paul Smith for their perceptive comments and suggestions in relation to earlier versions of this article.

Nottingham French Studies 53.2 (2014): 136–138
DOI: 10.3366/nfs.2014.0081
© University of Nottingham
www.euppublishing.com/nfs

« UN COURANT COMMENÇAIT À SE DESSINER… »: ENTRETIEN AVEC JEAN-LUC MONTEROSSO

PROPOS RECUEILLIS PAR KATHRIN YACAVONE

Notice biographique

Jean-Luc Monterosso est le fondateur et directeur de la Maison européenne de la photographie. Universitaire diplômé en philosophie, il intègre en 1974 l'équipe de préfiguration du Centre Pompidou. En 1979, il devient délégué général de l'association Paris Audiovisuel. En 1980, il crée le Mois de la Photo à Paris. En 1986, il fonde avec Christian Mayaud la revue *La Recherche photographique*, co-éditée par Paris-Audiovisuel, la MEP et Paris VIII. De 1986 à 1996, Jean-Luc Monterosso est responsable de l'Espace Photo du Forum des Halles, établissement qui disparaîtra lors de l'ouverture de la Maison européenne de la photographie en février 1996. De 2011 à 2013, il assure la direction artistique du Festival de la photographie méditerranéenne de Sanary et, sur la chaîne culturelle ARTE, anime avec Dominique Goutard l'émission Arte Video Night.

Kathrin Yacavone: Dans l'histoire de l'institutionnalisation culturelle de la photographie en France, vous vous inscrivez comme l'un des pionniers. Pourriez-vous nous décrire la situation de l'époque (à savoir les années 1970 et 80)?

Jean-Luc Monterosso: En France, en 1979, lorsque je suis arrivé à la Ville de Paris, il n'existait que peu d'institutions culturelles, si ce n'est la Galerie du Château d'Eau à Toulouse et le Festival d'Arles. Mon premier travail à la direction de l'association Paris-Audiovisuel a été de permettre l'émergence d'un département photo au Musée d'art moderne de la ville de Paris et au Musée Carnavalet. C'est à cette époque que j'ai suggéré la création d'un atelier de restauration de photographies, qui fut confié alors à Anne Cartier-Bresson et qui est abrité aujourd'hui à la MEP. Ce qui est important de signaler, c'est que pour beaucoup, la photographie était encore considérée comme un simple document et nullement comme un moyen d'expression original.

KY: Dans son ouvrage *La Photographie en France*, Christian Gattinoni suggère que pendant ces années-là « chacun s'est battu avec sa ville »[1]. Est-ce vrai que

1. Christian Gattinoni, *La Photographie en France, 1970–2005* (Paris: Panoramas/CulturesFrance, 2006), p. 30.

vous avez dû vous battre ou les années 1980 ne représentaient-elles pas plutôt un moment propice pour promouvoir des initiatives dans le domaine de la photographie?

J-LM: Le combat que j'ai dû mener à la Ville de Paris a été surtout de sensibiliser les autorités, et également les conservateurs de musée, à la photographie. Il est vrai que des initiatives sont nées à cette époque dans d'autres villes, comme Toulouse, ou Arles, où en 1982 a été créée l'École nationale de Photographie, ou encore à Metz. Un courant commençait à se dessiner à la fois dans les médias et dans l'édition, ce qui a permis incontestablement de pérenniser mon action.

KY: Depuis son inauguration en 1980, le Mois de la Photo a connu un énorme succès, avec des imitations un peu partout dans le monde (à Huston, Montréal, Barcelone etc.). Comment expliquez-vous cette réussite? Quelle était l'idée derrière la fondation du Mois de la Photo?

J-LM: La réussite du Mois de la Photo s'inscrit dans ce mouvement général de reconnaissance du medium. L'idée première était de permettre la rencontre d'œuvres photographiques avec le grand public. C'était aussi de tenter de fédérer les initiatives qui commençaient à poindre.

KY: La création de la MEP a été un moment charnière pour la reconnaissance de la valeur culturelle de la photographie. Pouvez-vous préciser la mission de la MEP et son rôle par rapport à d'autres institutions de la photographie?

J-LM: La MEP a été, en effet, la première institution en France à rassembler dans un même lieu une grande collection de photographies, une bibliothèque spécialisée et une vidéothèque. La mission de la MEP a été, bien sûr, de poursuivre son action en faveur de la reconnaissance de la valeur culturelle de la photographie, mais aussi de jouer un rôle moteur, dans la mesure où, comme le Mois de la Photo, cette Maison a entraîné des initiatives identiques, comme à Moscou par exemple.

KY: Le nom de la MEP indique un certain cadre de référence, c'est-à-dire qu'elle se veut un endroit européen. Pourquoi? La photographie française, a-t-elle à vos yeux une spécificité? Ou bien, la photographie est-elle sans frontières?

J-LM: Bien que la photographie soit évidemment sans frontières, inscrire la MEP dans un contexte européen a permis la création d'un réseau (comme le Mois Européen de la Photographie qui rassemble huit grandes capitales européennes: Berlin, Vienne, Luxembourg, Rome, etc.). Cela a permis aussi de mettre en lumière la photographie européenne et de stimuler la création dans de nombreux

pays où on a assisté à la mise en valeur d'un patrimoine jusque là ignoré, comme en Espagne, en Italie ou dans les pays d'Europe Centrale.

KY: Depuis 2011, vous êtes également le Directeur artistique du festival de la photographie méditerranéenne. Quelle est la spécificité de ce festival?

J-LM: J'ai, effectivement, assuré de 2011 à 2013 la direction artistique du Festival de la photographie méditerranéenne situé à Sanary. Le but de ce festival a été de mieux faire connaître la photographie des pays du pourtour méditerranéen, et plus particulièrement des photographies encore peu exposées, comme la photographie turque, albanaise, marocaine ou libanaise. C'est aussi de permettre des rencontres fructueuses entre les photographes des deux rives de la Méditerranée.

KY: Le Mois de la Photo fêtait sa dix-septième édition en 2012 et c'est devenu un événement bi-annuel incontournable; la MEP fêtera également son vingtième anniversaire bientôt. Quel est votre bilan de l'institutionnalisation de la photographie en France et quels sont vos souhaits pour l'avenir?

J-LM: Plus de trente ans après la création du Mois de la Photo, la photographie a enfin un statut reconnu et indiscutable. Avec l'émergence du numérique, cependant, on assiste à une véritable révolution, à la fois dans les moyens de production et les moyens de diffusion. Il semblerait que la photo argentique relève désormais d'un art patrimonial, tandis que, sur la toile et à travers les ordinateurs, émerge une création nouvelle encore en gestation. D'un côté les frontières entre les arts de l'image s'estompent, de l'autre surgissent des problèmes encore non résolus, comme le statut de l'œuvre ou celui du droit d'auteur. Comme la « cité des savants » dont parlait Gaston Bachelard, on voit peu à peu naître une « cité des créateurs d'images ». C'est un bouleversement qui vraisemblablement remettra en cause les missions traditionnellement dévolues aux institutions.

Nottingham French Studies 53.2 (2014): 139–154
DOI: 10.3366/nfs.2014.0082
© University of Nottingham
www.euppublishing.com/nfs

LA PHOTOGRAPHIE PLASTICIENNE: UNE QUESTION FRANÇAISE?

MAGALI NACHTERGAEL

L'expression « photographie plasticienne » est apparue en France pour la première fois en 1998 sous la plume de la philosophe Dominique Baqué, également critique et responsable de la rubrique photographie du magazine *Art Press*. D'abord récusée par les historiens de la photographie lui reprochant une certaine désinvolture théorique, la position de l'ouvrage *La Photographie plasticienne: un art paradoxal* marque les esprits, de sorte que l'on vit rapidement l'expression faire florès dans le monde de l'art contemporain[1]. Quelques années plus tard, en 2004, Baqué enfonce le clou tout en situant historiquement la photographie plasticienne dans un « extrême contemporain » à une charnière des vingtième et vingt-et-unième siècles qui s'étend de 1990 à la fin de la décennie 2010 – deux balises temporelles marquées à l'origine par l'apparition de la notion de « tableau photographique » d'un côté et de l'autre, par la massification des images à l'ère numérique[2]. S'il ne s'agit pas dans cet article de défendre corps et âme les termes choisis par Baqué, force est de constater qu'ils ont répondu de façon très juste à une lacune dans le paysage théorique de la photographie en France, mais aussi au-delà. Baqué ne place donc plus la photographie sous le régime de la recherche d'une qualité esthétique propre au medium, caractéristique du modernisme. Elle préfère à cette finalité puriste la notion de plasticité, plus vaste et intégrant la nouvelle condition de la photographie face au métissage de l'art contemporain: la photographie participe d'une hybridation des supports et des médias, évoluant vers l'image. Avec le terme de plasticité, ressurgit à l'arrière-plan la notion de modelage, contenue dans la racine grecque *plassein*, qui signifie modeler, mais qui a aussi donné *plasma*, l'image ou la figure en latin. *Plassein* traduit aussi un des sens du mot latin *fictio*, qui signifiait, avant de donner le terme de « fiction », modeler la cire de ses mains: le réseau plastique de l'image fraye dès ses premières manifestations avec l'horizon de la fiction, ce que la photographie plasticienne fait surgir de façon tangible. Mais cette qualité

1. Dominique Baqué, *La Photographie plasticienne: un art paradoxal* (Paris: Regard, 1998). L'expression a été majoritairement adoptée depuis, et de façon notable à la librairie Flammarion du Centre Pompidou qui affiche un rayon « Photo plasticienne ». Baqué constate elle-même que le « débat virulent » est désormais passé.

2. Dominique Baqué, *Photographie plasticienne: l'extrême contemporain* (Paris: Regard, 2004).

plastique de la photographie incarne aussi une vertu adaptative d'un medium capable de se mouler dans d'autres formes.

Dans le prolongement de l'usage photographique par les artistes conceptuels, la photographie plasticienne se manifeste en France au tournant d'un double débat: celui d'une photographie qui cherche toujours sa légitimité en tant qu'art et celui d'une rivalité entre peinture et photographie. L'expression de Baqué témoigne cependant d'une prise de distance radicale avec les canons esthétiques hérités du modernisme: la photographie plasticienne recouvre donc principalement des pratiques néo-conceptuelles de l'image, impures, mixtes et résolument métissées. C'est la raison pour laquelle on retrouve sous cette bannière à la fois des appropriationnistes (Richard Prince), des fictionnalistes de l'intime qui mettent en scène leurs images (Christian Boltanski, Sophie Calle, Nan Goldin, Nabuyoshi Araki), des néo-conceptuels (Jenny Holzer, Barbara Kruger, Hans Haacke) ou ces fameux photographes-artistes comme Jeff Wall, Thomas Ruff, Philip-Lorca diCorcia, Luc Delahaye ou Cindy Sherman. Si la notion de photographie plasticienne a émergé en France, les pratiques métissées, elles, n'ont pas eu de frontières.

Par ailleurs, comme le rappelle judicieusement Michel Poivert, la photographie contemporaine s'est réciproquement nourrie d'un moment théorique de la photographie en France au tournant des années 1970 et 80[3]: parmi quelques exemples marquants, on peut rappeler que *On Photography* de Susan Sontag est traduit dès 1979 en français, que *La Chambre claire* de Roland Barthes paraît en 1980, sans négliger non plus l'impact de certains événements éditoriaux comme la rupture de Denis Roche, renonçant à la poésie pour se consacrer à l'image, l'arrivée d'un critique photographique dans le journal *Le Monde* (Hervé Guibert, en 1977) et plus tard, la traduction des textes de Rosalind Krauss sous l'emblème du « photographique » dans les années 1990[4].

Cette montée en puissance du discours autour de la photographie, de l'émergence de la subjectivité et des représentations de l'intime, a en effet pour beaucoup conditionné les productions en France et favorisé un débat passant autant par des réponses formelles que théoriques. Mais pourquoi, malgré ses prétendues faiblesses, l'expression « photographie plasticienne » saisit-elle avec autant d'impact l'état de la création contemporaine? Étant donné le caractère très franco-français du débat, on ne s'étonnera pas de l'absence de références à la théorie photographique anglo-saxonne ou allemande, même si certains noms ou figures constrastives pourront être mentionnés. Fortement marquée par la tradition académique, l'histoire de l'art en France a toujours réservé une place ambiguë à la photographie. Cette dernière fait d'abord son entrée dans les

3. Michel Poivert, *La Photographie contemporaine* (Paris: Flammarion, 2002), p. 30.
4. Voir Katia Schneller, « Sur les traces de Rosalind Krauss: la réception française de la notion d'index (1977–1980) », *Études photographiques*, 21 (2007), 123–43.

collections nationales via la Bibliothèque nationale de France, qui collecte officiellement depuis 1925 les œuvres en dépôt légal mais reçoit en fait depuis 1851 des dons directs. Longtemps après son rival américain, le Museum of Modern Art de New York, les premières acquisitions de photographies dans la collection du Musée national d'art moderne n'ont lieu qu'en 1976 et ne feront l'objet d'une politique de collection claire qu'avec la création à l'orée des années 1980 du Cabinet de la photographie alors confié à Alain Sayag[5]. Cet écart institutionnel se résout progressivement dans le champ esthétique, mais l'on voit bien comment la photographie arrive tardivement dans le champ de l'art moderne et contemporain français. C'est d'ailleurs à cette période charnière de la décennie 1980 que la rivalité ouverte entre peinture et photographie fait l'objet du débat le plus intense en France. Parmi les effets positifs, on constate l'émergence progressive d'un discours critique plus large et englobant: la photographie, en s'intégrant dans des pratiques plasticiennes, va réciproquement voir son statut d'image et de document interrogé par ces nouveaux usages. Le discours critique, grâce et à cause de la position de Dominique Baqué, intègre et développe la notion problématique de plasticité au cœur de l'esthétique photographique contemporaine.

Issues du conflit moderniste: photo *vs* peinture

La friction entre photographie et peinture est ancienne, l'une et l'autre gardant longtemps des distances mesurées: il faut en effet attendre les années 1970 pour voir des pratiques artistiques mêlant peinture, pratiques graphiques et photographie sans que cette diversité de support ne soit perçue comme un antagonisme. Avec l'émergence de l'art conceptuel et des performances dans les années 1960 aux États-Unis, la photographie fut de plus en plus sollicitée en tant que support pour la documentation ou la démonstration d'une démarche plastique, chez des gens aussi différents que Joseph Kosuth, Dennis Oppenheim, Joseph Beuys, Douglas Huebler, Carolee Schneemann ou Gina Pane. La photographie était alors essentiellement considérée comme une arme contre-moderniste dont l'art conceptuel et le minimalisme incarnaient les formes les plus radicales et cette influence s'est aussi fait sentir chez les artistes néo-conceptuels qui ont utilisé la photographie comme arme contre un canon forgé outre-Atlantique[6].

5. Voir *Collection photographies: une histoire de la photographie à travers les collections du Centre Pompidou, Musée national d'art moderne*, dir. par Quentin Bajac et Clément Chéroux (Paris: Centre Pompidou, 2007) et Quentin Bajac, « Stratégies de légitimation. La photographie dans les collections du musée national d'art moderne et du musée d'Orsay », *Études photographiques*, 16 (2005), 222–33.

6. Voir *Une Aventure contemporaine: la photographie 1955–1995* (Paris: MEP/Paris Audiovisuel, 1995), dont Jean-Claude Lemagny « Photographie et art contemporain: enjeux et paradoxes », pp. 73–8 suivi d'André Rouillé, « Photographie et

Toutefois, comme le discours critique autour de la photographie en France a tendance à distinguer nettement le monde de l'art à celui de la photographie, la séparation a disséminé les forces. Cette opposition reste particulièrement visible lors des manifestations dédiées à la photographie de tradition esthétisante: pour la France, elle se retrouve aux Rencontres d'Arles ou à Paris Photo, la foire internationale annuelle de la photographie d'art. Le monde de la photographie vit en quelque sorte à l'écart d'un contexte artistique français hanté par la mythologie romantique de l'expressionnisme abstrait, le pop art, et la tradition picturale académique. Parallèlement, la photographie de reportage, l'esthétique documentaire et les visions humanistes se fabriquent à distance des ateliers théâtraux d'un Jackson Pollock ou d'un Mark Rothko – ou alors à titre de document (on pense ici aux clichés de Hans Namuth contribuant justement à fixer la gestuelle de Pollock dans le mythe héroïque de l'artiste moderne). La fabrique d'une philosophie esthétique de la photographie a donc connu une tension difficile à résoudre tant qu'elle se pensait soit exclusivement dans un modèle moderniste (une recherche sur le médium lui-même), soit en fonction de ses usages qui commençaient eux-mêmes à se spécialiser et à se subdiviser en tendances très singulières. Le différend sembla pourtant se résoudre lorsque apparut en France l'idée majeure de photo-tableau, développée et théorisée par Jean-François Chevrier en 1989 à l'occasion de l'exposition *Photo-Kunst*: elle laissait en effet pleinement entrer la photographie dans l'histoire de la peinture et pouvait tout à fait s'accorder avec les grandes théories modernistes de Michael Fried, notamment sur la relation entre art et spectateur[7]. D'un autre côté, la photographie que l'on qualifiera d'esthétisante, parfois documentaire, mais très construite selon des codes de représentation propre à l'histoire de la photographie depuis le mouvement pictorialiste et représenté aux Etats-Unis par le groupe *Camera Work* autour d'Alfred Stieglitz et Edward Steichen, cette tendance plus soucieuse d'une autonomie propre au médium, fut défendue par Gilles Mora, Claude Nori, Jean-Claude Lemagny et reste perpétuée aujourd'hui, avec bien des évolutions et des ouvertures, par les historiens de la photographie, dont Michel Poivert, Paul-Louis Roubert ou André Rouillé. À la croisée de ces deux points de vue théoriques (au sens de *standpoint theory*), photographie humaniste, photographie subjective, réalisme quotidien, photo-objet, fictions,

postphotographie », pp. 81–8, qui rappelle le postulat de Nancy Foote posé en 1976 dans son article « The Anti-Photographers », *Artforum*, 15 (1976), 46–54.

7. Jean-François Chevrier, « Les Aventures de la forme tableau dans l'histoire de la photographie », dans *Photo-Kunst. Arbeiten aus 150 Jahren. Du XXᵉ au XXIᵉ siècle, aller et retour*, cat. exp., 11 novembre 1989–14 janvier 1990 (Stuttgart: Staatsgalerie 1989), pp. 47–81 et Michael Fried, *Why Photography Matters as Art as Never Before* (New Haven: Yale University Press, 2008).

photomontages, récits-photos, détournements ou documentations artistiques frayent les multiples interprétations critiques de la photographie en France.

De quelle photographie est-il question, en France, lorsqu'on évoque la possible « autonomie du médium »? C'est au cœur du courant esthétisant que les lignes de force historique apparaissent le plus clairement. Claude Nori, grand animateur de la recherche photographique française pendant les années 1980 avec les *Cahiers de la photographie*, avait choisi comme mètre étalon esthétique une « photographie créative », en référence à la *Creative Photography* américaine. Dans son ouvrage sur la tradition photographique française, des origines à nos jours, il justifie l'usage de cette catégorie exogène en la liant à une tradition moderniste qui a façonné tout le paysage pictural outre-Atlantique de la seconde moitié du vingtième siècle, et au premier chef la peinture[8]. La photographie créative tendrait ainsi à une autonomie en tant qu'œuvre d'art au même titre que la peinture: c'est en tout cas l'argument récurrent qui est avancé tant chez Baqué, pour le contrer et exclure la photographie de cette tradition téléologique, ou chez Chevrier pour l'inclure à l'histoire de la peinture ou par Rouillé pour le modaliser et distinguer des régimes esthétiques. Ces trois théoriciens de l'image photographique prennent toutefois tous en considération le fait que certains artistes ont emprunté le « procédé photographique », et Rouillé insiste notamment sur le terme de procédé pour sa dimension technique, pour se l'approprier tantôt comme support technique mais aussi comme médium à part entière[9]. En 2008, Nori pose rétrospectivement la situation au tournant des années 1970–80 de cette manière: « si les plasticiens réclamant leur statut de peintre utilisaient la photographie comme documentation [. . .], les photographes artistes désiraient l'interroger de l'intérieur comme un matériau bien vivant auquel ils étaient directement et quotidiennement confrontés »[10]. Derrière ces propos se perçoit l'influence importante de Lemagny, conservateur pour la photographie dans son fief historique de la Bibliothèque nationale et œuvrant à une reconnaissance de la photographie comme art à part entière. Nori revendique donc la « créativité » à laquelle, ainsi qu'à la photographie de reportage, Baqué oppose la « plasticité ». Le constat de Baqué part en effet d'un point de départ très différent, celui « de l'hybridation généralisée des pratiques, du décloisonnement » propre à l'art contemporain qui a, selon elle, pour conséquence de ne plus inscrire l'image photographique dans une « histoire supposée pure et autonome du médium »[11]. Le paradoxe qu'elle soulève serait que si l'art contemporain par son

8. Claude Nori, *La Photographie en France: des origines à nos jours* (Paris: Flammarion, 2008).

9. André Rouillé, *La Photographie: entre document et art contemporain* (Paris: Gallimard, 2005), p. 473.

10. Nori, *La Photographie en France*, p. 187.

11. Baqué, *La Photographie plasticienne*, p. 9.

hétérogénéité formelle a bouleversé le statut de la photographie, réciproquement, la photographie a participé au renversement des valeurs académiques et à la réévaluation du statut des images dans le champ élargi de l'art[12].

Ce contrepoint de Baqué qui venait renverser un discours établi de longue date avec une lente obstination, n'a pas manqué de soulever bien des critiques. La plus notable venait de Poivert d'abord, ce dernier reprochant à Baqué de forger une notion à partir d'une suite de « notes de synthèses » trop déliées pour que les tenants suffisent à délimiter les contours d'une photographie identifiée selon lui comme simplement néo-conceptuelle[13]. Rouillé pour sa part considère la notion comme une « catégorie faible » voire, une « fausse notion »[14]. Il faut dire que l'expression « photographie plasticienne » ressemble à bien des égards à un coup d'État théorique dans le landerneau de la critique photographique en France tenu principalement par l'Ecole nationale supérieure de la photographie d'Arles et les Rencontres photographiques d'un côté (Christian Caujolle, Christian Gattinoni, et dans une moindre mesure, Arnaud Claass) et des personnalités animant des revues universitaires comme *Les Cahiers de la photographie* (Gilles Mora), *La Recherche photographique* (André Rouillé), et *Études photographiques* (André Gunthert, Michel Poivert), soutenues par Lemagny[15]. Jusqu'aux années 2000, les sociologues et médiologues étaient quant à eux généralement maintenus à l'écart des débats sur l'art et la photographie[16].

12. La position de Baqué répond également à la question soulevée par l'historienne de l'art Johanne Lamoureux en 1996, en réaction aux analyses de Rosalind Krauss sur le photographique et la notion de « champ élargi », voir Rosalind Krauss, *L'Originalité de l'avant-garde et autres mythes modernistes*, trad. par J.-P. Criqui (Paris: Macula, 1993) et Johanne Lamoureux, « La Critique postmoderne et le modèle photographique », *Études photographiques*, 1 (1996), 109–15.

13. Voir la recension des historiens de la photographie dont celle de Michel Poivert, « Dominique Baqué, *La Photographie plasticienne, un art paradoxal* », *Études photographiques*, 6 (1999) < http://etudesphotographiques.revues.org/196 > [vérifié le 4 septembre 2013].

14. Rouillé, *La Photographie*, pp. 472 et 474.

15. Gilles Mora décrit Lemagny dans la préface à la réédition de ses écrits: « planté devant les images qu'ensemble, Patrick Roegiers, lui et moi, avions présentées autour de la photographie actuelle en France, et qu'avec l'aide de l'AFAA (Association française pour l'action artistique), nous les faisions circuler, dans plusieurs pays et continents ». Jean-Claude Lemagny, *L'Ombre et le temps: essai sur la photographie comme art* [1992] (Paris: Nathan, 2005), p. 7.

16. Marin Dacos et Sylvain Maresca furent parmi les premiers sociologues à participer à la revue *Études photographiques* tandis que les médiologues et sémiologues de l'image trouvaient une tribune dans la revue *Les Cahiers de la médiologie* (aujourd'hui *Medium*) animée par Régis Debray. Depuis une petite dizaine d'années, les préoccupations critiques se sont nettement déportées vers les études visuelles, dont l'interface *culturevisuelle.org* d'André Gunthert traduit bien la mutation.

On aura cependant remarqué que, dans un article récent, Rouillé semble revenir, et avec une certaine mauvaise foi, sur sa critique émise à l'encontre de Baqué en 2005. Il soumet en effet une nouvelle notion, l'« art-photographie », guère éloignée conceptuellement et historiquement de la photographie plasticienne. En des termes très proches de Baqué, il affirme en effet que « les années 1980 voient donc [...] l'alliage longtemps inconcevable entre l'art et la photographie. Non seulement l'usage du procédé photographique comme outil ou vecteur de l'art, mais l'adoption de la photographie comme matière (souvent) exclusive des œuvres »[17]. De là Rouillé délimite « une version nouvelle de l'art que l'on pourrait désigner sous le terme "d'art-photographie" »[18], qui prend juste à l'envers l'affirmation de Baqué: ce sont les arts plastiques qui sont devenus photographiques et non la photographie qui est devenue plasticienne. On entend encore malgré tout dans ces propos, écrits en 2012, l'écho direct de l'idée développée par Baqué dans son ouvrage séminal de 1998, *La photographie plasticienne*. En 2004, cette dernière est tout à fait consciente que, comme l'énonce François Soulages, « face à l'art-contemporain et à la photographie-contemporaine [*sic*], il faut mettre en place une esthétique axiologique provisoire »[19] et inclut dans son propos réactualisé la notion d'un contexte contemporain en rapide évolution, non pas seulement en raison de l'arrivée du numérique mais aussi plus largement de l'omniprésence des écrans, rejoignant en cela le terrain plus vaste et plus politique des *visual studies*.

Une scène parisienne marquée par le débat théorique
Toutefois, ce que Dominique Baqué a désigné sous la bannière large de photographie plasticienne renvoie à une réalité française qui fait s'interpénétrer les frontières du champ de l'art, avec des débats et pratiques autour de la photographie proprement français et avec un groupe d'artistes relativement bien identifiés: Christian Boltanski, Annette Messager, Sophie Calle, Valérie Jouve, Denis Roche, Bernard Faucon, Patrick Tosani, Florence Paradeis, Eric Baudelaire, Sophie Riestelhueber pour ne citer que les Français. Dans l'ouvrage de référence de Christian Gattinoni sur *La Photographie en France, 1975–2005*, l'éditeur luxembourgeois Paul di Felice désigne sous le nom de « photographes plasticiens » des artistes qui illustrent selon lui « diverses caractéristiques de la photographie française », et particulièrement de « l'utilisation de l'image comme

17. André Rouillé, « La Photographie des artistes: un autre art dans l'art », dans *Photo-graphie-contemporaine et art-contemporain*, dir. par François Soulages et Marc Tamisier (Paris: Klincksieck, 2012), pp. 83–90 (p. 89).

18. Ibid.

19. François Soulages, « Photographie-contemporaine et art-contemporain », dans *Photo-graphie-contemporaine et art-contemporain*, pp. 9–63 (p. 60).

"mise en abyme" d'un réel "réinventé" »[20]. Régis Durand, ancien directeur du Centre national de la photographie, dans un essai sur la photographie allemande contemporaine, remarque par comparaison outre-Rhin une « moindre présence d'une photographie "plasticienne", picturale (ou "néo-pictorialiste" comme l'a très justement fait remarquer Alain Sayag) »[21]. C'est, avec la photographie journalistique et documentaire en plus, cette image difficile à nommer (plasticienne, néo-pictorialiste ou picturale) qui a fait de la « situation française », comme Durand la nomme, un cas particulier dans le paysage artistique contemporain – pendant peut-être fantasmé d'une exception culturelle ou procédant d'un « *narcissisme herméneutique* » dont Durand envisage d'être aussi lui-même la victime[22]. Son texte accompagne une exposition présentée aux États-Unis dans laquelle figuraient des œuvres de Sophie Calle, Annette Messager, Patrick Tosani, Pascal Kern, Suzanne Laffont et Christian Boltanski, ce dernier se trouvant à maintes reprises au centre du débat sur la frontière entre la photographie et l'art[23]. La question de la confrontation systématique des médiums et pratiques associées aux beaux-arts avait été en effet radicalement posée par Boltanski dès 1976 quand il avait évoqué le rôle de la photographie chez les « peintres photographes » à l'occasion de la fameuse exposition *Identités/ Identifications* (CAPC Bordeaux)[24].

Six ans plus tard, l'exposition *Ils se disent peintres, ils se disent photographes* en 1981 porte un coup fatal à la distinction entre deux statuts artistiques ouvrant ainsi la voie à une renégociation théorique des médiums. Si Durand considère que cette exposition « fut longtemps le symptôme » de « l'enlisement du débat »[25], Suzanne Pagé note en introduction à cette exposition majeure qu'il s'agit précisément de faire tomber les clivages entre photo et peinture, tant

> la distinction est de plus en plus vague et arbitraire au niveau des œuvres elles-mêmes qui, par leur caractère violemment subjectif, imaginaire, phantasmatique,

20. Christian Gattinoni, *La Photographie en France, 1970–2005* (Paris: Panoramas/ CulturesFrance, 2006), p. 19.
21. Régis Durand, *Habiter l'image: essais sur la photographie 1990–1994* (Paris: Marval, 1994), p. 93.
22. Ibid., p. 75.
23. Timothy Eaton (dir.), *La Photographie et au-delà: nouvelles expressions en France/ Photography and Beyond: New Expressions in France*, cat. exp. (Paris: Latitudes/APAA, 1994).
24. Cité par Jean-François Chevrier, « Christian Boltanski, entretien avec Jacques Clayssen », dans *Identités/Identifications*, dir. par Jean-Louis Froment, cat. exp. (Bordeaux: Capc-Entrepôt Lainé, 1976), pp. 23–5.
25. Durand, *Habiter l'image*, p. 77.

ou au contraire très analytique et formaliste débordent, de part et d'autre, toutes les frontières du genre, leur histoire et leur appareil.[26]

Dans cette exposition-manifeste, on retrouve en effet les artistes associés aux mythologies individuelles et au *Narrative Art* qui font usage de la photographie dans des mini-récits illustrés comme Bill Beckley, Christian Boltanski, James Collins, Paul-Armand Gette, Jean Le Gac, Annette Messager, Sarkis mais aussi des artistes néo-conceptuels liés tantôt au Land Art, à l'Arte Povera, au Body Art, à la performance ou à l'appropriationnisme: les Becher, Victor Burgin, Jan Dibbets, Hamish Fulton, Jochen Gerz, Gilbert and George, John Hilliard, les Leisgen, Giuseppe Penone, Richard Prince, Arnulf Rainer, Ed Ruscha, Cindy Sherman ou encore Michael Snow.

Pour décrire la « situation française », Durand souligne d'emblée, de façon certes assez convenue et diplomatique, « sa réelle originalité »[27]. Cette dernière procède selon lui de l'influence croisée d'une « riche tradition photographique » qui a « pu servir alternativement de stimulant ou de repoussoir »[28]. Ce paradigme photographique français a valu par exemple à Boltanski de se détourner de façon radicale de la « photographie d'art » (mais aussi humaniste, de reportage, de mode ou créative) pour aller vers « la photographie amateur » pour en souligner les stéréotypes à la fois culturels et esthétiques. En effet, les images imprimées depuis 1969 en petits livres dans le sous-sol de la galerie parisienne Givaudan compilent des clichés pétris de sociologie de l'image, sous l'influence grandissante des sciences humaines[29]. Par la suite, Boltanski intègre les photographies pour leur valeur d'usage à travers des dispositifs plastiques panoramiques: *L'Album de la famille D.* (1971) (Figure 1), présenté sous la forme d'un mur d'images en 1972 à la Documenta V de Cassel, institue sur la scène internationale un rapport critique non seulement à la photographie amateur mais aussi à ses fonctions sociales.

Les « images modèles » de Christian Boltanski sont corollairement à mettre en relation avec les photographies retouchées et dessins d'après photographies

26. Suzanne Pagé, « Avant-propos », *Ils se disent peintres, ils se disent photographes*, cat. exp., 22 novembre 1980–4 janvier 1981 (Paris: Arc-Musée d'art moderne de la ville de Paris, 1981), non paginé.

27. Durand, *Habiter l'image*, p. 78. Cette singularité historique a été mise en lumière par Dominique de Font-Réaulx, « Les Audaces d'une position française: l'exposition "Un siècle de vision nouvelle" à la Bibliothèque nationale (1955) », *Études photographiques*, 25 (2010), 70–105.

28. Durand, *Habiter l'image*, p. 78–9.

29. Boltanski évoque notamment l'influence de Lévi-Strauss, Christian Boltanski et Catherine Grenier, *La Vie possible de Christian Boltanski* (Paris: Seuil, 2007), p. 48.

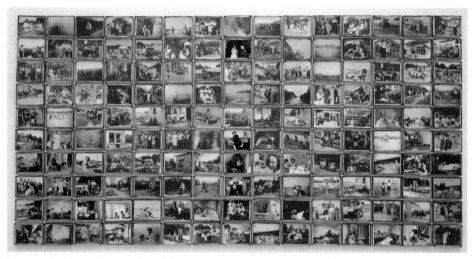

Figure 1. Christian Boltanski, *L'Album de la famille D.* (1971), 150 photographies noir et blanc encadrées de fer blanc. Dépôt de l'Institut d'art contemporain, Villeurbanne/Rhône-Alpes. Inv.: D.91.7.1 © ADAGP, Paris. Crédit photographique: Yves Bresson/Musée d'art moderne de Saint-Etienne Métropole.

d'Annette Messager dans ses nombreux carnets de collectionneuse[30]. Plusieurs de ses séries utilisent des photographies de presse ou commerciales, selon le principe appropriationniste qui intègre des objets esthétiques pour les relancer vers un sens nouveau. Dans la série *Mes jalousies* (1972) (Figure 2), Messager corrige au crayon des portraits publicitaires féminins en les grimant grossièrement, tandis que dans *Portraits des amants* (1977), elle collecte des photos de mannequins masculins pour les présenter comme son tableau de chasse amoureuse. Mais le travail autour des images peut aussi s'inverser. De l'image photographique n'est alors conservée que des représentations-clichés sous forme de vues stéréotypées reproduites par la main de Messager. La série de dessins *Le bonheur* (1976) fait ainsi défiler des couchers de soleil, des animaux sauvages dans la forêt, des baisers à contre-jour, toutes sortes de clichés faisant appel au sentiment de déjà-vu du spectateur. La production d'images chez Boltanski et Messager signale de façon archétypale la caducité du conflit entre art et photographie, puisque les pratiques se répondent et construisent un discours critique autour de la photographie et de l'image en général, d'un point de vue esthétique mais en lui intégrant une dimension socio-imaginaire. Ces problématiques ne sont pas exclusives de ces plasticiens photographes français, et se retrouvent chez les représentants de la photographie tableau: on pense aux vues panoramiques

30. Voir Christian Boltanski, *Les Modèles: cinq relations entre texte et image* (Paris: Cheval d'attaque, 1980).

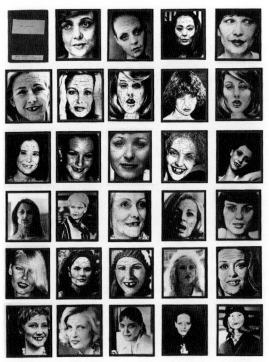

Figure 2. Annette Messager, *Mes jalousies – Album collection n°25, Annette Messager Collectionneuse* (1972), 29 photographies noir et blanc, crayon, stylobille sur papiers imprimés et collés, cahier. Inv.: 87–240 © ADAGP, Paris. Crédit photographique: Alain Béguerie.

d'Andreas Gursky dans les hauts lieux de la consommation contemporaine, supermarchés, salles de concert, piscines surpeuplées, aux scènes de genre de Jeff Wall (*Morning Cleaning – Mies van der Rohe Foundation, Barcelona*, 1999) ou aux mises en scènes d'Eric Baudelaire comme le diptyque *The Dreadful Details* (2006) qui rejoue un épisode de guérilla urbaine au Moyen Orient. Ces photographies commentent le monde contemporain tout en usant des outils de la tradition picturale moderniste et sans faire appel à un dispositif en installation qui a pour effet de décentrer la focalisation esthétique.

Mais ces variations peuvent tout aussi bien être opposées à d'autres tendances de la photographie contemporaine. En prenant exemple sur ces scènes reconstituées, Durand note dans les photographies de Patrick Tosani une véritable construction de l'image par la mise en scène d'objets et de l'espace aux antipodes de la philosophie de « l'instant décisif »[31]. L'influence de Henri

31. Durand, *Habiter l'image*, 79.

Cartier-Bresson qui emprunta au Cardinal de Retz la notion très politique de « moment décisif » a eu tendance à cristalliser fortement une conception de l'image photographique sur le mode de la coupure et de la temporalité, ce que Philippe Dubois contribue à sceller sur le plan théorique en 1983 dans son essai *L'Acte photographique*[32]. Le livre, très diffusé dans les écoles et les universités, a alimenté un rapport de dépendance de la photographie au temps, voire de subordination à un cinéma dégagé de la fixité, faisant un écho symétrique à la position esthétisante de Lemagny, à savoir une conception de l'image tournée vers une définition du médium *per se* et une quête esthétique à travers des moyens exclusivement photographiques.

Dans un autre de ses essais majeurs, *Le Regard pensif*, Durand cite encore Boltanski qui affirme que « toute photographie qui ne serait pas strictement analogique [. . .] serait "peinture" » avant d'analyser ce qui a été identifié comme une « volonté d'art de la photographie », directement empruntée au *Kunstwollen* d'Aloïs Riegl – une position que Durand rejette comme élément déterminant de la « situation française » au même titre que celle de « Zeitgeist »[33]. Chevrier, en forgeant la notion de « forme-tableau » à l'occasion des expositions mémorables *Photo-Kunst* (1989–90) et *Une autre objectivité* (1989) avait justement dépassé ces clivages stylistiques nationaux pour mettre en avant une caractéristique formaliste incluant la notion de frontalité de l'image et supposant un jeu moderniste avec la place du spectateur[34]. Chevrier commente donc la nouvelle condition photographique dans l'art en considérant que

> de nombreux artistes, qui ont plus ou moins assimilé les recherches conceptuelles, ont réutilisé le modèle du tableau et utilisent la photo, très consciemment, très systématiquement, pour produire des œuvres, et des œuvres autonomes, qui se présentent comme des tableaux photographiques.[35]

Il ne place pas toutefois cette pratique dans une perspective moderniste mais bien en intégrant « toutes les procédures d'usage du médium inventées par des artistes à partir de modèles extrêmement variés, voire hybrides »[36].

32. Toujours dans cette perspective, l'essai de Régis Durand, *Le Temps de l'image: essais sur les conditions d'une histoire des formes photographiques* (Paris: Mobile Matière/La Différence, 1995) creuse encore le sillon d'une photographie comme art du temps.

33. Régis Durand, *Le Regard pensif: lieux et objets de la photographie* (Paris: Mobile Matière/La Différence, 1990), pp. 76, 125 et 454–7.

34. Michael Fried, *La Place du spectateur* [*Absorption and Theatricality*, 1980], trad. par Claire Brunet (Paris: Gallimard, 1990).

35. Chevrier, « Les Aventures de la forme tableau », p. 50.

36. Ibid.

Entrée de la photo en art ou élargissement de l'art?

Ainsi, alors qu'on pourrait croire que Boltanski se situe aux antipodes de la photo-tableau, dans la mesure où il fut un des artisans majeurs de cette nouvelle plasticité de la photographie, on se rend compte que la convergence des arts en France à partir des années 1980 est beaucoup plus profonde que les apparences voudraient le laisser croire[37]. La photographie plasticienne va bientôt arriver à point nommé pour réconcilier ces divergences souvent ténues. Michel Nuridsany, dans son essai introductif « Ils se disent peintres, ils se disent photographes », rapporte une affirmation choc de l'artiste français qui avait alors médusé l'assistance des Amis du Musée d'art moderne. En un axiome radical, il renvoyait l'essentiel de la photographie à son usage médiatique et informatif: « la photographie c'est le photo journalisme, le reste c'est de la peinture »[38], semblant même associer les photographies amateurs à une nouvelle forme de peinture du dimanche. Dans un autre sens que Chevrier, les vues de Boltanski revendiquent une indistinction entre les modes de productions techniques des représentations. Il en ressort que la production d'image, qu'elle soit peinture ou photographie, participe d'une même démarche: artistique, et ancrée dans une relation à un contexte socio-culturel (le public, l'institution, la légitimité, l'histoire de l'art établie, etc.). Chevrier, comme Boltanski, rapproche la forme tableau d'une pratique d'artistes photographes, des termes autour desquels tourne inlassablement la critique, tout en lui adjoignant des caractéristiques stylistiques issues du formalisme pictural (il mentionne la *Subjektive Photographie* en Europe, le néo-pictorialisme, directorial mode[39] ou encore la *Straight, New color, Postmodern* ou *Concerned Photography*[40]).

37. Keisho Kirishima note d'ailleurs que Boltanski est « le seul peintre qui figure dans le *Dictionnaire des photographes* (dir. par Carole Naggar [Paris: Seuil, 1982], pp. 55–6) parmi des peintres qui ont utilisé la photographie en tant que média », « A propos d'un catalogue » *Critique*, 459–60 (1985), pp. 934–5.

38. Michel Nuridsany, « Ils se disent peintres, ils se disent photographes », dans *Ils se disent peintres, ils se disent photographes*, p. 7.

39. Chevrier, « Les Aventures de la forme tableau », p. 51.

40. Jean-François Chevrier et James Lingwood, « Introduction », dans *Une autre objectivité/ Another Objectivity*, cat. exp., 14 mars–30 avril 1989 (Paris/Milan: Idea Books, 1989), pp. 24–5. Ces tendances sont parmi les multiples ramifications de l'esthétique photographique: la *Subjektive Photographie* en Europe apparaît avec Otto Steinert dans la tradition du Bauhaus autour du groupe Fotoform, le néo-pictorialisme avec les photographes à la recherche du caractère auratique de l'œuvre (Paolo Gioli par exemple), la *directorial mode* du critique A.D. Coleman en 1976 portait sur les limites du réalisme photographique, tandis que la *Straight* revenait à une prise de vue directe, frontale du réel, la *New color* jouait des aplats ou des compositions de couleur sur l'image, et la *Postmodern Photography* faisait précisément entrer l'image dans la contradiction la plus totale avec sa fonction réaliste (par des effets, compositions ou déformations). La *Concerned Photography* relève de la photographie engagée.

Ainsi, cette supposée entrée en art de la photographie, que Rouillé rejette pour sa part complètement[41], est de toute façon, selon Durand, abolie par la disparition des figures des photographes et des peintres au profit de celle de l'artiste, qu'il relie à des « attitudes » qui rappellent l'exposition-manifeste de l'art conceptuel montée par Harald Szeemann à Berne, ou autant dire, en terrain neutre, en 1969[42]. La photographie se présente comme un élément transitif qui participe, à un moment donné, à la réalisation d'une œuvre au sens large. Ces termes sont très précisément révisés par Baqué en avant-propos de son ouvrage de 2004, *Photographie plasticienne: l'extrême contemporain*. Pour elle, la photographie créative, aux accents modernistes et humanistes défendus par Lemagny dans les années 1980, a été marquée par le sceau du déclin précisément à cause de la montée en puissance des formes néo-conceptuelles[43]. Baqué cite ceux qu'elle considère comme les « grands noms » de la photographie plasticienne, pionniers d'un *mixed media* conceptuel qui se caractérise par des pratiques variées[44]. Pour abonder dans son sens, on constate en effet aujourd'hui que les institutions dédiées initialement à la photographie, le Centre national de la photographie par exemple, transféré au Jeu de Paume, le Centre photographique d'Ile de France ou la collection du FRAC-Aquitaine, historiquement tournée vers la photographie, ont évolué vers des pratiques plus larges de l'image, intégrant images mobiles, installations ou formats numériques. Ainsi, la Maison européenne de la photographie reste, avec les Rencontres d'Arles, un des derniers bastions d'une photographie créative se rapprochant des conceptions historiques de la photographie en France, tandis que la photographie dans le champ de l'art contemporain[45] a rebattu les catégories esthétiques et ouvert non seulement à une perméabilité des genres mais aussi des discours théoriques, ce dont témoignent les nombreuses publications de référence consacrées à la photographie dans l'art contemporain[46].

41. Rouillé, *La Photographie*, p. 473.

42. Harald Szeemann, *Live in Your Head. When Attitudes Become Forms* (Berne: Kunsthalle, 1969).

43. Je renvoie au très éclairant catalogue portant sur l'intégration de la photographie dans l'art conceptuel en France et en Europe: Matthew S. Witkovsky, *Light Years. Conceptual Art and the Photograph, 1964–1977* (Chicago/New Haven/London: The Art Institute of Chicago/Yale University Press, 2011). Voir également Erik Verhagen, « La Photographie conceptuelle: paradoxes, contradictions et impossibilités », *Études photographiques*, 22 (2008), 118–39.

44. Baqué, *Photographie plasticienne*, p. 10.

45. Voir Jean Poderos (dir.), *Qu'est-ce que la photographie aujourd'hui? Beaux Arts Magazine*, hors série (2002) et la réédition par Fabrice Bousteau (2009).

46. Voir Elisabeth Couturier, *Photographie contemporaine* (Paris: Flammarion, 2011) et aussi, pour un panorama plus orienté vers la scène internationale, Charlotte Cotton, *The Photograph in Contemporary Art* (London: Thames and Hudson, 2004).

En conclusion: la force plastique

La plupart des critiques s'accordent pour considérer que les artistes des mythologies individuelles, les photographes fictionnalistes et les plasticiens utilisant la photographie en France ont participé à la destitution du mythe moderniste de l'aura de l'œuvre d'art en poussant au dernier point la photographie pour ne plus garder que sa valeur d'usage ou métacritique, lui faisant atteindre son degré zéro. En effet, à la manière du Nouveau roman qui ne gardait du langage qu'une valeur fonctionnelle, comme un grand répertoire de sens, Baqué considère également que cette pratique non-photographique de la photographie a eu pour conséquence de redéfinir la fonction-auteur, comme s'il pouvait ne plus y avoir que des « scripteurs-photographes »[47]. Ainsi la photographie plasticienne, reprenant à son compte les qualités de la plasticité se caractérise comme une matière presque neutre, dans ses aspects techniques mais aussi médiatiques[48]. Le contexte de production et d'exposition déterminent alors pour beaucoup l'usage qui est fait du matériau photographique. En cela, la photographie plasticienne participe de cet art contextuel dont Paul Ardenne a délimité les contours et dont les exemples rejoignent souvent ceux de Baqué, prolongeant ainsi le « Manifeste pour un art contextuel » défini en 1976 par l'artiste polonais transmédiatique Jan Świdziński[49]. Cette posture n'est pas sans rappeler la position fondatrice de l'Américain Aaron Scharf qui affirmait en 1968 que « la photographie est aujourd'hui, au même titre que l'art et la nature, une source permanente d'art »[50]. Prenant en compte les possibilités de la reproduction de masse, il ajoute qu'une « nouvelle hiérarchie, soutenue par l'histoire de l'art, sera imposée par la photographie » et se réfère à Malraux pour affirmer que « du fait des reproductions photographiques, l'art aura tendance à être plus intellectualisé », de sorte que « la grande hétérogénéité collective de l'art ne trouve pas son issue dans un plaisir des yeux mais dans la connaissance des relations »[51].

Ce débat est-il le signe d'une opposition entre la photographie et l'art contemporain, ou ne nous indique-t-il pas justement que la photographie, au même titre que la peinture ou le dessin, participe à part égale de la construction

47. Baqué, *Photographie plasticienne*, p. 9.

48. Voir Catherine Malabou (dir.), *Plasticité* (Paris: Léo Scheer, 2000).

49. Paul Ardenne, *Un Art contextuel: création artistique en milieu urbain, en situation d'intervention, de participation* (Paris: Flammarion, 2009). La dimension politique est très présente dans l'ouvrage qui fait écho mais dans un registre différent à un autre livre de Dominique Baqué, *Pour un nouvel art politique: de l'art contemporain au documentaire* (Paris: Flammarion, 2004).

50. Aaron Scharf, *Art and Photography* (Harmondsworth: Pelican Books, 1974), p. 323 (notre traduction).

51. Ibid., pp. 324 et 323–4 (notre traduction).

du champ esthétique contemporain dans toute sa latitude, et même au-delà? Les derniers ouvrages parus sur la photographie contemporaine revendiquent pour certains cette *articité* dont on semble toujours soupçonner l'image technique d'être dépourvue[52]. D'un autre côté, la photographie contemporaine en France présente des visages variés, qui forment un continuum entre expressions plastiques intermédiales et travail exclusif sur l'image. Ces variations élargissent les domaines théoriques disciplinaires et ont eu pour effet de déboguer la photographie des considérations sclérosantes dans lesquelles elle a été longtemps enfermée (la référentialité, l'indexicalité, le réalisme, les oppositions de nature technique). L'idée d'une photographie plasticienne, à l'orée de l'ère numérique, a sans conteste préparé son entrée dans le brassage contemporain et résolument plastique des usages et des représentations par l'image[53].

52. André Gunthert et Michel Poivert (dir.), *L'Art de la photographie: des origines à nos jours* (Paris: Citadelles et Mazenod, 2007).
53. Voir Hilde Van Gelder et Helen Westgeest, *Photography Theory in Historical Perspective. Case Studies from Contemporary Art* (Chichester: Wiley-Blackwell, 2011).

Nottingham French Studies 53.2 (2014): 155–168
DOI: 10.3366/nfs.2014.0083
© University of Nottingham
www.euppublishing.com/nfs

THE SPACES OF CONTAINMENT:
VALÉRIE JOUVE'S URBAN PORTRAITS

OLGA SMITH

In her art Valérie Jouve has been exploring situations arising from human interaction with urban space since the 1990s, initially in photography, and from 2001 also in film. The French artist's achievements in both media have been recognized and rewarded with prizes and exhibitions in major art museums.[1] Single-minded attachment to the exploration of the theme of urban experience endows Jouve's extensive body of work with cohesion and unity, further emphasized by the idiomatic manner in which this topic has been treated: throughout her career the artist has repeated, with minor variations, a given device or a composition, elaborating on it within a given series. Proceeding with awareness of the interconnected nature of Jouve's œuvre, I focus in this paper on her two photographic series, *Les Personnages* (begun in 1991) (Figures 1–3) and *Les Façades* (begun in 1997) (Figure 4). Both series can be described as urban portraits: works gathered in *Les Personnages* show figures posing against the backdrop of the modern city they inhabit, while *Les Façades*, as the title suggests, offers views of the exterior of buildings, which, while unpopulated, bear indelible marks of human presence. I approach the complex dynamics between the human body and the urban environment as a process of containment. I first discuss it as a matter of enclosure of the body by architecture and civic structures, subsequently applying the idea of containment to the strategies of pictorial delineation within the photographic frame, with the theoretical discourse on the *tableau* providing the main analytical framework. The issue of delimiting inevitably raises the question of geographical boundaries and the relationship of the urban centre to its periphery, which in the context of France has been inextricably bound up with narratives of social stratification. This paper makes clear the complex strategies which underlie the organization of physical, social and pictorial space undertaken by Jouve in her photography.

1. Jouve was the winner of the Prix Niépce (known as the Goncourt of photography) in 2013 and the Prix Georges de Beauregard in 2003, and nominated for the prestigious Prix Marcel Duchamp in 2002. Her solo exhibitions have been held at the Centre Pompidou (2010), Sprengel Museum (2005), MAC/VAL (2004) and Fotomuseum Winterthur (2002).

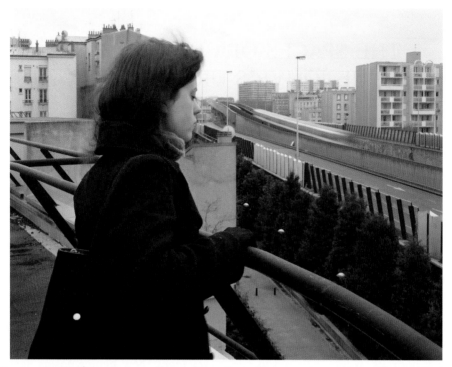

Figure 1: Valérie Jouve, *Sans titre (Les Personnages avec Claire Deniel)* (2008–9), C-print, 100 × 130 cm. Copyright: The Artist, Courtesy Galerie Xippas.

Social Structures of Containment

The narratives in Jouve's urban portraits are so thin that they seem to sit on the very surface of the image. In *Sans titre (Les Personnages avec Claire Deniel,* 2008–9) (Figure 1) a young woman stands on a footbridge, contemplating the view below with her hands on the railings. The urban view in the background seems, at first glance, to belong to any city, with only the Haussmannian townhouses offering a clue to its geographical location. The title of the work provides us with the name of the woman depicted, but the image remains opaque, denying us any insight into her psychology, occupation or character. Our experience of meeting Claire Deniel remains as provisional and fleeting as a chance encounter with a stranger in the street – a space shared with hundreds of people, but which is navigated under the protection of anonymity. As a result, Claire and other characters in the *Personnages* series can only be defined by the most basic of attributes, such as their looks (Claire is a brunette), clothing or belongings (she wears a dark coat and carries a handbag) and simple actions they perform (standing, holding on to the railings). Of these attributes, actions seem particularly important for Jouve in describing the person's relationship to their

environment at a given moment in time. Thus, in the urban portraits gathered in series *Les Passants* and *Les Fumeurs*, the title defines the individuals as walkers, or smokers. Quotidian acts of walking the street and taking a cigarette break seem capable of defining one's identity, albeit provisionally and in the most rudimentary manner. At the same time, the actual range of actions depicted in *Les Passants*, *Les Fumeurs* and *Les Personnages* is remarkably limited: people walk, smoke, rest, mount the steps or simply stay still and observe. Given that situations in Jouve's photography almost always occur in the context of public space, this limited vocabulary of gestures indicates restrictions arising from the unwritten, but deeply internalized rules of socially acceptable behaviour. Elaine Scarry has attested to the formative role of the 'civil' space: 'the human animal [. . .] learns to stand upright, to walk, to wave and signal, to speak, and the general "civilizing" takes place within particular "civil" realms'.[2] The tenacity with which the body stores gestures it has been accumulating since childhood in the process of socialization is indicative of the profound nature of its loyalty to the political realms of the 'civilized' space. The manifestations of the body and its expressions are thus insidiously managed by culturally derived conventions, with civic structures of public space acting as a containing and delimiting force. Jouve's achievement lies in making these structures of containment visible, through the very specific manner in which her photography comes into being.

For Jouve, work on the image begins long before the actual moment of taking the photograph. Having defined the parameters of the project, the artist begins by approaching the sitters with a request to pose for her, involving them from the outset in the process of developing the choreography of the scene, as well as selecting the location for the shoot. The actual process of taking a photograph involves an equally considerable investment of time: the artist uses a large-format camera (usually a 4×5, mounted on a tripod), which requires the sitters to hold their poses for several minutes while the artist revises the composition, adjusting exposure and depth of field. These conditions inevitably affect the way Jouve's sitters behave in front of the camera: their poses, while being unaffected and unremarkable, nevertheless feel deliberate and composed. This feeling of stilled composure has been described by Michel Poivert as one of the main effects of Jouve's work: 'each figure seems to show merely the effort of its own movement [. . .] of feeling its own elementary actions – breathing, for example.'[3] I would add to this analysis that the concentration on keeping still over a relatively long period of time not only makes apparent the effort invested in performing the most basic of actions, but also discloses the lengthy process by which the photograph comes into being. In other words, the 'elementary action' performed by every

2. Elaine Scarry, *The Body in Pain* (Oxford: Oxford University Press, 1985), p. 109.

3. Michel Poivert, *Valérie Jouve*, exh. cat. (Paris: Centre national de la photographie, 1998), p. 12.

sitter is, quite simply, the act of waiting – waiting for the image to emerge on the photosensitive surface. (Interestingly, *En attente* was the title of Jouve's mid-career retrospective at the Centre Pompidou in 2010.[4]) By requesting her sitters to remain in the pose while she takes the photograph, Jouve slows down the flow of life until it breaks down to a vocabulary of rudimentary gestures, thus making visible through this process the social and cultural mechanisms that manage our behaviour.[5]

The Place of the *personnage*
The elaborate process of taking the photograph, as well as the extensive preparatory phase, establish conditions under which a relationship of collaboration can develop between the sitter and the artist. Vincent Honoré has described Jouve as an artist working in 'shared consciousness' with her sitters, who thereby become the co-creators of their own image.[6] In this Jouve's approach is quite distinct from the other practitioners of staged photography with whom she is often compared. In his survey of contemporary photography, Poivert lists Jouve's name among other artists of the 'image performée' strand of photography, such as Larry Sultan, Gregory Crewdson, Suzanne Lafont and Jeff Wall.[7] While these artists share certain key procedures, such as staging an event specifically for the camera, Jouve's method is distinct from the 'directorial mode' of photography typical of such artists as Wall and Crewdson, where the artist takes on the role of a director and works with professional actors. For Jouve, the creative process is grounded in collaboration and consultation,

4. *En attente*, Centre Pompidou, 23 June–13 September 2010. This exhibition gathered a series of photographs taken in the Palestinian Autonomous Territories and Israel. In her introduction to the exhibition, Milena Paez offered a number of interpretations of the theme of waiting: 'L'attente plane au dessus des personnages qu'elle nous campe, souvent bordés par la ville, "en attente" sans doute d'une action qu'ils sont sur le point d'ébaucher. L'exposition [...] nous éloigne des banlieues périurbaines françaises en nous immergeant dans des strates temporelles en suspension, envolées poétiques qui prennent "racine ailleurs", dans les territoires autonomes palestiniens, condamnés eux aussi à l'attente.' < http://elles.centrepompidou.fr/blog/?p=878 > [accessed 8 May 2013].

5. See Shirley Jordan, 'Urban Photography as Interruption', in *Inert Cities*, ed. by Christoph Lindner and Stephanie Hemelryk-Donald (London: I.B. Tauris, 2014). In this forth-coming publication Jordan discusses the process of stilling in Jouve's (and other artists' works) as a matter of disruptive interruption as well as a function of the photographic image.

6. Vincent Honoré, 'Valérie Jouve', in *Vitamin Ph: New Perspectives in Photography*, ed. by T.J. Demos (New York: Phaidon, 2006), pp. 130–1 (p. 130).

7. Michel Poivert, *La Photographie contemporaine* (Paris, Flammarion, 2010), p. 218. For another attempt to place Jouve's work in the history of contemporary photography, see Quentin Bajac, 'Valérie Jouve: Spatial Practices', in *Valérie Jouve: En attente*, exh. cat. (Paris: Centre Pompidou, 2010), pp. 15–21 (p. 15).

which means that her control over the image production is much looser in comparison. Rather than working with professional actors, the artist often draws her models from her circle of friends and acquaintances, whose real names are given in the titles. In this way, even though Jouve's photography is based on a staged situation, the sitters, in the words of the artist, play themselves.[8]

As the title of the series suggests, the human presence lies at the very core of Jouve's project in *Les Personnages*. The study of humankind represents Jouve's first research interest that led her to take a degree course in anthropology, and it was during her studies that she first began using photography. She eventually abandoned anthropology to pursue a career as a photographer, but her interest in the human subject continues to inform her work. In *Les Personnages*, the artist deployed a number of compositional devices expressly to draw attention to the human figure. The large scale of the photographic prints (the works in the series measure 100×130 cm) endows human figures with near life-size proportions when encountered in the space of an exhibition. This prominence is emphasized by placing the figure at the centre of the compositional focus, which is often arranged along the central axis of the image; the total isolation of the figure serves to accentuate this centrality. Above all, by placing her models in elevated locations, the artist arranges her composition in a manner that reverses the normal proportion of the figure to the landscape. Standing on a footbridge high above the ground, the figure of Claire Deniel literally towers over the cityscape, dominating the skyline and reducing the setting to a distant backdrop. The use of the low angle perspective from which this photograph is taken further highlights the imposing monumentality of the figure.

Combined, these devices produce an unusual planar arrangement, where the middle ground is cut out, leaving the foreground, occupied by the human figure, and the background, composed of the view of the city in the distance. The split of the pictorial space into a foreground and a background in *Les Personnages* is articulated along a clearly defined line that separates the characters from the landscape behind them. This line traverses the pictorial space horizontally (or occasionally vertically) and often takes the form of railings, balustrades, fences or other kinds of barriers. In *Sans titre (Les Personnages avec Andréa Keen)* (1994–5), a female figure stands with her back to the camera, resting her elbow on the railings of the footbridge that cuts across the image horizontally, thereby separating the figure from the view on the street she contemplates. *Sans titre (Les Personnages avec Thierry Crombet)* (1994–6) shows a solitary male figure on a flyover, with a metal balustrade cutting him off from the view on the streets beneath. In *Sans titre (Les Personnages avec Claire Deniel)*, discussed above, the

8. In an interview with the author, 4 July 2013.

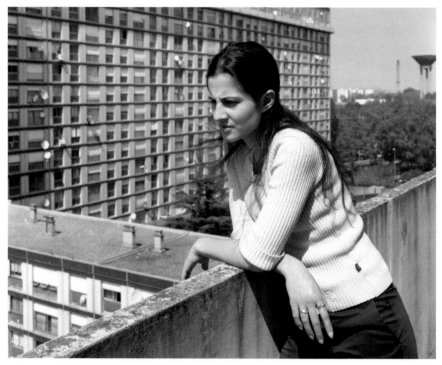

Figure 2: Valérie Jouve, *Sans titre (Les Personnages avec Mademoiselle Burricand)* (2002), C-Print, 100 × 130 cm. Copyright: The Artist, Courtesy Galerie Xippas.

character holds on to the handrail of a footbridge, which separates her from the cityscape she contemplates, and which is itself littered with structural boundaries: red and white traffic barriers edging the road and, further away, the concrete wall of the rail track. Occasionally Jouve's characters treat safety barriers as obstacles to be overcome: in *Sans titre (Les Personnages)* (1998–9) an unnamed New York teenager is photographed in the act of attempting to scale the railings of a footbridge, with a guarded look over his shoulder that discloses awareness of his transgression.

While the motif of the railings is a recurrent feature in many of Jouve's works, photographs depicting situations taking place within the confines of the balcony offer particularly pertinent material for analysing the compositional function of this motif. *Sans titre (Les Personnages avec Mademoiselle Burricand)* (2002) (Figure 2) shows a young woman standing on a balcony of one of the top floors of a high-rise apartment block, observing the view below. The wall of the balcony traverses the image diagonally from the right-hand edge to the lower left corner, separating the figure from the backdrop, which is composed of a view onto other high-rise blocks. Compositionally, this work replicates the layout of another

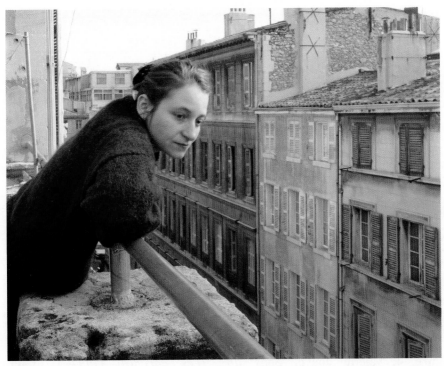

Figure 3: Valérie Jouve, *Sans titre (Les Personnages avec Raphaëlle Paupert-Borne)* (1996–8), C-Print, 100 × 130 cm. Copyright: The Artist, Courtesy Galerie Xippas.

balcony portrait that predates it by several years. *Sans titre (Les Personnages avec Raphaëlle Paupert-Borne)* (1998) (Figure 3) shows another young woman on a balcony, photographed in the pose of leaning onto the rail to look into the well of a street below. As in *Sans titre (Les Personnages avec Mademoiselle Burricand)*, the wall of the balcony cuts across the image diagonally, only here in reverse, from left to right. The settings in these two works are quite different – one shows a view onto a street of nineteenth-century *immeubles* while the other is set in the modern *banlieue* – but compositionally, the two works are mirror images of each other. In both photographs, the balcony acts as the support for the inclining bodies of the women, allowing them the opportunity to relax: Raphaëlle Paupert-Borne slumps low, her chest and elbows resting comfortably on the railings, while Mademoiselle Burricand rests her elbow on the edge of the balcony, her wrists relaxed, fingers long and loose. The women seem at ease in a space that allows them a sheltered observation point, while guarding them from the accident of falling. The combination of ease and composure, self-awareness and absorption that defines the attitude of Jouve's sitters is thus not only the result of working in an atmosphere of 'shared consciousness' and trust, but is also a product of the

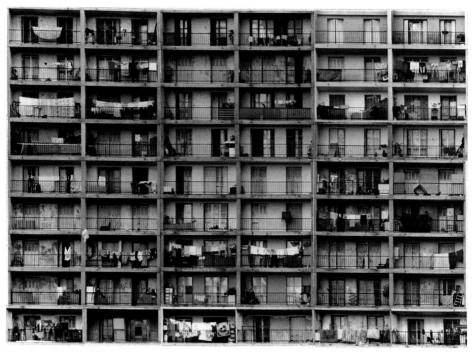

Figure 4: Valérie Jouve, *Sans titre (Les Façades)* (1994–5), C-Print, 125 × 175 cm. Copyright: The Artist, Courtesy Galerie Xippas.

choice of the setting, the balcony being an extension of the domestic interior and yet part of the building's exterior, thus combining the properties of private and public space.

Spaces Shared, Spaces Divided

Balconies also feature in the settings of *Les Façades*, *Les Paysages* and in other series. In *Les Façades*, as the title indicates, Jouve documents buildings' exteriors, often zooming in on a section of the façade. *Sans titre (Les Façades)* (1994) (Figure 4) depicts a segment of the exterior of a high-density apartment building, its façade divided into rectangular cells of balconies. Each balcony is identical in size and construction, but the appearance of each has been slightly altered by its owners who have adapted it for their needs: most commonly, to dry laundry, but also as a social space, equipped with chairs and tables, or as storage for the overspill of objects from the interior. The interplay between the mechanical repetition of the grid-like architecture of the balconies on the one hand, and the chaos of the assorted belongings they contain on the other, creates tension, which nevertheless is not allowed to develop into a conflict. Stamped with the individual marks of their owners, who remain invisible, these architectural units

of habitation emerge as portraits *in absentia*: after all, the word 'façade' derives from vulgar Latin *facia*, meaning 'face'.

In this sense, it is interesting to draw a comparison with *Montparnasse* (1993) by Andreas Gursky, the celebrated German photographer associated with the Düsseldorf school of photography. This work, like *Sans titre (Les Façades)*, shows a façade of a high-density apartment building, marked by a remarkably regular pattern of fenestration. However, the resemblance between the two works is superficial, as Gursky's view, taken from a considerable distance, favours the overview at the expense of detail, ultimately creating a sense of emotional withdrawal. This work is characteristic of Gursky's bleak view of life in the globalized world, where the scope for individual self-expression is limited to the choice between different consumer patterns. But where Gursky emphasizes the standardization of human life through strategies of distancing and abstraction, Jouve zooms in to emphasize diversity and variation within the shared commonality of the public space. The apartment block provides an architectural structure for this act of sharing, each balcony cell acting as a container for a microcosm of human habitation.

Because of the tendency towards a generalized abstraction, Gursky's work has often been criticized for divorcing the image from reality, and specifically the reality of labour and power relations, in the context of globalization.[9] In contrast, Jouve's close focus reveals not only the interplay of differences within a shared given, but also the imprint of historical and political forces on the architectural fabric of the city. In *Sans titre (Les Personnages avec Claire Deniel)* (Figure 1) the cityscape, while being utterly unremarkable, nevertheless contains architectural elements that make it possible to place it with certainty in France. The buildings on the left of the figure belong to the style of architecture known as Haussmannian, after the nineteenth-century architect who gave Paris its emblematic appearance. To the right of the figure, contemporary apartment blocks cluster further in the distance. In the almost seamless progression from the left to the right of the image continuity is suggested between Haussmann's grand reconstruction project and the history of the modern suburbs, the infamous *banlieues*. The benefits of Haussmann's modernization are numerous and well-documented, from the major overhaul of the city's ailing infrastructure, to the transformation of Paris into one of the world's most beautiful cites though the imposition of a unified plan of urban reconstruction. However, the main beneficiaries of these reforms, as Christopher Prendergast notes, were 'the property speculator, the genteel resident and the well-to-do tourist', while the situation of 'the ragpicker, the beggar and the slum dweller' remained

9. Alex Alberro has argued that in Gursky's hands digital manipulation divorces representation from reality, resulting in 'a highly superficial, aestheticized approach to labour', Alberro, 'Blind Ambition', *Artforum*, 39:5 (2001), 109–14 (p. 113).

unchanged.[10] Clearing the slums out of the city centre while doing nothing to eradicate the reasons for their existence meant that they sprang up in the peripheries, where life in unsanitary conditions continued, unaffected by modernization. This grand project of reconstruction thus initiated the process of the systematic exile of the city's poor, setting a precedent for the subsequent expulsions a century later, in the post-war reconstruction boom of *les trente glorieuses*. This renewed attempt at a modernization of Paris coincided, as Kristin Ross has demonstrated, with the processes of industrialization and decolonization.[11] During this time France's metropolitan centres were re-built and expanded, while its builders, many of whom were recently arrived foreign immigrants from North Africa, found themselves banished to the outskirts. In this process, social and economic divisions in France became deeper and more firmly entrenched, ultimately turning Paris into a city of two halves: 'the white, upper-class city *intra muros*, surrounded by islands of immigrant communities a long RER ride away.'[12] This division dominates present-day Paris, depicted in *Sans titre (Les Personnages avec Claire Deniel)*: the ring road, contemplated by Claire Deniel, articulates the spatial separation of the historic city centre from the *banlieue*, symbolically guarding the city centre and the cultural, political and social capital it represents from those who are confined to a life on the periphery. According to Françoise Paul-Levy, the root 'ban' contained in the term *banlieue* evokes such notions as banishment and the state of being banned.[13] The double function of the boundary thus becomes apparent: to shelter and contain, but also to keep out and exclude.

The Space of Representation
France's troubled histories of modernization, urban expansion and decolonization are subtly interwoven into the backgrounds of many of Jouve's urban portraits, but the reach of her photography is broader than that of social documentary or reportage. It combines, on the one hand, the intimate knowledge of the cities she photographs – Paris and Marseille, where she has lived for many decades, Lyon, where she studied, New York and Rotterdam, where she worked on commissioned projects, often in response to real-life issues affecting resident communities.[14]

10. Christopher Prendergast, *Paris and the Nineteenth Century* (Oxford: Blackwell, 1992), pp. 8–9.
11. Kristin Ross, *Fast Cars, Clean Bodies: Decolonization and the Reordering of French Culture* (Cambridge, MA: MIT Press, 1995).
12. Ibid., p. 12.
13. Quoted in Mustafa Dikeç, *Badlands of the Republic: Space, Politics and Urban Policy* (Oxford: Blackwell, 2007), p. 7.
14. In her film *Time is working around Rotterdam* (2006) Jouve documented changes in the life of the city and its inhabitants brought about by the construction of the first high-speed rail route in the Netherlands.

On the other hand, Jouve draws on her training as an anthropologist to portray human existence in the city – any city. A case in point is her recent exhibition entitled *Entre Marseille et Jéricho* (2012) that gathered works made during a time when the artist divided her time between these two cities.[15] Despite the significant geographical and cultural distance separating Marseille and Jericho, the images in the exhibition left spectators unsure about the exact locations of the scenes. As such, while rooted in knowledge of social and cultural forces that have shaped urban landscapes, Jouve's project goes beyond the limits of documentary reportage, by highlighting certain universal conditions of urban existence.

An articulate and astute theoretician of her own practice, Jouve explained the difference between reportage photography and what she calls 'l'esthétique documentaire', with which she aligns her work:

> J'opère par ailleurs une distinction claire entre le reportage et le document. Alors que le reportage produit le type même de photographie qui se donne pour la réalité, l'esthétique documentaire entretient un rapport au monde plus distancié, prenant toujours en compte le spectateur en lui proposant un outil de lecture sous la forme de cette distanciation. Cela est nécessaire pour penser l'image en tant que représentation et non comme simple présentation d'une réalité. Le document ne se réduit toutefois pas à sa fonction critique, il contient aussi et surtout une forte charge poétique.[16]

Jouve suggests that strategies of distancing, implied in the relationship of 'l'esthétique documentaire' to the world, invite the viewer to be attentive to the status of the photographic image as representation: 'penser l'image en tant que representation et non comme simple présentation d'une réalité'. I would argue that such attentiveness is fostered in the viewer through the procedures of framing and enclosure in Jouve's photography. The enclosing wall of the balcony, as it has been discussed in the examples of the three works from the *Personnages* series, delimits the physical space that constrains the characters. Simultaneously, the line of the railings separates the narrow stretch of the picture's foreground from the background. Such an overlap of pictorial and physical space establishes a relationship of correspondence between two forms of containment. In *Sans titre (Les Façades)*, for example, the entire structure of the building is made to coincide with the photographic frame, the edges of the concrete frame perfectly aligned with the concrete (in the sense of being definitive) boundary of the

15. *Entre Marseille et Jéricho* was a part of the exhibition *Une École française*, held on the occasion of the Rencontres d'Arles festival in 2012.

16. Valérie Jouve, 'Entretien avec Michel Poivert', *Le Bulletin de la société française de photographie*, 143:1 (1997), 3–7 (p. 6).

photographic image. The rectangular openings of the balconies inside this frame repeat the motif of the containing frame in miniature, thereby reiterating its importance. The regularity of this pattern of fenestration and the neat precision of the overlap of the edges of pictorial and spatial space, however, seems a little too neat. It is in fact a product of digital manipulation, which was used to 'correct' the visual effect of curving at the edges, created by the wide-angle lens of the camera. Interestingly, Gursky, who was one of the pioneers of digital manipulation, used a similar procedure to correct the same optical flaws in *Montparnasse*. But whereas for Gursky digital technology offered a means of expressing the effect of global standardization by creating an image of imposing symmetry and grandeur, for Jouve digital manipulation offers an opportunity to highlight 'the gap between representation and the world, in a context in which photography is still [perceived as] a mirror of reality.'[17] Rather than cutting out a section of external reality in the manner of the photographic window onto the world, the photograph draws attention to its constructed nature. The direct correspondence of the physical space to pictorial space, subtly underscored by digital manipulation, draws attention to the frame, which contains and encloses the space of photographic representation, deliberately and decisively.

Jean-François Chevrier gave the space of photographic representation, delineated by the frame, the term *tableau*. This term first emerged in his writings in the late 1980s, where he argued that the fixing of the boundaries of the *tableau* produces '*another* space, fictitious in nature'.[18] 'The image is no longer simply the trace of a lived experience, a memory, but a new objective reality: the reality of the image as picture.'[19] In the recent past, the term *tableau* has re-entered photography discourse primarily to assert the autonomy of photographic representation and even to revive modernist values of medium specificity.[20] This is not the place to engage in a detailed discussion of these highly problematic claims, including those made by Chevrier in his more recent

17. Valérie Jouve, 'Entretien avec Michel Poivert', in Poivert, *Valérie Jouve*, p. 18.
18. Jean-François Chevrier and James Lingwood, 'Introduction', in *Une autre objectivité/ Another Objectivity*, ed. by J.-F. Chevrier and J. Lingwood, exh. cat. (Milano: Idea Books, 1989), pp. 9–38 (pp. 34–5). See also Jean-François Chevrier, 'The Adventures of the Picture Form in the History of Photography' (1989), reprinted in *The Last Picture Show: Artists Using Photography, 1960–1982*, ed. by Douglas Fogle (Minneapolis: Walker Art Center, 2003), pp. 113–28.
19. Chevrier and Lingwood, 'Introduction', in *Une autre objectivité*, p. 35.
20. See Michael Fried, *Why Photography Matters as Art as Never Before* (New Haven: Yale University Press, 2008). Fried's claim that photography continues the work of modernism because it apparently realizes its status as an art with particular urgency was met with almost unanimous contestation.

appraisals.[21] My interest lies in the capacity of the *tableau* to produce 'another space', where meanings are delimited and defined by the enclosing frame, and its significance for Jouve's photography.

The ongoing relevance of the form of *tableau* to contemporary photography in France has been asserted by Guillaume Le Gall, who elaborated on this thesis in his exhibition *Fabrique de l'image* (2004), which brought together photography by a number of (predominantly French) artists, including Jouve. The main premise of the exhibition is compelling, and the revision it offers of the idea of the *tableau* in the light of new modes of image production is timely. However, certain aspects of Le Gall's understanding of the *tableau* form in relation to Jouve's art stand to be corrected. Uniqueness and autonomy of the photographic image are singled out as the quintessential feature of her (and other artists') photography, as Le Gall argues: 'la nature de leurs images implique une autonomie, fondant même sur l'idée de tableau'.[22] It is difficult to see what grounds for such an argument could be found, given that working in series is fundamental to Jouve's practice: her works always form part of a set thematic sequence (*Les Personnages*, *Les Passants*, *Les Façades*), which, in turn, is conceptually and thematically linked to other series. In the context of an exhibition, Jouve's photography is rarely encountered as autonomous works, as the artist prefers to group images in carefully curated sequences. This principle extends to the arrangement of the works on the pages of the exhibition catalogue, in accordance with the artist's avowed desire to take the viewer/reader on a journey, a guided 'parcours' through the images.[23] The property of the *tableau* that remains overlooked, but which I believe offers the most satisfying way of approaching Jouve's work, is its ability to give the photograph the weight and gravity, 'within an actualized perceptual space, of an "object of thought"'.[24] The materiality of the space of representation, carefully constructed and contained by the photographic frame, possesses the power to solicit a reflective attitude in the viewer. The presence of the camera, as it has been argued, is felt in the attitudes of the sitters, who are consumed

21. Chevrier has described 'the encounter between the *tableau* (as a pictorial form) and the document' as 'one of the distinctive characteristics of current photographic creation', conflating issues of formal interpretation, subject-matter and institutional validation of photography. Chevrier, 'The Tableau and the Document of Experience', in *Click Doubleclick: The Documentary Factor*, ed. by Thomas Weski et al., exh. cat. (Cologne: Walter König, 2006), pp. 51–61 (p. 51).

22. Guillaume Le Gall, *Fabrique de l'image*, exh. cat. (Arles: Actes Sud, 2004), p. 14. Artists in the exhibition, in addition to Jouve, included Yto Barrada, Patrick Faigenbaum, Jean-Baptiste Ganne, Suzanne Lafont, Jean-Luc Moulène and Paola Salerno.

23. Valérie Jouve, *Résonances* (Göttingen: Steidl, 2011), p. 3. The layout of this publication has been designed by the artist as 'une promenade, une déambulation à travers des villes que j'ai traversées'. Ibid.

24. Chevrier, 'The Adventures of the Picture Form', p. 120.

with the thoughtful effort of holding the pose as they contemplate their urban surroundings. The enigmatic stillness of Jouve's *personnages* encourages the viewer to adopt their attitude, matching their silent contemplation with his or her own. Such investment of attentive reflection emerges as the key condition for understanding the image as representation: 'penser l'image en tant que représentation'.

Conclusion

In this article, I have discussed Jouve's meticulously composed photographs as spaces of containment, understood as the process of delimiting the image within the confines of the photographic frame, which thereby transforms reality into representation. The civic structures of public space, in the meantime, act as another form of container, restricting the body and its range of expression to the socially acceptable. In spatial terms, the idea of containment relates closely to the notions of holding and accommodating, the city in Jouve's urban portraits acting as a receptacle for the body and its actions. The artist herself has relied on the metaphor of the container to describe the function of the city: 'The city is a receptacle, the crucible of an alchemy between infinitely diverse bodies, as they move, interact and influence each other and are transformed, bringing forth the living body of the city itself.'[25] The built environment serves as a receptacle for human activity, but its 'living body' is produced by its inhabitants, the anonymously circulating *personnages*.

25. Jouve, *Résonances*, p. 3.

Nottingham French Studies 53.2 (2014): 169–185
DOI: 10.3366/nfs.2014.0084
© University of Nottingham
www.euppublishing.com/nfs

NOT YET FALLEN: MEMORY, TRACE AND TIME IN STÉPHANE COUTURIER'S CITY PHOTOGRAPHY

SHIRLEY JORDAN

[T]he building you walk through/within – what is the speed of flux that is keeping it assembled? It seems permanent... but it is ephemeral nonetheless: whilst you are there, it is falling down, it is just happening very slowly [...].[1]

This article asks what Stéphane Couturier's distinctive photographs of urban matter tell us about the evolving relationship between photography and the contemporary city. It focuses on two of Couturier's investigative series: *Archéologie urbaine* (1994–2010) and *Melting Point* (2005–13), both of which are powerfully responsive to upheaval in the cityscapes of Europe and beyond. Attentive to tensions between demolition, construction and renovation, the former series comprises intricate studies prompted by work sites and fractured heritage shells. Taken in locations such as Paris, Berlin, Rome and Liège, these photographs hesitate between conveying the timbre of particular cities and eclipsing particularity by documenting generic phenomena related to mutation, excavation and architectural standardization. It is precisely standardization that is the focus of *Melting Point*, a series in which time, memory and trace are completely recast, while remaining nonetheless relevant to our experience of the photographs concerned. Both series ask us to rethink the potential of art photography to reconfigure the city as photographic subject and interrogate its fabric in unexpected ways.[2] I argue that this rethinking becomes especially effective when we activate connections between Couturier's work and that of nineteenth-century French pioneers in architectural and industrial photography, such as Marville, Delmaet and Durandelle and the frères Bisson, all of whom established a sense of intricate correlation between their own medium and the stunningly rapid development taking place around them. This same correlation, now mapping photography onto postmodern, globalizing cityscapes, is inherent in Couturier. We can also trace numerous parallels between Couturier's concern

1. J.D. Dewsbury, 'Performativity and the Event: Enacting a Philosophy of Difference', *Environment and Planning: Society and Space*, 18 (2000), 473–96 (p. 487).
2. For details of Couturier's other main series, *Monuments* (1997–2000) and *Landscaping* (2002–present), see < www.stephanecouturier.fr> [accessed 15 November 2013].

for the fabric of cities and Eugène Atget's attentive (visual) preservation of the remnants of old Paris which stood in powerful tension with the new city transformed by Haussmannization. While documenting the city, both photographers also reshape it through original composition and a powerfully de-familiarizing imagination. Atget, even more so than the pioneers already mentioned, enjoys an afterlife through Couturier's studies as they loop back to dialogue with his work. My reading of Couturier in this article will, then, be punctuated by the kind of slippages back in time that his photographs invite.

In terms of contemporary thinking on the city, Couturier's work resonates particularly sensitively with, on the one hand, concepts of the palimpsest and the archive, and, on the other, with Dutch architect Rem Koolhaas's famous idea of ubiquitous urban matter stripped of memory and identity.[3] Couturier seizes the processes of layering and displacement inherent in cities, processes which are increasingly so rapid and so devastating that they threaten recollection. The photograph's function in this perspective is to preserve the present/past for the future, and a strong documentary consciousness patently links Couturier to his nineteenth- and early twentieth-century predecessors. Equally clearly, Couturier's photographs display the city as palimpsest, exposing strata of its fabric which habitually remain invisible, either because they are unremarkable (until the camera gets at them), or because they are literally concealed, or both at once. The strangeness of his cityscapes interrupts their perpetual re-modelling, prompting critical questioning about dwelling and urban renewal and reflection on the interaction of personal and public memory. In my title is inherent a web of tensions between the ruin, the trace and the preservation of heritage 'layers', all contributing to an interrogation of contemporary construction which straddles the ironic, the regretful and the clinically detached in photographs that seem to offer themselves up as archive material. As Jae Emerling observes in his consideration of the productive relationship between photography and the archive, 'the logic of the archive is the logic of loss and control.'[4]

Couturier's complex relationship with the idea of the archive takes several forms: he creates photographs, grouped by series or commission, which are destined to be held as records; he gives them the sparest of titles, limited to the notation of precise places and dates, thus underscoring their documentary status; he unearths existing records, either through approaching the city's layers as a ready-made archive which is reactivated in his images or through working within heritage spaces already redolent with history and associated with storage and display, spaces which he photographs at moments of transformation or

3. See Rem Koolhaas, *La Ville générique: mutations* (Barcelona: Actar, 2001).
4. Jae Emerling, *Photography History and Theory* (Oxford and New York: Routledge, 2012), p. 121.

renovation.[5] One photograph, entitled *Musée des monuments français, Paris XVIe* (1999), is telling in this regard. It depicts a heavily damaged display of small black and white photographs documenting the poor condition of the Syrian medieval spur castle *Crac des Chevaliers* prior to its restoration by the French State in the 1930s. Four of the photographs are missing. Two appear to have been cut out of the frame, leaving holes that reveal bare brick and batons in the wall behind. This picture of a ruined archival display suggests a number of things: fascination with the construction, historicity and completeness of archives; anxiety about their resilience and durability; concern about breakdowns in memory; a desire to keep archival layers 'alive' in the present; and a self-reflexive preoccupation with the uses, destiny and nature of documentary photographs. Couturier's photograph, of course, is in turn part of a new (meta-) archive, and an act of salvage detailing a distinct moment in the history of the Musée des monuments français and its artefacts. It is clear, then, that Couturier, like Atget, conceives of his photographic work as inherently related to the archive, although the notional archive to which his broader project contributes is bound less by geography than by phenomena associated with global urban development. Thus he does not set out to map a given environment exhaustively, but instead to document significant *categories* of urban phenomena wherever they may crop up. What is also clear is that as experimental art photography, his work remains suspended between the photograph and the picture and belongs not only to the archive but, very self-consciously, to the gallery. Couturier's work, then, affirms the status of the photograph as art while testing the technological aptness of his medium to accompany and reveal new facets of urban change and expansion. He sets out to make us see the city's stratification or 'feuilletage complexe'[6] differently; to stop us in our tracks with images which confirm afresh the visual richness of the changing city, the intricate truth of the photo-document, and the intense aesthetic pleasures made available by the photograph.

Crucially, as Couturier's subject matter and idiom indicate, he was originally trained as an architectural photographer. This legacy accounts for the keen observations of scale in his images, their precisely rendered detail, their sense of transparency and completeness, and their great control over focus, depth of field and perspective (achieved by using a large format view camera with a bellows box). In his shift to the production of photographs for the art world, Couturier nevertheless retains the functional dimension of his initial craft, so that we frequently find ourselves plunged in conceptual disorientation, wondering what category of space and image we are looking at. This set of considerations about

5. For instance, Paris's Palais de Tokyo, Musée des monuments français, Grand Palais and Musée Guimet.
6. Régis Durand, 'Attractions contraires', in *Stéphane Couturier. Photographies*, ed. by Matthieu Poirier (Paris: L'Insolite, 2005), pp. 136–8 (p. 138).

the photograph perceived simultaneously as archival fodder and as art, which Couturier expresses in such concentrated form, reaches back to debates concerning the specific value of Atget's images (documentary in the mind of their maker; of supreme artistic value to the Surrealists). In so doing Couturier's photography declares not its own transcendence, but its powerful mobilization of the dichotomy precisely in order to activate debates about the nature and value of photographic regimes.

A further layer of this article's concern with memory involves the subtle dialogues set up between Couturier's photographs and other key responses to the urban environment not only in photographs but in impressionist and modernist painting. Analysts have occasionally commented on the painterly or sculptural qualities of Couturier's choice of motif, framing or aesthetic.[7] Here, I pinpoint some specific correspondences between photographs and related paintings whose mutual engagement with what we might call 'la ville-machine'[8] leads to original experiments with form. I suggest that the powerfully engaging play on memory and traces that is set in motion by Couturier is in part due to the meanings that are released by such visual conversations.

Archéologie urbaine: Intersections

The photographs of the *Archéologie urbaine* series cut deep into urban matter, severing its strata and slicing into time. As the series title suggests, Couturier gravitates to sites where memory lurks and where past and present are revealed in striking simultaneity. These temporarily re-historicized arenas, exposing what the photographer refers to in a somewhat Zolaesque metaphor as 'les tripes de la ville,'[9] are captured in congested, frontal images attentive to the eloquence of texture and structure. Couturier is interested in the materials laid bare by urban upheaval and in those used to effect change: steel girders, electric wires, concrete slabs, rubble and vegetation, forgotten substrata of brick, stone and clay. An early urban slice, *Liège* (1997) (Figure 1) is a good example of a lateral cross-section which incorporates layer upon layer of superimposed planes, from the mysterious ruined interiors exposed at the base of the composition to the roofs of heritage constructions in its upper section.[10] The dovetailing of past and present, or what

7. For example, Poirier, 'Morpho-logies', in *Stéphane Couturier*, pp. 7–51 (pp. 7; 36–7).

8. I quote Elvire Perego whose 'La Ville-Machine: architecture et industrie', in *Nouvelle histoire de la photographie*, ed. by Michel Frizot (Paris: Éditions Adam Biro/Larousse, 2001), pp. 197–223, is a useful source on nineteenth-century architectural photography.

9. Stéphane Couturier, quoted in Emmanuel Hermange, 'Plasticité de l'entropie urbaine', in *Stéphane Couturier*, pp. 139–41 (p. 139).

10. Certain of Atget's more congested compositions, frontally stacked with overlapping planes (for instance, his 1903 study of the roof of the Saint-Séverin church or his 1922

Figure 1. Stéphane Couturier, *Archéologie urbaine, Liège* (1997). Courtesy Galerie Polaris, Paris.

Régis Durand refers to as 'un état d'entre-deux temporel',[11] as well as the apprehension of time and matter are exceptionally strong here. The photograph is, one might almost say, its own archive; indeed its hypnotically attractive archival base seems, as it rises up, set to engulf the edifices still standing above it. Formal echoes between the picture's flattened planes, hyper-real sharpness of detail, hesitation between two- and three-dimensionality and a surreal sense that there are superimposed landscapes as well as buildings in this intersection draw our eye around it until, discovering an eerie archway at the bottom right, we make a visual 'exit' into the milky light beyond. This is less the city as machine and more the city as mystery: what Anthony Vidler has termed 'the architectural

study of the Cour de Rohan, both in Paris's fifth *arrondissement*) feel like companion pieces to such photographs.

11. Durand, 'Attractions contraires', p. 136.

uncanny'.[12] We linger over it as a perplexing, richly fascinating space, all the more so given its size (170 × 134 cm). Key to our relationship with all Couturier's photographs, in fact, is their large format which establishes them as architectural environments in their own right rather than simply representations of such.

Durand confirms the indeterminacy of meaning of Couturier's layered and uncovered spaces, arguing that it can be tricky to calibrate our response to them: 'ni neutres ni indifférents' they are 'tout sauf des "non-lieux"'.[13] At the same time, he suggests that Couturier steers us away from affective attachment: '[c]e qui semble le retenir, c'est qu'il s'agit d'espaces en mutation, saisis ni dans une fonctionnalité maintenant caduque, ni dans un état d'abandon qui pourrait être propice à la nostalgie.'[14] Yet affect and attachment to the past do tug at us from these images. The title of this article, 'Not Yet Fallen', leans deliberately towards the spectre of entropy since I believe that Couturier's idiom – particularly but not only in this series – does make room for nostalgia. I am interested in how his city sections create time locks where a thrust to the future co-exists with a sense of connection to what still stands, so that although the hierarchy of urban matter is overthrown (all layers, materials and forms are shown as equally interesting) there remains a residue of melancholic attachment to what is past. Visually, intellectually and emotionally we shuttle between a range of responses before Couturier's photographs, just as the photographs themselves shuttle between architectural, documentary and art images.

Let us turn now to heritage Paris and to two studies of the Grand Palais which exemplify Couturier's practice of turning the city inside out and levelling the equivalence of its matter. Habitually, representations of this iconic jewel of classicism and art nouveau linger on its barrel-vaulted glass roof, its fabulous metalwork, and its famously dynamic bronze horses 'prancing out of a sea of verdigris on the roof'.[15] Couturier's take on the historic edifice is a marked departure from such views, differently rich in information, deliberately focusing on the monument as a site where past and present collide and producing perspectives which stand in ironic relation to the photographs' titles. This irony is lesser than, but nonetheless related to, the provocative nomenclature of Couturier's *Monuments* series (1997–2000), a collection devoted to the soulless high-rise residential buildings which spread like rashes in peri-urban areas across the world in response to inexorable urban growth. Couturier refers to such edifices

12. Anthony Vidler, *The Architectural Uncanny: Essays in the Modern Unhomely* (Cambridge, MA: MIT Press, 1992). See especially 'Posturbanism', pp. 177–86.
13. Durand, 'Attractions contraires', p. 137.
14. Ibid.
15. Edmund White, *The Flaneur: A Stroll through the Paradoxes of Paris* (New York: Bloomsbury, 2001), p. 51.

Figure 2. Stéphane Couturier, *Archéologie urbaine, Grand Palais, Paris VIIIe* (1997). Courtesy Galerie Polaris, Paris.

as 'monuments involontaires'[16] and focuses on their (brutal) façades, which even as they are under construction conjure images of obsolescence and collapse. Conversely, the extravagant historic exterior of the Grand Palais is eschewed in favour of surprisingly restricted views of crude construction materials within its interior as the unstable edifice went through the first stage of its renovation.

The 1997 photograph *Grand Palais, Paris VIIIe* (Figure 2) is framed by rusting metal beams which make two powerful crosses over its surface. This unremarkable matter lends the image a strong, almost abstract geometry. It also keeps us at bay, debarring visual access to the building. The sole visual marker of history – and it almost feels secondary – is a fragment of the sinuous art nouveau staircase, sweeping somewhere out of the frame in the left half of the photograph. Especially foregrounded are rivets, punctuating the image throughout its planes. We also see information about construction in the form of carefully dated notes on the front beams which emphasize the temporal depth of a recent part of the building's history and confirm that the edifice is 'in progress'. Other ungracious

16. Couturier, quoted in Hermange, 'Plasticité de l'entropie urbaine', p. 140.

material is featured: thick plastic sheeting nailed over walls and doorways, and a rough wooden framework constructed to support the window aperture in the upper left of the composition (this latter device, a signature obsession in Couturier's photographs of heritage buildings, reaches its mesmerizing, reiterative height in the diptych *Rue Boissy d'Anglais, Paris VIII^e* [2002] and is an important trope denaturalizing the presence of historic façades in the city and re-calibrating our sense of their durability). There is a strong functionality to this photograph, a sense that it might be driven by archival desire, taken precisely to be preserved in some repository along with other visual fragments as part of a larger record of change. The monument becomes ordinary, reduced to anonymous matter, its aesthetic interest, historic significance and emotional resonance relegated to the background so that our relationship to it is destabilized. Our desire to 'look through' is curtailed by the surprising visual pleasure available in the screening device whose strong haptic appeal, compositional elegance, sharpness of form and precision of colour (Couturier is an extraordinary colourist) contribute to the photograph's distinct painterly quality. As it wavers between the documentary and the aesthetic, this quiet photograph is in its own way thrilling. It un-grounds us, providing no single specific focal point but casting us adrift in Couturier's preferred environment of urban matter without stable meaning. Tensions between material reality and abstraction, between old and new, past and future, preservation and demolition, monument and ruin are all at work here, along with provocative questions about the investment that collectively and individually we have in historic landmarks.

Let us briefly set Couturier's photograph beside two famous city paintings and one architectural photograph, all from the late nineteenth century, which linger within it as traces. The paintings, by Gustave Caillebotte, are *Le Pont de l'Europe* (1876) and *Sur le pont de l'Europe* (1877).[17] Both foreground the powerfully beautiful engineering work of the truss bridge built in 1868. In the first, the bridge's imposing criss-cross structure thrusts obliquely into the pictorial space, leading our eye to a vanishing point and occupying around half of the field; in the second it forms a massive grid, pressing forward within and filling the picture frame. Here the right half of the image is entirely given over to a study of the intersecting beams. Caillbotte's fascination with their materiality, as well as with an aesthetic of the fragment, is as palpable as Couturier's. More than this, it is as though the act of looking that Couturier requires of us were pre-inscribed in these painterly precedents. Foregrounded in both paintings are men who face the impressive metal structure and whose gaze is absorbed in the mesh of iron. The direction of their gaze is indeterminate. We cannot say whether it focuses close-up on the crossed girders or on the distant fragments of the city which these frame,

17. Thanks to Nigel Saint for spotting this visual echo.

but it is clear that visual access to what is beyond the bridge is now dependent on this new context, that the two must be seen in relation. The beams interrupting our view of the Grand Palais have precisely the same function. The photograph that I wish to draw in to this dialogue is *La Galerie des machines de l'Exposition Universelle de 1889* by Durandelle and Chevojon. In this image too the foreground is taken up by the massive base of one of the gallery's curving metal pillars, a base studded by rivets and traversed by beams describing two huge crosses. These crosses are replicated down the length of the enormous hall, filling the roof space with this dominant, receding motif. The latent dialogues with painterly and photographic antecedents that are stored as memories within Couturier's composition arguably intensify its affective and intellectual appeal, underlining the complex cross-fertilization between visual representations from different periods which engage with the city as construction site. We are called upon to measure the distance between earlier modes of visual fascination whose celebratory underpinning conveys the sense of a new era of progress, and a more ambivalent mode consistent with postmodern anxieties.[18]

In a photograph of the Grand Palais taken six years later, during the second phase of restoration, Couturier further pursues his emphasis on the technologies and techniques which shore up heritage space and his interest in generic construction material. *Grand Palais, Paris VIII^e, Echafaudages* (2003) does this so intensively in fact that the building's original architecture is almost totally masked by the new structure of yellow scaffolding which is grafted within it, forming a surface grid that interrupts perspective and congests space.[19] The complexity and density of information in this sectional fragment are so visually overwhelming, the geometrical patterning and primary colour of the grid so dominant that we strain to look beyond the scaffolding to capture anything of the title edifice. As a city image, this is amnesiac. The Grand Palais as historic reference point is unavailable, supplanted by a new formal autonomy. Couturier seems to set up here a visual relationship not with a monument but with the idea of the abstract modernist grid pattern: indeed, the mesh of golden yellow poles which keeps us suspended on the surface conjures the spectre of Mondrian, evoking some of the artist's later paintings, such as *New York City* (1942), which underwrite this photograph. The red dots (actually labels stuck at different

18. More work in this perspective would be rewarding. Certain photographs of fragments by Couturier – that of a pillar under restoration in *Musée Guimet, Paris XVI^e* (1998) or that of bronze heads sitting on a wooden crate in *Grand Palais, Paris VIII^e, Tetes n^o 2* (1998) – are well worth comparing with photographs from Delamaet and Durandelle's inventory, made during the construction of the Palais Garnier, of its architectural and decorative features. Atget's studies of railings and balconies in nineteenth-century Paris also constitute interesting comparators.

19. This photograph may be seen on Couturier's website (see note 2).

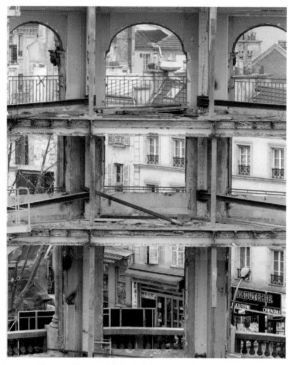

Figure 3. Stéphane Couturier, *Archéologie urbaine, Bd Barbès, Paris XVIIIe* (2002). Courtesy Galerie Polaris, Paris.

junctures on the scaffolding) that syncopate the picture's surface seem to pull it still further towards the world of pure form. This image in particular reminds us that Couturier's photographs do not merely constitute an important statement within the history of the documentary style but are envisaged by their creator as artistic works; as bridging points connecting regimes of image-making.

Let us turn now to two further photographs, both from 2002: *Bd Barbès, Paris XVIIIe* (Figure 3) and *Bd St Germain, Paris VIe*.[20] Both are dense, sectional views of work sites, both betray strong phenomenological pleasure derived from the matter and debris of the innards of buildings and both speak powerfully to the temporal drift and dislocation that we experience in cities. The first is a study of an architectural shell, incorporating multiple, fragmented signs and shapes and deploying once more the device of a surface grid. In this instance, it is the framework of a heritage façade that screens the cityscape behind. Such an image is differently surprising and dramatic from the view onto Paris provided by Gordon Matta Clark's ingenious *Conical Intersect* project (1975), for Couturier is

20. Ibid.

more attentive to the structure's interior and apertures than to what we see through them and focuses on what is inherent in the site without any material intervention. Once more, his preoccupation is to engage with the secret underside of the city. This reflection on impermanence interrogates once again the way in which the city engages in new construction and seeks simultaneously to preserve its architectural façades. To foreground a gutted building in this way, both for its inherent (aesthetic or documentary) interest and as a grid separating us from the world beyond it, is to hold us in a space where we must question the permanence and density of all edifices. Couturier has us oscillate between responses in this photograph, playing at once on the deadpan precision of architectural photography and on a photography of affect which speaks of abandonment and nostalgia. On the one hand, the geometrical schematization, clinical sharpness and resolute frontality are devices associated with the cool provision of information: no dynamism or emotive overlay, no oblique angle shots or distinctive luminous effects are sought; instead the light is neutral and vertical, devoid of shadows, shafts or indicators of time. On the other hand, the image is dense and inviting, both phenomenologically and emotionally. The arches in particular offer indicators of period nostalgia: as we look both at and through them, the logic of Haussmann's Paris is captured not just for archiving, but for dreaming. There is an opening in this image for psychological and symbolic content which brings to mind Baudelaire's lament for the disappearing city and, once more, the nostalgia inherent in Atget. Further, it lays a deliberate trace back through a lineage of canonical archiving projects, from recent antecedents such as the heroic documenting of demolitions in Paris's thirteenth *arrondissement* by Daniel Boudinet and Yves Simon[21] to the vast photographic survey of France's historic sites in the 1851 *Mission héliographique*[22] to that undertaken in 1850s Paris by Atget's predecessor Charles Marville in anticipation of Haussmannian upheaval. What Elvire Perego describes as Marville's double achievement: an 'exactitude poussée jusqu'au délire',[23] and the (perhaps unwitting) production of a new urban imaginary, also feels applicable to Couturier. Couturier's photograph, though, is marked by greater indeterminacy: is the edifice in the

21. Daniel Boudinet and Yves Simon, *Bagdad-sur-Seine* (Paris: Fayard, 1973). Boudinet's exquisitely detailed panoramas of destruction and construction, his focus on the abutting of old and new, on the interior become exterior and on temporal complexity make for interesting comparisons with Couturier. It is in the clarity of Boudinet's political intention that the projects diverge.

22. France's first official photographic commission, ordered by the government agency the Commission des monuments historiques, was devised to determine the nature and urgency of preservation and restoration work required at historic sites throughout the country. Photographic knowledge thus replaced for the first time the forms of knowledge previously provided by architectural drawing.

23. Perego, 'La Ville-Machine', p. 200.

foreground being renovated or demolished? Of what set of values does this image speak?

One striking factor made visible here is how effectively Couturier thickens our perception of time in the photograph. Clearly, Durand's 'feuilletage complexe'[24] can usefully be considered as having a temporal as well as a material dimension, the two combining in a powerful memory project. There is no sense of a decisive moment or of something fleeting being seized, but a sculptural transcendence of the moment and a meditation of a different order on time's passing: while, as Victor Burgin remarks in a recent essay entitled 'The Eclipse of Time', one is not in the habit of asking 'How long is the photograph?',[25] the question is not without relevance here. As the city's multiple layers and surfaces are unveiled, it is newly historicized, newly yielding. Couturier's photograph offers a particularly dense temporal pocket, inducing reflection on the time of the ruin, the time of (re-)construction and the pace of urban evolution to come.

Bd St Germain, Paris VI^e once again draws attention to flux by conveying the strata of a work site. Once again, space is tightly stacked in a congested composition excluding any sky; once again there is an absence of focal point and an abundance of abruptly juxtaposed planes that push forward and fill the picture surface, the whole calling to mind Fernand Léger's pictorial devices as well as his penchant for construction materials.[26] What also strikes us here is the problem of human involvement. A tiny blue body framed in one of the site's lower apertures reminds us that humanity, ant-like if present at all, is squeezed out of Couturier's photography (once more, we think of Atget). Such visual insignificance is, according to Philippe Piguet, '[u]ne façon pour lui de souligner la dureté du monde urbain, comme si c'était un milieu invivable'.[27] Here the man is a dot, a punctuation mark in a building not yet fallen, a coloured element in a composition. Yet while, as Couturier confirms, people in his photographs often go unnoticed, their carefully calibrated peripheral role makes them the carriers of vital questions: 'est-ce que l'Homme maîtrise véritablement la ville dans laquelle il vit? Est-ce qu'on peut dire qu'il a construit une ville? L'Homme', continues

24. See note 6.

25. Victor Burgin, 'The Eclipse of Time', in *Time and Photography*, ed. by Jan Baetens et al. (Leuven: Leuven University Press, 2010), pp. 125–40 (p. 131).

26. Léger, an artist with architectural training who responds to urban development in the early years of a new century, is in many ways Couturier's chief modernist counterpart. His motifs, frontalization and congested pictorial field compare interestingly with aspects of Couturier's work.

27. Philippe Piguet, 'Stéphane Couturier – embrasser l'espace', in *Stéphane Couturier. Photographie-Vidéo*, ed. by Philippe Piguet (Annecy: Fondation Salomon, 2012), pp. 5–9 (p. 9).

the photographer, 'n'est pas grand-chose par rapport à la ville, qui est un organisme que personne ne maîtrise'.[28]

Our own uncertain position as spectators also deserves mention for an anthropocentric viewpoint is as remote from Couturier's work as it is from Gursky's. A shift in perceptual habits is required if we are to accommodate ourselves to his images. In this particular example, although the image feels proximate and the sharpness of detail and frontal aesthetic permit a degree of phenomenological involvement, we are nevertheless distanced by a competing thrust to abstraction and wonder where Couturier's work situates us as our eye jolts restlessly from plane to plane. Invited to interact with the image not as inhabitants but as spectators of the city, we grope for a stable place in/before this dialectically ambivalent statement of transience.

Melting Point
This article's final section turns to Couturier's latest experimental series to date: one in which matter, memory, trace and time are very differently configured. In *Melting Point* Walter Benjamin's fascination with Paris as 'la ville qui remue et se déplace sans cesse',[29] goes global. The series includes large-scale all-over photographic works based on details of urban façades in Havana (2006–7), Chandigarh (2006–7), Brasilia (2007–9), Barcelona (2008), Nice (2012) and Algiers (2013) as well as a range of commissioned projects including two which explore industrial environments. These latter involve sharp, disorientating composite photographs of, or perhaps rather *about*, the Toyota assembly plant in Valenciennes (2005) and the Alstom factory in Belfort (2009).[30] It is no accident that the challenge of finding a visual language appropriate to high-tech industrial production and the task of visual engagement with global urban development belong to the same conceptual series. The overwhelming speed and scale of both are clearly interconnected in Couturier, and *Melting Point* further reinforces an apprehension of the city as machine, increasingly dominated by speed, technological advancement, production and process.

28. See Jean-Louis Perrier's interview with Couturier in *Avignon: créations photographiques*, Maison des vins, 8–26 July 2011 (Recueil Festival d'Avignon, 2011).

29. Walter Benjamin, *Paris, capital du XIXe siècle, le livre des passages*, transl. by Jean Lacoste (Paris: Éditions du Cerf, 1989), p. 533.

30. Gilles Mora sets the Toyota commission in the context of a long tradition of photography's involvement with working environments in the exhibition catalogue *Le dur labeur* (Arles: Actes Sud, 2007). For the project itself, see *Melting Point* (Paris: Trans Photographic Press/Ville Ouverte, 2006), with introduction by André Rouillé (pp. 8–15). The Alstom series, commissioned for the 130th anniversary of Alstom's establishment in Belfort, is available in the portfolio *Stéphane Couturier: Melting Power* (Paris: Ville Ouverte, 2009).

If Susan Sontag's idea of 'time's relentless melt'[31] in photography surfaces sharply in the *Archéologie urbaine* project, here melting takes over in a way that is quite differently pronounced. What melts? Couturier's title refers to subject, medium and their interrelationship. The subject is urban matter turned molten as architectural elements seep between continents, countries and cultures in relentless self-replication. Like Gursky, Couturier produces visually indigestible observations on urban spread which hover between representation and pure non-perspectival pattern. His work contributes originally to the narrative of fascinated awe that threads throughout city photography, finding contemporary expression in vocabularies related to modular contagion and the grid motif. *La Havane n°2, Giron Building* (2006–7) (Figure 4) is a good example. Urban matter seems here to seep into an infinite mould and the photograph to have neither beginning nor ending. Space is entirely flattened by an architectural screen of cloned units and the whole has become impenetrable, offering no entry point to the eye. A mad two-dimensional blueprint, the image intimates that postmodern urban development involves a dehumanizing level of abstraction.

Couturier's distinctiveness in his *Melting Point* work resides in the challenge he sets for his medium since his focus is on between-ness, becoming, dynamism and instability. André Rouillé refers to Couturier's Toyota photographs as 'invertébrés':[32] flowing and mystifying, they teem with traces of disparate elements, their vivid colours evoking coral reefs and shoals of tropical fish as much as complex computerized industrial production. Couturier finds here an experiential language which captures much more than the physical appearance of the factory environment. The architectural melts also reference a quality of experience as they flow towards abstraction focusing on surfaces, not environments. Within them memory and trace are scarcely at issue; they seem amnesiac, with no spatial specificity and no layers of the past to map. They offer up an idea – that of the infinitely extensible modular city – and a pronounced sense of rhythm. Roland Barthes's famous reference to cameras as 'horloges à voir',[33] devices connecting photographer and viewer alike to a moment in time, begins here to feel anachronistic; merely a memory, perhaps, of a staging post in the development of photography and our relationship with its take on the world. Couturier's photography interrupts time in differently intricate ways, bringing the swift malleability of its own medium to bear on complex spatio-temporal phenomena of global urban change so that both are embodied and explored in the image, or the 'melt'. The melting point, in fact, is the point where the subject *is* process; where feverish mutations in cityscapes and in image-making melt

31. Susan Sontag, *On Photography* (New York: Anchor Doubleday, 1977), p. 15.
32. Rouillé, in *Melting Point*, p. 9.
33. Roland Barthes, *La Chambre claire: note sur la photographie* (Paris: Cahiers du cinéma/Gallimard/Seuil, 1980), p. 33.

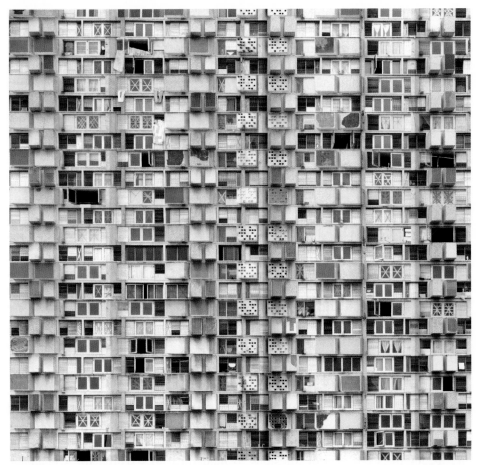

Figure 4. Stéphane Couturier, *Melting Point, La Havane n°2, Giron Building* (2006–7). Courtesy Galerie Polaris, Paris.

together. Rouillé articulates the shifting relationship between photography and its subject thus: 'Il faut donc débrider la fixité photographique, la fluidifer, abolir son armature perspectiviste, pour la mettre en mesure d'*accueillir* (et non plus *saisir*) la matière et les formes en fusion d'un monde mouvant, en devenir'.[34]

In terms of technology, *Melting Point* involves experiments with hybridization, collages, double exposures, superimpositions and complex imbrications of gelatine silver with digital image-making. While Couturier's unerring documentary sensibility prevents him from resorting to computer generation as an autonomous tool, he nevertheless combines image-making procedures and viewpoints in order precisely to make photographs which not only complicate our

34. Rouillé, in *Melting Point*, p. 15 (my emphases).

sense of relation to the subject but which also, as Piguet has observed, 'remettent en question le fait photographique lui-même.'[35] In a further adventurous melt of medium, technology and subject matter Couturier has also been exploring the potential of video since 2006, probing relationships between the moving and the still, expanding photography's capacity to respond to flux and grafting installations into newly disorientating spaces of display. Looped video films such as *Brasilia-Axe Monumental* (2007–8) or *Séoul-Tanji* (2006–10) produce disquieting urban fantasies. The former consists of two interwoven recordings taken from either side of the Monumental Axis. The latter is a seven-minute long travelling shot over a succession of large-scale photographs of massive suburban façades under construction in two global locations. Its focus is uninterrupted, hyperbolic and hypnotic. First projected in a darkened gallery, this film subsequently re-entered city space. Shown (uninterrupted) for several months at a time on giant outdoor screens in Amsterdam and Perth, it re-melted into the thick of the urban fabric, inducing conjunctions and interruptions upon which one can only speculate.[36] The theatricality inherent in Couturier's still photographs assumes new impact with these video experiments, shunting his practice further towards the world of art, towards what Rouillé has called 'une sorte d'"abstraction figurative"',[37] and towards flow.

Ultimately, Couturier produces a vision of city matter as a living organism, finds a range of technical means to elude fixed perspectives on it, and develops an idiom adapted to its evolution. I conclude this section of my argument with reference to one of his particularly layered industrial images, *Belfort, Usine Alstom n° 2* (2009) which belongs to a project, commissioned by Alstom, entitled *Melting Power.*[38] This dynamic photograph I read as a seamless incorporation not only of disparate elements related to the manufacture of turbines, machine tools and locomotives but also of allusions to modernist art's search for a language adequate to express modern engineering and the changing city. The concern for machine imagery in Cubism, Futurism and Vorticism stalk this photograph. More particularly, it is inhabited by two (very different) famous artistic statements about modernity and machines which melt into its visual fabric and its meaning: Robert Delaunay's *Homage à Blériot* (1914) and Max Ernst's *L'Eléphant Célèbes* (1921). Delaunay's dynamic bright disks, a visual short-hand for excitement and optimism about the industrial age, are here an industry-derived leitmotif which animates and enlivens the right-hand side of the photographic image. In contrast, the monstrously primitive ogre of a turbine that squats intimidatingly

35. Piguet, 'Stéphane Couturier – embrasser l'espace', p. 9.
36. Couturier's videos are available on request (see website in note 2).
37. Rouillé, in *Melting Point*, p. 13.
38. This photograph may be seen on Couturier's website (see note 2).

in the photograph's centre, a presence part mechanical part organic, evokes Dada's suspicious – even apocalyptic – response to the machine.[39] Inescapably too one thinks of Bernd and Hilla Becher's more threatening studies of industrial organisms and disquieting water towers. Humorously, ingeniously, Couturier's photograph of the Alstom factory melts within one frame a long history of visual and ideological responses to mechanization. Most particularly it is a reminder – and an example – of how such responses, both to industry and to the urban fabric, have sought to convey not just the visual appearance, but the logic of their subject.

Conclusion

I have argued that Couturier's series offer a compelling map of evolving 'takes' on the city as photographic subject, making visible contemporary dialogues between photography and urban matter and confirming the status of the photograph as, simultaneously, document, art work and object of (lens-related) thought. Looking at Couturier's city photography in the negative, I have argued the following: that it does not celebrate the city, famous landmarks, iconic edifices or contemporary urban culture; that it is not rooted in a particular city; that it is concerned neither with the street nor with documenting social conditions (even Couturier's building sites are empty and there is scant allusion to the labour on which urban development is contingent); that it is not concerned with capturing the fleeting moment or the unexpected event; and that it is not personalized: we cannot locate Couturier, or indeed ourselves, with regard to it.

Instead, as it dismantles permanence and threatens place, Couturier's photography describes proliferation and flux and offers simultaneously a remarkable example of photography's increasing malleability and phenomenological reach in the post-medium age. Articulations of the trace in Couturier reveal not only the city's past embedded in its present, but shadows of the analogue in the digital, of the still image in the moving sequence, and everywhere of the motifs and formal devices characterizing iconic photographic and painterly responses to the city fabric as/and modern engineering. The photographer's own experimentation is thus most comprehensively understood when set within a broader history of visual responses to urban transformation. Not satisfied with merely showing us what is *there* in cityscapes, he mimes and comments on their rhythms of growth, on their overwhelming self-replication. The sophisticated engagement with urban upheaval that is evidenced in Couturier's slices, melts and video loops will ensure their enduring status not only as artworks, but as important records of the contemporary (global) city and of evolving experimentation with lens-based art.

39. My own nervous response to this image is bound up with Alstom's involvement in the nuclear industry.

Nottingham French Studies 53.2 (2014): 186–200
DOI: 10.3366/nfs.2014.0085
© University of Nottingham
www.euppublishing.com/nfs

LA CARTE ET LE TERRITOIRE: MAPPING, PHOTOGRAPHY AND THE VISUALIZATION OF CONTEMPORARY FRANCE

EDWARD WELCH

Michel Houellebecq's novel *La Carte et le territoire*, published in 2010, tells the story of Jed Martin, an artist whose name and fortune are made by a series of large-format photographs of Michelin road maps. During a fuel stop at a service station on the A20 motorway, Martin is sent by his father to buy map number 325 (Creuse, Haute Vienne) of the famous 1/150,000-scale *série jaune*, which has dominated the market since its introduction in the first decade of the twentieth century, and offers the most familiar cartographic representation of French national territory. Martin is overwhelmed by the map's aesthetic qualities, and the tensions latent within its representation of the French landscape:

> L'essence de la modernité, de l'appréhension scientifique et technique du monde, s'y trouvait mêlée avec l'essence de la vie animale. Le dessin était complexe et beau, d'une clarté absolue, n'utilisant qu'un code restreint de couleurs. Mais dans chacun des hameaux, des villages, représentés suivant leur importance, on sentait la palpitation, l'appel, de dizaines de vies humaines, de dizaines ou de centaines d'âmes – les unes promises à la damnation, les autres à la vie éternelle.[1]

His reaction elucidates the contradictory nature of the map as a technology of vision and a mode of representation. On the one hand, its transformation of territory into symbolic form – a signifying combination of lines and colours – is aesthetically attractive, and facilitates the consumption of French territory as an object of tourism, constituted in particular as an engagement with a sequence of landscapes and views. After all, Michelin maps are primarily for road users, and designed with both the professional driver and the motorized tourist in mind.

On the other hand, as Martin recognizes, maps are manifestations of technical and scientific expertise. They are a form of visual representation produced by increasingly sophisticated methods of data capture which aid knowledge of space and territory through techniques of abstraction and schematization (and in which are inherent the aesthetic qualities and possibilities identified by Martin). As such, maps also signify the power of certain institutions (state and non-state) to capture and represent the world in symbolic form, and thereby make it vulnerable to

1. Michel Houellebecq, *La Carte et le territoire* (Paris: Flammarion, 2010), p. 54.

intervention, manipulation and transformation. As a tool of governance, planning and development, mapping makes easier human action on the world, and such scenarios always imply a human dimension.

Human presence on the ground is the final element of the drama of mapping identified by Martin; for the very acts of schematization and abstraction draw attention to the landscape as a place of lived experience by highlighting human habitats and dwellings. The peculiar force of the map lies in how it embodies the everyday, technological sophistication of the human race. It is an object which is ubiquitous and seemingly utilitarian, and yet latent with great power: it stages man's dominion over the world both in terms of capturing the degree by which it has been transformed by humans, and as an example of the technologies which permit such transformations. It reminds us too that the spatial transformations and interventions it depicts and permits are also, inevitably, interventions in the lives of others, who constitute, and are constituted by, the places they inhabit.

Jed Martin's response to the Michelin maps is to photograph sections of different maps from a high angle, so that the territory depicted recedes into the distance and disappears over the horizon. The first image he shows, as part of a group exhibition, is noticed by Olga, a member of Michelin's PR team, and this in turn leads to a solo exhibition of his work, which marks his breakthrough as an artist and is supported (discreetly) by the Michelin corporation. The subsequent online sale of prints of the series is, it is implied, of significant financial benefit both to the company and Jed himself, who nevertheless (and as befits his artistic disposition) seems oblivious to the worldly success of his creative endeavours. Michelin's commercial director, on the other hand, is acutely alert (equally unsurprisingly) to the economic and symbolic capital which accrues as a result of Jed's artistic engagement with his company's maps.

What might be at stake in Houellebecq's decision to make photographs of Michelin maps the key to Martin's trajectory and success as an artist? It is useful as a plot device not least because it allows the writer to develop themes which relate to his fundamentally dystopian and ironic view of contemporary France. Through the amorous relationship which develops between Jed and Olga, Houellebecq can thematize the question of France's position in the contemporary world as a major international tourist destination. The novel explores the role played by companies such as Michelin, with its roots in the French provinces, in the commodification of the country through its distillation into a series of stereotypes for consumption by a range of foreign audiences. At the same time, Houellebecq keeps in play an awareness of the growing gap between the France constructed for a tourist gaze, and the country's rather more prosaic and depressed reality. Olga

> faisait partie de ces Russes attachants qui ont appris au cours de leurs années de formation à admirer une certaine image de la France – galanterie, gastronomie,

littérature et ainsi de suite – et se désolent régulièrement de ce que le pays réel corresponde si mal à leurs attentes.[2]

Her job is to market a vision of France the deceptiveness of which she is only too well aware.

Houellebecq's depiction of contemporary, post-industrial France as primarily a commodity for consumption by international tourists – and especially those from the economic powers of the developing world – pursues the dominant theme of French dysfunction present in his work since *Extension du domaine de la lutte* (1998); but while it is always important to remember that irony is one of Houellebecq's principle modes, it is nevertheless worth pausing to take seriously the works of art which he imagines for his central character. I would suggest that they can be seen as invitations to think about the role of visual culture in shaping understanding of the nature of space, and concomitantly, of French territory and identity. The title of Houellebecq's novel itself signals the centrality of such questions, encouraging us as it does to reflect on the relationship between 'la carte' and 'le territoire', and in particular, on the role played by techniques of visualization such as mapping and photography in conceptions of space, territory and identity.

Indeed, Houellebecq's interest in the topic exemplifies a broader, on-going concern with both the contemporary state and direction of the country and its representation in visual form especially. At the time when Houellebecq's novel was published in the autumn of 2010, a major exhibition of new work by photographer and filmmaker Raymond Depardon was in preparation at the Bibliothèque nationale de France (BnF) in Paris. *La France de Raymond Depardon* marked the culmination of a project lasting six years, during which Depardon had embarked on a photographic tour of metropolitan France. The very scale of the project, along with the institutional and financial support it received, foregrounded the privileged role seemingly afforded to the photographic image in articulating and conveying an image of contemporary France. Like Houellebecq's novel, it raises questions about the representation of France in the contemporary period; the techniques of visualization deployed in the process; and the understanding of France as sovereign territory and imagined place which emerges as a result. My aim in the remainder of this article is to explore this shared concern with the visualization of contemporary France, before focusing more closely on Depardon's project and exhibition, and the significance it acquires as a commentary on the country in the first decade of the twenty-first century.

2. Ibid., p. 71.

Carte contre territoire?

Jed Martin decides to entitle his first solo show 'La carte est plus intéressante que le territoire'.[3] As if to prove the point, he juxtaposes a satellite image of a corner of rural France with the cartographic representation of the same area:

> Le contraste était frappant: alors que la photo satellite ne laissait apparaître qu'une soupe de verts plus ou moins uniformes parsemées de vagues taches bleues, la carte développait un fascinant lacis de départementales, de routes pittoresques, de *points de vue*, de forêts, de lacs et de cols.[4]

If the map is more 'interesting' than the space it represents, Martin's juxtaposition of the two images would suggest, it is so first and most obviously in terms of its transformation of space into symbolic form, and the opportunities for aesthetic expression which emerge from that process of codification; but the cartographic rendering of the landscape is also a gesture of appropriation and possession. It serves to domesticate space, thereby confirming its place within the sovereign territory of the nation, as well as realizing it as a potential source of spectacle: the map is an object which opens up the prospect of the 'point of view', a perspective sanctioned as aesthetically pleasing. Here we see a second sense in which the map is 'intéressante', in that peculiarly French sense of offering benefit or advantage. If the map is more 'interesting' than the space it represents, it is also because of the possibility for agency and intervention it affords, as much as for its rendering of raw terrain.

Depardon would undoubtedly take issue with Martin's privileging of map over territory. *La France de Raymond Depardon* is an exploration precisely of 'territoire', as well as an investigation of what the concept means in a French context. In the introduction to his exhibition catalogue, Depardon aligns 'le territoire' with 'l'espace public' and 'l'espace vécu'.[5] His concern, that is to say, is with the constitution and nature of space at the level of lived experience, and with the ways in which collective identity of various sorts (local, regional, national) finds articulation in spatial terms. The project is an examination of how 'Frenchness' might be expressed visually within the landscape, and how the landscape might be co-opted into carrying the *imprimatur* of Frenchness. As such, Depardon's investigation of 'le territoire' implies a view from the ground, or a grounded perspective, the latter in a sense both literal (located and anchored in specific places) and figurative (sensitive to the realities of those locations in a way which identifies with common concerns and preoccupations). It is through this interest in the lived realities of everyday life for ordinary people that *La France de*

3. Ibid., p. 82.
4. Ibid. (emphasis in the original).
5. Raymond Depardon, *La France de Raymond Depardon* (Paris: Seuil/Bibliothèque nationale de France, 2010), no pagination.

Raymond Depardon becomes a political project for the photographer, insofar as it offers a portrait of both how the French live at the turn of the twenty-first century, and more to the point perhaps, of *how well* they live: 'non pas seulement montrer des gens, mais montrer les lieux en se demandant comment les gens vivent-là'.[6]

In fact, Depardon places himself explicitly in contradistinction to an increasingly dominant mode of visualizing space in the contemporary period; namely, the trend for aerial and satellite imagery exemplified by Jed Martin's fictional works of art; by computer software such as Google Earth; and by the work of photographers such as Yann Arthus-Bertrand, who rose to international prominence in the late 1990s and early 2000s thanks to his *Earth from the Air* series. Arthus-Bertrand's project, and the wide circulation of his images through public exhibition, did much to promote a photographic mode whose distancing and defamiliarizing perspectives can help to raise the viewer's consciousness about the complexity, sophistication and vulnerability of the planet; but the perspective is also one which implies a potentially problematic hierarchy of visual superiority. For aerial photography is nearly always the prerogative of the economically and politically powerful, simply by dint of the apparatus it requires (such as the ready deployment of planes and helicopters); and its distance from the photographic subject, which might bring with it a more commanding or globalizing viewpoint, cannot but help lose sight of the material conditions of life as it is lived on the ground and made manifest in the environments of the everyday. Such is the increasing ubiquity of the aerial perspective, perhaps, that Depardon feels the need to make clear that his is a portrait of the nation 'vue de la terre, pas du ciel!'.[7]

Photography, Modernity and State Planning
The interest of Depardon's project, then, lies on one level in what it reveals about the look and feel of France in the early twenty-first century; but it is also

6. 'L'Exilé de l'intérieur: entretien avec Raymond Depardon', propos recueillis par Véronique Brocard et Catherine Portevin, in *Télérama horizons*, 'La France de Raymond Depardon' (September 2010), pp. 14–21 (p. 18).

7. Ibid., p. 14. On Arthus-Bertrand and aerial photography, see also Edward Welch and Joseph McGonagle, *Contesting Views: The Visual Economy of France and Algeria* (Liverpool: Liverpool University Press, 2013), pp. 177–9. For a historicized perspective on the growing dominance of satellite and aerial imagery, see Mark Dorrian and Frédéric Pousin (eds.), *Seeing From Above: The Aerial View in Visual Culture* (London: I.B. Tauris, 2013). In his discussion of Google Earth in that volume, Dorrian explores the contradictions latent within the corporation's avowed desire to widen access to information as far as possible – that is to say in relation to Google Earth, for example, to disrupt the hierarchies of vision and power implicit within the aerial view – while gathering as much data as it can about its users to be mined for a range of purposes. See Dorrian, 'On Google Earth', pp. 290–307.

important because it highlights once again the persistent and complicated relationship in France between photography, modernity and modernization. At stake in this relationship is not just the privileged role acquired by photography in capturing the state of the French nation as it moves through time; but also that the medium is intimately bound up in the broader processes of change that it is called upon periodically to depict. After all, it was not the first time that Depardon had been involved in a photographic project of this type and ambition. During the early 1980s, he was part of the thirty-strong team of photographers co-ordinated by Bernard Latarjet and François Hers as part of the landmark *Mission photographique* funded by the Délégation à l'aménagement du territoire et à l'action régionale (DATAR), the state agency which had been responsible for planning and development across metropolitan France since the early 1960s.

The *Mission photographique de la DATAR* was itself placed self-consciously in the tradition of grand photographic projects in France and elsewhere, including the Farm Security Administration project in the Depression-era United States, and the *Mission héliographique* of 1851 in France. It also asserted a link between photography, state action and national identity. The aim of the *Mission héliographique* was to mobilize the new technology of photography in order to create an inventory of historic public buildings in France, especially those left abandoned after the French Revolution, and in danger of dereliction and collapse. In other words, photography was part of an act of salvage, recording and preserving for posterity what would now be termed the nation's 'heritage'. The aim of the *Mission photographique* was rather different, being concerned not so much with salvage, as with aftermath, setting out to examine the consequences of twenty years of state-led modernization as co-ordinated by the DATAR. It was as if the organization responsible for spatial production and the reshaping of French territory had become conscious of the scale on which it had been working, and of the need to register and acknowledge the potentially problematic effects of its actions.

The DATAR was established in 1963 during the first presidency of Charles de Gaulle. It was led by Olivier Guichard, who reported directly to the Prime Minister. Its founding and reporting structures were typical of governance under de Gaulle. A long-time ally of the president, Guichard was an important figure of state administration, with a reputation for forward planning and reflection on the nation's future.[8] The role of the DATAR was to co-ordinate projects designed to develop the national infrastructure in a range of ways, from tourist resorts to

8. The DATAR offers its own overview of post-war planning in Claude Lacour and Aliette Delamarre, *Quarante ans d'aménagement du territoire* (Paris: La Documentation française, 2008). On Gaullist modes of governance, see Delphine Dulong, *Moderniser la politique: aux origines de la Cinquième République* (Paris: L'Harmattan, 1997). Two years after he was put in charge of the DATAR by Georges Pompidou, Guichard set out

petrochemical complexes and a network of motorways. The aim in doing so was to reshape national territory along more efficient and better organized lines, and to facilitate in turn economic development, mobility and growth; and it is the modernized landscapes produced by this process especially which the *Mission photographique* is tasked with investigating. Also striking, however, is the working assumption of Latarjet and Hers that what had emerged above all was a landscape which was chaotic and uncertain, one in which they had to orientate themselves, and help others find orientation: 'comment, en effet, *se repérer* dans un espace dont les formes n'expriment plus de valeurs reconnues et partagées?'[9] The question they pose articulates a central irony of post-war planning and modernization in France; namely, that a process intended to bring order and efficiency to the national territory in fact brings spatial disruption and a troubling sense of the new.

The DATAR's turn to photography in order to audit the consequences of its activities served as a high profile endorsement of the medium's value as a way of capturing and understanding the nature of spatial change. As Raphaële Bertho has discussed, and I have noted elsewhere, the *Mission photographique* was intended to lend credibility to documentary photography as a means of artistic expression;[10] but in many respects, the prominence afforded to it by Latarjet and Hers served simply to underscore the already central role of photography and visual representation in processes of spatial transformation and modernization. Vincent Guigueno notes the privileged relationship between photography and state planning in post-war France, and the importance ascribed to it – consciously or otherwise – by planners and architects as a tool of visualization and territorial intervention.[11] The link between the two finds neat expression in an image of Paul Delouvrier in front of a vast, aerial photo of the Paris region, taken in the mid-1960s (Figure 1). Delouvrier was responsible for directing and implementing the *Schéma directeur d'aménagement et d'urbanisme de la région de Paris* (SDAURP), a planning blueprint for the Paris region which paralleled the national programme being orchestrated by the DATAR.

his views on France's planning needs in *Aménager la France: inventaire de l'avenir* (Paris: Laffont, 1965).

9. Bernard Latarjet and François Hers, 'L'Expérience du paysage', in *Paysages photographies: en France les années quatre-vingt* (Paris: Hazan, 1989), pp. 13–19 (p. 14).

10. Raphaële Bertho, 'Depardon, la DATAR et le paysage', *Image and Narrative*, 12:4 (2011), 115–29 (pp. 122–4), and Edward Welch, 'Portrait of a Nation: Depardon, France, Photography', *Journal of Romance Studies*, 8:1 (2008), 19–30 (p. 28). See also Vincent Guigueno, 'La France vue du sol: une histoire de la Mission photographique de la Datar (1983–1989)', *Études photographiques*, 18 (2006), 97–119.

11. Guigueno, 'La France vue du sol', pp. 98–100.

Figure 1: Réunion de travail avec Paul Delouvrier au centre, Maurice Doublet préfet de Paris, Jean Verdier préfet de Seine-et-Marne à gauche et Maurice Grimaud préfet de police à droite et le préfet de Seine-et-Oise (1960s). Credit: IAU-îdf.

The significance of the image lies firstly in how it captures the planners' relationship to the space of the nation's capital, a relationship of power implicit within the perspective of aerial photography. The presence of the Paris region as a backdrop for the discussions of Delouvrier's committee suggests their dominion over space, and over the lives lived there – the pulsating life which Jed Martin detected beneath the apparently cool abstractions of the Michelin map. At the same time, the image foregrounds the agency of the planners, expressed especially in the confident and dynamic pose of Delouvrier in front of the aerial photo of Paris. Agency is embedded too within the aerial photo itself, which facilitates intervention in the landscape through its totalizing perspective. It allows the planners to grasp *at a glance* the lie of the land; to give shape to amorphous spaces of urban development; and to understand the landscape as a totality, eliding the messy details of lived experience on the ground. In short, the image highlights the degree to which images are embedded within, and mobilized as part of, large-scale planning work, and the ways in which they themselves enable that work.

Writing in *Paysages photographies*, the substantial volume of images drawn from the DATAR project, Jean-Paul de Gaudemar notes that 'on oublie parfois que l'aménageur ne travaille jamais qu'à partir de représentations de son objet'.[12] His observation indicates a self-reflexive dimension to the DATAR project in its acknowledgement of the importance of the photographic image in planning activity. The agency's turn to photography to record the aftermath of its spatial interventions was a natural extension of the medium's role in its activities since its inception; and the consequences it articulates, as I noted above, are defined by confusion and uncertainty as much as clarity and order.

'Un réglage de comptes': Depardon and State Planning

Such themes are central to Depardon's own contribution to the DATAR project, which marked his first sustained engagement with the policies and politics of French *aménagement du territoire*. He sets out to explore how planning is transformed into action on the ground, and the nature of the gap between space and its representation, between the maps and aerial photos used by planners, and the lived environments which are the focus of their attention. His interest in this gap and its implications is motivated by an important personal investment on his part, for the subject of his investigation was the transformation of land which had been expropriated from his father's farm by the government in the 1970s for the route of the new A6 motorway between Paris and Lyon:

> J'étais en colère contre les grands travaux d'aménagement qui avaient démantelé la ferme de mon père en l'expropriant pour faire passer l'autoroute au milieu de ses terres pour établir une zone industrielle et enfin une zone commerciale sur le reste de terres cultivables. Je n'avais qu'une envie, c'était de régler mes comptes avec ce désastre, ce grand chamboulement qui avait rendu mon père malade et l'avait précipité dans la dépression.[13]

Depardon is concerned to expose the affective and emotional impact of a project seeking to transform land in the name of national modernization on the lived experience of individuals rooted in specific locations. In doing so, he raises the question of both how and in whose name a landscape is made. In particular, he stages an encounter between two modes of spatial organization in France, and what happens when an ideology of progress through spatial transformation collides with the established modes and rhythms of rural life.

12. Jean-Paul de Gaudemar, 'Le Territoire aux qualités', in *Paysages photographies*, pp. 51–85 (p. 51). The claim is not entirely accurate: Paul Delouvrier famously spent time driving round the Paris region in an open-topped car in order to identify locations for the new towns to be built as part of the SDAURP. See Roselyne Chenu, *Paul Delouvrier ou la passion d'agir* (Paris: Seuil, 1994), p. 255.

13. Depardon, *La France de Raymond Depardon*, no pagination.

As such, he articulates the imbalance of power between the state and the subjects under its jurisdiction, and therefore the injustices it brings; but he is concerned as well to depict the nature of the spaces produced by the construction of the motorway. He explores the new locations and (non-)places which emerge in its wake and bear witness to its presence in the landscape. He is preoccupied especially with warehouses, storage depots, and other elements of an infrastructure of distribution and circulation. The arrival of developed space is signalled by the power lines which start to criss-cross the sky. He depicts the geometric precision of new road junctions, roundabouts, and the street furniture which accompanies them, though what we notice especially are the reverse sides of the road signs which guide the traffic. Such images can be seen as a comment on the reproducibility of these new spaces; but they also invite us to reflect on their composition and design, and the way in which geometry and order start to imprint themselves on the landscape. It is as if Depardon is trying to get to grips with the look of the new as it moulds and shapes the long-established spaces of provincial France.

Re-viewing the State of the Nation

Perhaps the first question posed by *La France de Raymond Depardon*, then, is how things look twenty or so years later. In many respects, it is a project of similar scale and magnitude to that of the DATAR: it unfolds over six years between 2004 and 2010, and covers a similarly extensive geographical area (though like the DATAR project, it is resolutely metropolitan – not to say hexagonal – in its focus, insofar as Depardon does not visit Corsica as part of his trip, let alone the DOM-TOMs). At the same time, the project is notable for the way in which it places emphasis very much on Depardon's singular perspective.[14] It invites us to acknowledge Depardon's established place in the star system not just of contemporary French photography, but of French culture more broadly, and to recognize the validity and authority of his perspective as a means of understanding contemporary France. That the invitation was widely taken up is reflected in the popular success of the BnF exhibition, which attracted some 82,000 people between October 2010 and January 2011 (making it, according to the BnF, one of their three most popular exhibitions as of August 2013).[15]

How might we account for the enthusiastic response to (and thereby, legitimation of) Depardon's point of view? Moreover, what sort of image of contemporary France emerges from his project? How does it help us to grasp the current state of the nation? The success of *La France de Raymond Depardon* lies arguably in the degree to which his vision of France is in some way recognizable to a substantial viewing public. In his discussion of the project,

14. I discuss this point further in 'Portrait of a Nation', p. 28.
15. Email correspondence with the author, 6 August 2013.

Depardon foregrounds his sense that France is a country uncertain of itself, a country in a state of unease.[16] As such, his perception chimes with a mood of angst and anxiety which persists in France throughout the first decade of the twenty-first century and resonates across French culture, finding expression (for example) in the mood and tone of novels by such as Houellebecq; introducing in 2013 a study which itself revisited the findings of a project carried out in the 1980s, Hervé Le Bras and Emmanuel Todd argue that the starting point for their investigation into 'le mystère français' was a feeling that 'la France ne se sent pas bien'.[17]

Depardon picks up on a sense of unease in the locations he visits; and here also is where we undoubtedly find another reason for the popularity and recognizability of Depardon's France. He offers a portrait of the country which is resolutely rural and provincial. He deliberately avoids large city centres (on the rather dubious grounds that the presence of national and multinational commercial chains make them appear interchangeable), and the suburban areas of the big cities (on the more reasonable basis that going there would skew the focus of the project towards other, more dominant themes in the debate about France's national and territorial identity).[18] These omissions apart, he captures the diversity of landscapes and environments which make up the territory of metropolitan France, and reminds his viewer of the degree to which different traditions, environments and identities are yoked together within France's national space. Indeed, he asserts a vision of France as constituted not by the administrative units defined and imposed by a central state, but by a hugely diverse and more organically-formed collection of 'pays':

> En sillonnant la France par ces routes secondaires, ce ne sont pas 22 régions que l'on voit, ni 95 départements, mais quelques 400 'pays'. Et l'on voit toutes ces petites différences qui font la particularité: [...] organisation très stricte de l'habitat (village, puis lotissement, puis rien autour) dans l'Hérault par exemple, le contraire de l'Ardèche, où tout le monde construit n'importe où au bout d'une vigne.[19]

Of course, Depardon is here explicitly mobilizing the pre-Revolutionary currency of territorial and spatial identity, one which is rooted in specificities locally rather than centrally defined and lived; and his recourse to this vocabulary implies one possible narrative to emerge from his portrait of France. *La France de Raymond Depardon* can be seen as a celebration of more heterogeneous and improvised

16. 'L'Exilé de l'intérieur', p. 18.
17. Hervé Le Bras and Emmanuel Todd, *Le Mystère français* (Paris: Seuil/La République des idées, 2013), p. 7.
18. 'L'Exilé de l'intérieur', p. 18.
19. Ibid., p. 21.

spatial production in France, and a resolutely anti-establishment view 'd'en bas' of the national space, one which sides plainly with the 'done to' rather than the 'doers', but which emphasizes also the initiative, modes of resistance and *bricolage* of those on the ground. Depardon shows himself keen to display the diverse architectural forms which emerge beyond or despite the 'big' *aménagement* of the central state.

A narrative of *bricolage*, improvisation, and thereby implicitly, resistance to central authority, is further elaborated by the geographer Michel Lussault in an essay which accompanies Depardon's images in the pocket (and therefore mass-market), second edition of *La France de Raymond Depardon*:

> Loin des grands discours et des prétentions des experts territoriaux, des spécialistes des ingénieries de contrôle des espaces humains (l'aménagement, l'urbanisme, l'architecture), des représentants des institutions politiques, les photographies de Raymond montrent une France de l'improvisation permanente, où l'assemblage de guingois et le bricolage hasardeux règnent en maîtres, où le brinquebalant, le jamais-vraiment-fini, le composite, la contingence deviennent, par défaut, des principes directeurs.[20]

It chimes with other narratives of resistance to state-imposed order which emerge as a key theme in post-war French writing about urban space and its relationship to the state (of which De Certeau's notion of the ruse would be the most obvious example). Narratives such as these place the French citizen in a playful and disruptive relationship to central(ized) government, and remind us of the centrifugal forces which are at work within the territorial entity named France, and can challenge a vision of the country asserting unity over difference.

A decentred vision of spatial development in France emerges in other ways as well. Depardon's concern is with locations across provincial France which might be assumed to be at the margins of processes of spatial production and change, and especially those state-driven programmes of modernization setting out radically to transform landscapes in the name of greater national prosperity and development. More accurately, perhaps, we can say that Depardon captures the *reach* of those processes; that is to say, the extent to which spatial transformation and expressions of territorial identity have affected the whole of France, even if they have done so unevenly. As Depardon puts it, 'quand je photographie la France, je ne suis pas chez moi dans 99% de mes photos. Et pourtant, je la reconnais, c'est ma nation, c'est mon État... [...] La France, ça se joue à une infinité d'infimes détails.'[21] His images of road signs and other indicators of direction and geographical location articulate the ways in which marks of

20. Michel Lussault, 'Bric-à-brac', in *La France de Raymond Depardon* (Paris: Points, 2012), pp. 291–5 (p. 294).
21. 'L'Exilé de l'intérieur', p. 16.

territorial identity are written across the landscape, and 'France' as a recognizable spatial entity takes shape. He homes in on clusters of road signs at junctions; but unlike the images he took twenty years previously, he shows us the places to which they point, hierarchized and colour-coded depending on the size and administrative importance of the destination. In an image of an old, concrete sign at a bridge in Moselle naming the river being crossed can be read the systematic, almost obsessive, way in which landscape is inscribed. It captures something of the drive to name and appropriate which seems to propel the identification of a French national space.

Depardon's photographs also highlight the palimpsestual nature of public space in France, reflecting how it has been constituted and remodelled over time. Two motifs or reference points resurface in particular: the war memorial and the wayside cross, which are often to be found co-existing in – and thereby giving shape to – municipal spaces across provincial France. They are significant in the first place because they remind us of two formative threads of collective identity in France: the Catholic faith on the one hand, and on the other, a burgeoning sense of a secular republican identity reasserted during the Third Republic, and expressed in the wake of the First World War especially. They often reflect too how the pragmatics of national politics in the Third Republic allowed for the melding of two traditions which (ideologically and conceptually) should be incompatible, as a number of war memorials incorporate religious iconography. Yet not only do these images highlight how expressions of collective identity were incorporated into public space on behalf of an imagined community, they also capture the fate of such monuments as they become implicated in processes of spatial change.

Throughout *La France de Raymond Depardon*, the photographer shows himself sensitive to the points at which different histories, visions and uses of space co-exist and collide. In Saint-Omer (Pas-de-Calais), for example, he photographs a wayside cross on the edge of a new retail outlet on the town's outskirts (Figure 2). The image draws attention to the ironies and peculiarities produced by contemporary spatial development, such as the increasing use of peri-urban space for commercial and retail purposes. The viewer is struck by the almost deferential way in which the wayside cross, marked off by its original low fence of ornate iron railings, has been incorporated into the site, maintained at a discreet distance from the retail unit's car park by a lawned area. Yet at the same time, its position on the edge of the site suggests its presence as an object which had to be accommodated, however inconveniently. The image expresses the tensions of spatial use in France in the form of a simultaneous recognition and marginalization of history and tradition. Remaining in the landscape as a relic or trace of a historically significant form of collective identity, the wayside cross nevertheless finds itself jostled and squeezed by the expansiveness of a space turned over to more profane and profitable uses.

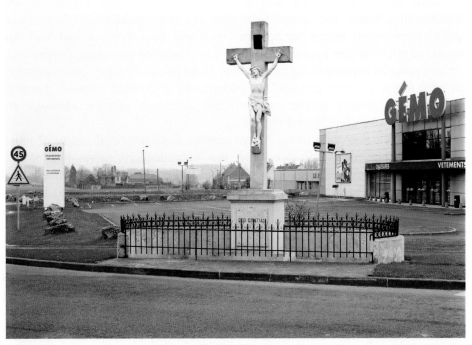

Figure 2: Raymond Depardon, FRANCE. Nord-Pas de Calais region. Pas-de-Calais department. Saint-Omer (2005). Credit: Raymond Depardon/Magnum Photos.

Thus, Depardon's portrait of contemporary France reminds us of how space is constituted by a co-existing accumulation of different historical periods and ideologies made manifest in built forms. It reminds us too that it is inscribed and re-inscribed with differing and historically specific visions of how the new and the modern should be expressed, from the reinforced concrete of 1930s modernism and the prefabricated concrete social housing of the 1950s, to the mirrored glass and coloured steel of the 1980s, and the standardized style of contemporary *pavillons*. As Lussault suggests, the spatial and architectural heterogeneity revealed by Depardon's survey invites us to reconsider processes of spatial change and modernization not as coherent and systematically organized transformation, but as sporadic, punctual and local interventions which co-exist or overwrite each other, and produce a landscape which is untidy, unfinished and inevitably therefore complex. Or rather, and more precisely, *La France de Raymond Depardon* is a story of how space is ordered and inscribed by markers of national territorial identity, and of how those efforts of spatial ordering must contend with

a degree of spatial confusion and layering, and with local innovation and architectural heterogeneity. The DATAR project, fundamentally, and as evinced by Depardon's contribution, was a reflection on rupture, disruption and discontinuity; it was also about measuring the consequences of often radical spatial intervention driven by political will, and how that political will had imprinted itself on the French landscape. *La France de Raymond Depardon* is perhaps more an exploration of persistence; of the often surprising co-existence of different forms and expressions of the modern; and of the heterogeneous nature of territory in a country whose traditions and dominant political ideology are predicated on spatial unity and integrity.

Depardon's celebration of the heterogeneous and centrifugal nature of much spatial development in France, and the complications born out of the juxtaposition, co-existence and layering of different spatial and architectural forms, points to a mood of resistance and resilience which perhaps has its roots in his own, traumatic encounter with the state-led *aménagement* of the post-war period. As such, his vision chimes with the broader sense of disillusion and uncertainty characterizing the France of the early twenty-first century. It is a country caught between the persistence of tradition, and a continued anxiety about its own sense of national identity and its place in the world. If we are to account for the resonance of Depardon's portrait of contemporary France, it is perhaps because a vision of the country predicated on persistence and resilience at the level of everyday life is one which offers the greatest comfort for a French viewing public. It suggests as well that for much of the French population, and *pace* Jed Martin, the nature and fortunes of *le territoire* – of the complex imbrications of space and identity which lie at once beyond and subject to the cartographic gaze – remain central to their preoccupations and concerns. It reasserts too the centrality of the photographic image in articulating those concerns through its staging and investigation of spatial production and change.

Nottingham French Studies 53.2 (2014): 201–215
DOI: 10.3366/nfs.2014.0086
© University of Nottingham
www.euppublishing.com/nfs

RETOUR/DÉTOUR: BRUNO BOUDJELAL'S *JOURS INTRANQUILLES*

AMANDA CRAWLEY JACKSON

In this paper I will present an analysis of a series of photographic works made by the Franco-Algerian artist Bruno Boudjelal between 1993–2003 and collated in a book published by ABP Autograph (London) in 2009 under the title *Jours intranquilles/Disquiet Days*. These photographs, in which the artist interrogates his own complex cultural identity and the multidirectional intersections of his own and his family's life stories with recent Algerian history, document a number of separate journeys made by the artist: in 1993, alone, to trace and visit his family in Sétif; in 1997, with his father, again to meet his Algerian family; in 2001–3, with friends, across Algeria from east to west (a trip he had planned to take in 1993 but was forced to defer due to the escalating violence of the civil war); and specifically in 2002, when he visited the village of Bentalha, situated 15km south of Algiers in the Mitidja plain, where up to 400 people were massacred in 1997. The book also contains facsimiles of pages from Boudjelal's notebooks which the artist began to make retrospectively, in 2007, using writing, photographs, Polaroids, contact sheets, found images, documents and texts pertaining to his Algerian journeys.

My paper will cohere around the following propositions. First, the entwined photographs and journal extracts attest to Boudjelal's shifting relationships with his extended paternal family and his own journey of self-exploration. However, at the level of both form and content, they also enact a testimony to the complex entanglement of the personal, political and historical in projects of (self-) knowledge and (self-)representation. The photographs point obliquely to the violence of the dirty war of the 1990s and its impact on the Algerian people and landscape. This obliquity prompts a series of reflections on the political and ethical latency afforded by Boudjelal's photographic idiom, as it circulates within a regime of representation characterized by censorship, on the one hand, and the (deeply political) media spectacle of violence and war, on the other. I will suggest that Boudjelal's works operate metonymically, both within and against the grain of the documentary tradition, reworking (rather than rejecting) the indexicality of the photographic medium. The overarching argument I will pursue is that Boudjelal's *retours* to Algeria might be better described as *détours*, in which the linear temporalities of return and the teleology of origin give way to a provisional intersection of trajectories and an ongoing, negotiated sense of cultural identity

which, as Stuart Hall has argued, 'belongs to the future as much as to the past'.[1] Following Barbara Mella's study of the detour in Derrida's work, I suggest that the detour in Boudjelal's journey and photographic project is 'a critique of metaphysical foundations from the inside',[2] affording a space for the radical interrogation of what constitutes selfhood and the real. With reference to the specific qualities of Boudjelal's photographs (most notably *le flou*, obliquity and the metonymic) I will make the case that the idea of the detour can be applied as much to the idiom of his photographic practice as it can to his physical return to Algeria. In these multiple detours, Boudjelal discovers a space for the enactment of (an identity within) a community of political practice, rather than a stable or essential point of filiation.

A Fractured Family History
Bruno Boudjelal was born in Montreuil (Seine-Saint-Denis) to an unmarried French mother and an Algerian father in 1961, the year in which the violence of the Algerian War of Independence spilled over onto French soil.[3] Boudjelal's father, Lemaouche Boudjelal, who had migrated to France in 1953, disappeared during the artist's mother's pregnancy. Although Boudjelal's maternal French grandparents formally recognized his birth, giving him the French name Bruno and their own family name, Sombret, he was placed, at the insistence of his grandfather, in a home for illegitimate children the day after he was born. Boudjelal writes: 'J'étais cette faute trop lourde à assumer. J'étais à peine né et je venais d'être abandonné deux fois, par mon père et par ma mère et sa famille qui ne pouvaient pas m'accepter chez eux'.[4] The child – an outsider, a foreign

1. Stuart Hall, 'Cultural Identity and Diaspora', in *Identity: Community, Culture and Difference*, ed. by J. Rutherford (London: Lawrence and Wishart, 1990), pp. 222–37 (p. 225). I am grateful to Martin Elms for drawing my attention to Hall's text and its relevance to the questions explored here.

2. Barbara Mella, 'Derrida's Detour', *Reconstruction*, 2:4 (2002) < http://reconstruction. eserver.org/024/mella.htm> [accessed 13 July 2013].

3. Nebia Bendjebbour writes: '[en 1961] le conflit s'est transporté en métropole. Si le principe de l'indépendance était acquis, [...] la cohabitation entre les deux communautés est extrêmement tendue. Attentats, assassinats à la fois d'indépendantistes algériens et de policiers se multiplient', '17 octobre 1961: une nuit noire à Paris', *Le Nouvel Observateur* (16 October 2011) < http://tempsreel.nouvelobs.com/monde/20111016.OBS2564/17-octobre-1961-une-nuit-noire-a-paris.html> [accessed 17 June 2013].

4. Bruno Boudjelal, *Disquiet Days/Jours intranquilles* (London: Autograph, 2009), no pagination. Henceforth, all references to this work are abbreviated as *JI* and inserted parenthetically in the text.

body unwelcome in the home – represented at once a flaw, a sin and a stain; an apposite and painful symbol of the 'troubling proximities'[5] that threatened the integrity of the French family.

Jours intranquilles represents, in many ways, Boudjelal's failed attempt to forge a relationship with his father, in whom he recognizes (in the first instance, at least) a shared sense of homelessness and enforced amnesia.

> Pour sa nouvelle vie en France, il [Lemaouche] a décidé de tout renier. Il lui a fallu plus de quarante ans pour se créer sa nouvelle vie, sa nouvelle identité. [...] Avec le recul, je crois que mes grands-parents français ont tout fait pour que mon père se sente coupable de ses origines algériennes. Ils ont fait de même pour moi, peut-être que lorsque mon père a décidé que je serais élevé par mes grands-parents, a-t-il pensé que cela serait mieux pour moi, un moyen d'effacer cette faute, ce nom... Et il est vrai qu'à partir du moment où j'ai vécu avec eux, tout a été fait pour me taire mes origines, rien ne devait transparaître. On a fait en sorte de me rendre amnésique. (*JI*)

Born in 'l'Algérie française', Lemaouche Boudjelal was entitled by French law to claim *réintégration* and naturalization. He was also offered the opportunity as part of this process – although it was not a pre-requisite – to choose a French name.[6] By the time he returned to Montreuil some years after his son's birth and married Boudjelal's mother (the couple also went on to reclaim their son), he had assumed the name Jean-Claude and had fostered – or, at least, done little to counter – the assumption amongst his friends that he was of Italian origin. In this attempt to (re-)construct himself in the French present, he sought to foreclose the guilt of his own foreignness. It was only in 1981, when Boudjelal obtained a copy of his birth certificate in order to apply for a passport, that he became aware of his family's 'Algerian secret'.

Boudjelal made his first journey to Algeria in 1993, precisely forty years after his father migrated to France, thereby imbuing the project with a ritual, anamnestic quality:

> *Jours intranquilles* est avant tout une histoire personnelle. Tout ce travail a été dicté par une nécessité de comprendre qui j'étais, de quoi j'étais fait et d'où je venais. Ce travail a été motivé par mon désir de retrouver ma famille, d'essayer de comprendre ce qu'était l'Algérie, essayer de démêler les choses là-bas pour pouvoir avancer

5. Bruno Boudjelal, 'Bruno Boudjelal: Algeria, Troubling Proximities', interview with The Leica Camera Blog (26 February 2013) < http://blog.leica-camera.com/photographers/interviews/bruno-boudjelal-algeria-troubling-proximities/ > [accessed 23 August 2013].

6. The formal *francisation* of name and family name is still offered to those granted nationality by the French authorities.

dans ma vie en France. C'est parallèlement à ces sentiments que la photographie
s'est mise en place.[7]

Both father and son had experienced (or been made to experience) their
algérianité as a sin or stain, which – if it could not be wholly expiated – had at all
costs to be masked and disavowed through a series of complex recantations.
However, it is clear from the quotation above that the memory work and recovery
represented by the journey are future-oriented, rather than nostalgic or restorative.
Inasmuch as Boudjelal's journey – which is contemporaneous with his artistic
practice – is articulated as a 'return' to Algeria, born of a desire to recover or
connect with that hitherto occluded 'Algerian part' of him, it is equally performed
as a physical, cognitive and creative *dépaysement* that will enable him eventually
to return to a home – understood both in its literal meaning and as a stable
cultural or personal identity – that has been destabilized and de-structured by the
trauma caused by the knowledge of his occluded origins.

Jours intranquilles is framed by the two occasions on which Lemaouche
Boudjelal abandons his son: first, when the latter is still in his mother's womb and
secondly, when a journey they make together to Algeria in 1997 ends with the
artist being temporarily detained at the Houari Boumediene airport, as officials
authorizing their exit visas suspect him of evading military service. Boudjelal
remembers how his frightened father walked quickly away and without a
backward glance, abandoning him to his fate. During their journeys together,
Boudjelal learns from family members of his father's refusal to fight in the war of
independence and also of his uncle's death at the hands of the colonial French
army. In one of his notebooks, reproduced in *Jours intranquilles*, Boudjelal
painted a thick, white totemic mask over a photograph of his father, entirely
obliterating his face and leaving only two dark holes for his invisible eyes. The
image clearly gestures to the 1952 work *Peau noire, masques blancs* by Frantz
Fanon (whose life Boudjelal explored in a commissioned work in 2013) and
might be seen as pointing to an act of betrayal or identification with the colonial
oppressor. However, we can also see in the deliberate brushstrokes that deface/
efface his father's image the enactment of a violent gesture of dis-identification
and erasure, prompted by an ambivalence that Judith Butler has described in
another context as 'the uneasy sense of standing under a sign to which one does
and does not belong'.[8] The father Boudjelal had sought to recover is lost anew

7. Bruno Boudjelal, 'Bruno Boudjelal: Images Singulières est un festival de convictions',
 interview with Roxana Traista (undated) < http://www.photographie.com/news/bruno-
 boudjelal-imagesingulieres-est-un-festival-de-convictions> [accessed 19 June 2013].
8. Judith Butler, *Bodies that Matter: On the Discursive Limits of "Sex"* (London
 and New York: Routledge, 1993), p. 219. Quoted in Jonathan Dean, '"The lady doth
 protest too much": Theorising Disidentification in Contemporary Gender Politics',

and repudiated by the artist in a deliberate gesture of self-sculpting. The chiastic symmetry described at the beginning of *Jours intranquilles*, of the artist's journey to Algeria and his father's journey forty years previously to France, finally discloses (rather than closes) the abyss that separates them. Formally, the journeys made in different directions across the Mediterranean can be seen to produce a *chassé-croisé* – a crossing of paths, a failed encounter that un-works, rather than reinforces, the paternal bond.

Boudjelal's encounter with his Algerian family proves equally ambivalent. In the course of his first journey, he managed to trace some family members in El-Maouane, a small town near Sétif in north-eastern Algeria. Speaking no Arabic, his notebooks document his struggle to understand what is being said and the embarrassment caused by questions pertaining to his father (from whom his family have had no news for over four decades), his mother and his own French name. He is given photographs of his grandfather, Amar, by his aunt Nouara, who takes him to visit the ruined house that was once the family home and tells him, 'Tu nous a retrouvés et nous sommes à nouveau réunis!' (*JI*). However, it is clear from his diary extracts that Boudjelal does not experience a reciprocal sense of recovery, recognition and reconciliation (and indeed, as the narrative in *Jours intranquilles* attests, he is gradually drawn away from the essentialist focus of family ties towards the work and world of the activists and intellectuals he meets in the course of his journeys). The final diary entry for this journey, dated 8 June 1993, reads:

> C'est le dernier soir que j'écris dans ce carnet. Je ne reviendrai jamais en Algérie, je le sens. Pourtant je n'ai rien osé dire à ma tante, mes cousines, mes cousins. Ce voyage a été trop difficile pour moi, il m'a obligé à plonger beaucoup trop profondément en moi-même pour trouver l'énergie de surmonter toute cette adversité. Je pensais en allant en Algérie trouver des réponses, ce sont toutes mes certitudes qui ont volé en éclats. (*JI*)

Boudjelal's journey to Algeria can be seen in the above quotation as the scene of a radical unhoming, in which the artist's epistemological and ethical certainties are shaken and his physical and psychological integrity threatened. The scene of arrival is suspended in purgatorial chaos.

Indeed, from the outset, Algeria proves elusive and resistant to incorporation in Boudjelal's protean narrative of return. When he arrives in Algiers for the first time on 3 May 1993, he is immediately cast into an unfamiliar and frightening Algerian present, the violence and quotidian exigencies of which thwart any sense of 'homecoming'. In his diary, he describes how, on his first day, he is knocked to the ground and aggressively searched by two 'ninjas' (the masked special forces

IDA World, 24 (2008) < http://www.essex.ac.uk/idaworld/paper240708.pdf > [accessed 30 June 2013].

who became a common sight in the streets of Algerian cities in the 1990s), then later attacked by a group of young men who attempt to steal his belongings in the Casbah. The police officers who arrive to help him drive him to an unspecified police station located some kilometres outside the city, where he hears what he believes to be the sound of prisoners being tortured. He realizes that he has no obvious means of contacting his family, as his father provided him with only the sketchiest of details before his departure, and he is alone in a country which, as Martin Evans and John Phillips observe, had, by 1993, tipped 'over into the abyss'.[9] On 4 May 1993, he writes in his diary:

> J'essaie de me poser et de réfléchir. J'ai l'impression que ces deux jours m'ont fait voler en éclats. Je dois tenter de me reconstruire, je n'ai jamais été confronté à une telle violence, tout me semble chaotique. Je ne sais pas quoi faire. Dois-je rentrer comme tout le monde semble me le suggérer? Et puis, rester pourquoi? La famille? Mon seul indice est le nom d'un lieu griffonné sur un bout de papier. Continuer à photographier? Je n'ose même plus sortir mon appareil.
> [...]
> Je n'ai qu'une seule idée en tête: fuir, partir, quitter ce lieu, cette ville, ce pays maudit. (*JI*)

Caught in the irresolution of the present tense, punctuated with urgent questions, the texture of the language in this extract is testimony to the shattering effect of the incomprehensible 'hyperviolence'[10] that met Boudjelal on his arrival and which, he would go on to realize, structured and subtended daily life in Algeria during the 1990s, a time which has come to be known as the black decade.

Photographing the Dirty War

Between 1991 and 2002, Algeria was wracked by a dirty war that had been sparked by the cancellation by the Algerian military of the second round of legislative elections in 1991, following the majority vote secured in the first round by the *Front Islamique du Salut* (FIS). Scholars have contested the aptness of the term 'civil war' to describe the opacity of a conflict in which

> it is not just identities that changed or shifted (e.g. soldiers, insurgents becoming pro-government militias) but their identities could be hybrid and manifold (police

9. Martin Evans and John Phillips, *Algeria: Anger of the Dispossessed* (New Haven and London: Yale University Press, 2007), p. 185. Benjamin Stora also observes: 'L'année 1993 apparaît vraiment comme celle de l'embrasement', *La Guerre invisible: Algérie, années 1990* (Paris: Presses de Sciences Po, 2001), p. 20.
10. Akram Belkaïd-Ellyas and Jean-Pierre Peyroulou, *L'Algérie en guerre civile* (Paris: Calmann-Lévy, 2002), p. 39.

by day, soldiers by night). This is further complicated, in the Algerian case, by the fact that identities were often deliberately obscured.[11]

The complexity of the conflict was scarcely masked by 'the official script of the "good army" versus the "evil terrorists" '.[12] The Algerian state was certainly involved in the large number of forced disappearances – estimated by Amnesty International to be around 7,000[13] – in the 1990s, and it is largely accepted that the army was complicit in the massacres in the Mitidja plain and elsewhere (most notably in the town of Bentalha), if not a direct participant.[14] According to Evans and Phillips, the Algerian state authorities clearly 'exploited the generalized violence as a smokescreen to settle accounts',[15] initiating and participating in atrocities, which they strategically attributed to the Islamists. Stora describes the conflict as a 'guerre sans front, sans visages',[16] the opacity of which was reinforced and institutionalized by Bouteflika in his 2002 civil concord. As Evans and Phillips note:

> truth and justice had to be sacrificed. [...] Amnesia was the order of the day [...]. So, despite pledges to Amnesty International, nobody was brought to account for violence inflicted on the population. The government displayed no concern for the families of the victims and the disappeared and this indifference provoked a growing sense of anger from below.[17]

It is important for us to retain and develop a sense of this complex opacity in order to understand how it is negotiated by Boudjelal in his photographic works, which constitute some of the few made during 'the black decade', which Stora has compellingly argued was characterized by '[l']absence d'images et la crise des représentations'.[18] Following the exodus of many Algerian writers, artists and intellectuals to Europe and the USA, and the departure of international news

11. Jacob Mundy, 'Deconstructing Civil Wars: Beyond the New Wars Debate', *Security Dialogue*, 42:3 (2011), 279–95 (p. 288).

12. Evans and Phillips, *Algeria*, p. 240.

13. See Brian May, 'Les "Disparus" d'Algérie', *Amnesty International Belgique Francophone* (5 May 2003) < http://www.amnestyinternational.be/doc/s-informer/notre-magazine-le-fil/libertes-archives/les-anciens-numeros/394-Numero-de-mai-2003/Dossier, 367/article/les-disparus-d-algerie> [accessed 12 June 2013].

14. See the account of a survivor of the Bentalha massacre, Nesroulah Yous, *Qui a tué à Bentalha?* (Paris: La Découverte, 2000). See also the 'Envoyé spécial' TV documentary aired on France 2 on 23 September 1999, *Bentalha: autopsie d'un massacre*, dir. Jean-Baptiste Rivoire, Jean-Paul Billaut, Thierry Thuillier and Bruno Girodon.

15. Evans and Phillips, *Algeria*, p. 197.

16. Stora, *La Guerre invisible*, p. 60.

17. Evans and Phillips, *Algeria*, p. 263.

18. Stora, *La Guerre invisible*, p. 111.

bureaux, representation of the dirty war fell largely to the Algerian domestic media, who were subject to censorship laws and allowed to put forward only the sanctioned – and deeply contested – view of a Manichean dichotomy between state power and terrorist violence, and an international media apparatus concerned more with the circulation of shocking images of brutality than reflective interpretation or analysis. Stora notes how, in their focus on the spectacle of atrocity, French journalists constructed a misleading – and intensely ideological – continuity of barbarism between this dirty war and the Algerian war of independence, creating a '"mise en spectacle" televisuelle', 'à l'écart de tout "sens", hors de l'attraction lourde d'une histoire continue'.[19] Stora is thus compelled to observe how, 'dans les représentations de cette tragédie, se devine également toute l'impossibilité à montrer vraiment cette guerre'.[20]

Contributing to this impossibility of representation is the primordial difficulty of understanding a war that was played out 'dans des non-lieux, [une guerre qui] pénètre dans des entre-deux identitaires et architecturaux'.[21] The radical journalist and campaigner Salima Ghezali, in the essays he wrote to accompany *Jours intranquilles*, observes: 'Dès l'annonce de l'état de siège en juin 1991, le monde est redevenu flou. Comme avant l'indépendance, irrémédiablement flou' (*JI*). For Véronique Nahoum-Grappe, it was a matter of 'beaucoup de sang, peu de sens'.[22] The war did not present itself in battles; it was not fought openly between clearly divided and identifiable opponents. It was difficult, if not impossible, in the context of this shape-shifting war, played out within a regime of (in)visibility, to determine the larger picture or make sense of a broader whole.

Boudjelal's images in many ways render something of this 'guerre sans images', negotiating with and reflecting the conditions in which they were produced. The photographs taken during his first trip in 1993 are shot with grainy black and white film stock (Figure 1). There is an overwhelming sense of confinement and containment; most of the photographs are taken from inside the claustrophobic interiors of hotel rooms, tiny apartments or cars, with a very restricted field of view. Furthermore, they are frequently enclosed within multiple frames – windows, mirrors, windscreens and shutters. To an extent, the predominant conceptual and figurative space accorded to the framing of the images – the conditions in which they were taken, with difficulty and in fear – becomes the subject of the work, rather than the journey or the war. The play of shadows, darkness and motion blur, the mist and the rain further obscure

19. Ibid., p. 58.
20. Ibid., p. 113.
21. Belkaïd-Ellyas and Peyroulou, *L'Algérie en guerre civile*, p. 65.
22. Quoted in ibid., p. 43.

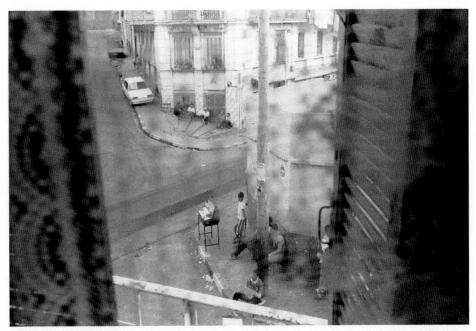

Figure 1. Bruno Boudjelal, Quartier de Bab-El-Oued, Alger (1993). Reproduced courtesy of the artist and Agence VU.

our vision and appear to endorse in literal fashion Philippe Sollers's observation in 1994 that the dirty war had imprisoned Algeria in '[une] nouvelle nuit, [un] nouveau brouillard'.[23] Even the expansive, empty roads, which Boudjelal photographs through the windscreen as he travels with his family under heavy and ominous skies appear as a threat and an obstacle, rather than an invitation to travel. The sense of enclosure is reinforced by the overwhelming proximity of his family members in the photographs, shot in extreme close-up, their faces blurred and just centimetres away from his lens. The camera registers the eye's confusion, causing a *détournement* of what Amy Hubbell has described as the 'repossessive gaze'[24] that frequently characterizes narratives of return. The shots lack composition and focus, rendering the shock of Boudjelal's encounter with a moving, bewildering and proximal world that refuses to stand still as he photographs it, breaching the distance that affords cognition.

Boudjelal's photographs also reflect the protective interiority he, like many others in this period, sought in the 'cocon familial' (*JI*), although his is

23. Philippe Sollers, 'Nouvelle nuit, nouveau brouillard', in *Les Disparitions*, ed. by Amnesty International (Paris: Amnesty International, 1994), pp. 9–16.

24. Amy Hubbell, 'Looking Back: Deconstructing Postcolonial Blindness in Nostalgérie', *CELAAN*, 3:1–2 (2004), 85–95 (p. 86).

an awkward encounter born of the dangerous exigencies of the dirty war. A series of family portraits are for the most part taken in domestic spaces and recount, obliquely, the meetings between his father and his extended family in Sétif. In their claustrophobic interiority, which I suggest must be read as a metonymical sign of the conditions of their production, rather than an object of representation, the photographs operate as an index of quotidian existence in the reality of the dirty war. An inscription of the effects of war, they distance themselves from the spectacle of power and atrocity, rendering instead something of the enclosure and impasse that came to typify life in Algeria during the 1990s. There are no images of executions or assassinations; the apparatus and physical engagements of war are absent in his work. Instead, by focusing on the embodied resonance of violence and fear, Boudjelal better describes a reality that was governed by a conflict at once pervasive and tangible but difficult to attribute or define.

Post-traumatic Landscapes

Boudjelal's second visit to Algeria was with his father in 1997, the year in which a series of massacres took place in the villages and suburbs of the Mitidja plain, most notably in Bentalha, when 400 people were killed on the night of 22–3 September. Nesroulah Yous, a survivor of the massacre, questions in his 2000 testimony, *Qui a tué à Bentalha?* (which was banned in Algeria), who the perpetrators were,[25] despite the fact that the GIA claimed responsibility for the massacre in a press release issued from London three days later. A debate still rages regarding the military's involvement, particularly given the proximity of local army barracks and the troops' apparent refusal to intervene or respond to calls from the townspeople for assistance. For five years, Boudjelal considered visiting the site of the massacre but stayed away, 'par manque de courage ou de peur de ne pas trop savoir quoi y faire' (*JI*). In 2002, his friend Dahmane drove him there without prior warning:

> Le ciel était gris et menaçant. J'étais nerveux. Soudain je vois le panneau 'Bentalha'. Je fais quelques photos à travers le pare-brise. Nous roulons dans le quartier où s'est produit le massacre. Le temps me semble suspendu et les gens comme figés. Dahmane me propose de me rendre dans une de ces maisons où ils ont massacré des personnes. [. . .] On ne semble même pas nous remarquer: cette femme assise dehors, cette fillette jouant derrière cette porte ou des hommes endormis par terre. Nous entrons dans la cour où ils ont égorgé neuf personnes... [. . .] En rentrant sur Alger, je pris conscience que nous n'étions restés qu'une vingtaine de minutes et que j'avais fait une quinzaine d'images, sans même cadrer et réfléchir. De retour en France, pendant longtemps je me demandais si le sentiment d'avoir été 'au cœur des ténèbres' était le fruit de mon imagination ou non. Et c'est bien plus tard,

25. Nesroulah Yous, *Qui a tué à Bentalha?* (Paris: La Découverte, 2000).

en développant le film de Bentalha, que je compris que les choses que j'avais
ressenties existaient bel et bien. (*JI*)

Boudjelal's journey to Bentalha is again a detour, an unplanned deviation which
takes him to a site where – unlike the documentary photographer or photo-
journalist – he is unsure what to do, which visual information to look for or
capture. He arrives too late, in the aftermath.

The massacre presents itself obliquely, in the gestures, poses and demeanour of
those who remain; in the stubborn residues that are produced by, survive and
encircle it and in the inscrutable – though for this no less resonant –
reconfiguration of the everyday that attends what we might describe as post-
traumatic landscapes. Boudjelal's photographs show Bentalha as a town much
like any of the others that cluster along the length and breadth of Algeria's poorly
maintained roads. Water and mud collect in the streets, which are full of potholes
and alternately dilapidated and half-built housing blocks. Pylons and power lines
punctuate a landscape dominated by an overwhelming sense of dirt and entropy,
as human constructions appear to slide back into the miasma from which they
have emerged. The interiors are basic and unadorned. There is little or no
furniture and only minimal traces of any human presence (for example an
abandoned pair of trainers or a mirror). A simple standpipe set against the wall
provides water; televisions are omnipresent.

And yet this apparent banality is punctured by a number of 'poignant
details' – I draw here on the vocabulary that coheres around Roland Barthes's
punctum[26] – or strange bodies that are at once meaningless and meaningful, and
which attest to the presence *within* the broader landscape of unincorporated
residues from the past. In one photograph (Figure 2), two fully clothed men sleep
on a rug on a bare floor, using their rucksacks as pillows. They do not stir as
Boudjelal enters the room but remain indifferent to his presence. Nothing in the
image enables us to understand what their circumstances are, how or why they
have come to sleep here or indeed who they might be; and yet they articulate
some connection we cannot understand with Bentalha's past and the ways in
which that past continues to contaminate or make itself felt in the present. The
sleeping men are a kind of 'fistula', a term from the biological sciences meaning
'abnormal passageway' and which has been appropriated by the historian Eelco
Runia to describe 'holes through which the past discharges into the present',
'a kind of "leak" in time through which "presence" wells up from the past into the
present'.[27] Another photograph is filled entirely with an expanse of rough
concrete floor, stained with brown patches that may or may not be traces of blood.

26. See Roland Barthes, *La Chambre claire: note sur la photographie* (Paris: Cahiers du
 cinéma/Gallimard/Seuil, 1980).
27. Eelco Runia, 'Presence', *History and Theory*, 45 (2006), 1–29 (p. 16).

Figure 2. Bruno Boudjelal, Bentalha (2002). Reproduced courtesy of the artist and Agence VU.

The photograph evokes Jean Dubuffet's post-war *sols* paintings, both in terms of its textured abstraction and the way in which it draws the gaze into its irreducible detail, while at the same time resisting all totalising spectatorial appropriation. This is a fragment or detail that is at once complete in itself, yet which points also beyond its own frame to an experience that remains outside the cognitive range of the spectator.

The Post-traumatic and Post-production
The representation of sites like Bentalha and events such as the dirty war must negotiate an impossible path between both a surfeit and absence of meaning. The hermeneutic, semantic and affective network in which Bentalha is enmeshed and through which it discloses itself to Boudjelal in the aftermath of the massacre – *even if he cannot make immediate sense of what presents to him while he is there, in the midst of the (unclaimable) experience* – inevitably inflects the way in which the site signs to him and how he makes meaning of it. The very name – Bentalha – carries a powerfully resonant charge, functioning metonymically as a cipher for the worst atrocities of the dirty war and the state's (hidden and disavowed) involvement in attacks against its own citizens. And yet when Boudjelal visits Bentalha, what he discovers is an incarnated negative space

produced by what happened there and which now structures what remains as a potent presence in absence. Everything in Bentalha points to the event, yet the event itself remains a hole in cognition – a blind spot.

Michael Rothberg has written compellingly of what he calls the 'traumatic index', a sign produced causally by the event that is its referent, but which points back to this referent as an absence:

> Instead of indicating an object or phenomenon that caused it, and in that sense making the referent present, the traumatic index points to a necessary absence. [The traumatic detail] does not embody the real but evokes it as a felt lack, as the startling impact of that which cannot be known immediately.[28]

It is only after Boudjelal leaves Bentalha and prints the images he made there, that he is able to begin to (post-)process the affective response which dominated his encounter with the site. In this way, he severs the photographic medium from the privileged contemporaneity with which it is traditionally associated. The photographs do not yield an unmediated encounter with Bentalha; nor do they perform a mnemonic function. Rather, they constitute another element or artefact of the aftermath, pointing to the traumatic event indirectly in their own materiality – in other words, by foregrounding or reflecting the conditions and determinants of their own production within the post-traumatic scene (and thereby effecting a *détournement* of indexical/photographic 'authenticity', as this is traditionally understood). In this sense, they too are oblique signs demanding interpretation. They exist, resolutely, in their own present, in which the past and future of Bentalha remain perpetually at stake.

When he speaks of the traumatic index, Rothberg invokes the 'possibility of indirect reference through the self-conscious staging of the conundrum of representing historical reality' and draws this into a wider discussion concerning the challenges made by 'traumatic realist texts' to the narrative form of realism.[29] Although *Jours intranquilles* is presented in chronologically ordered sections, with explanatory textual prefaces, drawn from the artist's diaries and notebooks, framing each cluster of untitled photographs, pages from the artist's notebooks reproduced in facsimile at the beginning of *Jours intranquilles* display a more complex structure. Boudjelal purchased three notebooks in Ghana in 2007 and has to date filled two of them with images, texts and other artefacts (both found and made) relating to his Algerian journeys. As *ex post facto* artefacts, they reflect the artist's re-working of the raw data of his experience and the changing shape of that experience as it is reviewed and revisited over time. The visual and textual

28. Michael Rothberg, *Traumatic Realism: The Demands of Holocaust Representation* (Minneapolis: University of Minnesota Press, 2000), p. 104.

29. Ibid.

artefacts are excised from the teleological frame one might expect of a return narrative, and re-constellated through Boudjelal's use of techniques such as collage and alteration, in novel networks and narratives of meaning. For Walter Benjamin (summarized here by Rothberg), the constellation – 'a sort of montage in which diverse elements are brought together through the act of writing – is meant to emphasize the importance of representation in the interpretation of history'.[30] It is precisely this work of interpretation that demonstrates Boudjelal's active engagement with a history in which he reflectively participates, rather than being passively positioned by it. 'Je suis à cheval entre petite et grande Histoire', he observes in an interview in 2010.[31] But more important than this recognition of the convoluted intersection between his own life and the broader historical relation between France and Algeria is his developing (and future-oriented) awareness of the political stakes of contemporary Algeria and the role he might play, within a community of intellectuals and activists, in disrupting – or refusing to take part in a visual economy that is played out not only at the level of the media but also that of the nascent (yet powerful and largely state-controlled) art institution in Algeria. 'Plus j'y vais, plus ça me radicalise dans mon opposition', Boudjelal stated in 2013.[32] Rather than any recovered sense of *algérianité*, Boudjelal's practice has been shaped, in terms of both the production and dissemination of his work, by his sustained commitment to the estrangement of vision and, more explicitly, a refusal to attenuate his critical voice for the purposes of being admitted to an institution overseen by a government whose legitimacy he contests.

The sense Boudjelal has of practising within a broader political landscape is reflected in the dynamic, relational construction of his own identity, a plastic and multidirectional entity – both malleable and resistive – that we see him *working* in the pages of his notebooks as the journeys he makes cause him to deviate from any linear, retrogressive search for the origins of selfhood or stable points of filiation. If *Jours intranquilles* opens with his failure to complete a journey across Algeria, from east to west, due to the dangers posed by the escalating conflict, it closes with Boudjelal arriving finally at the Moroccan border, yet with no sense at all that he has in fact arrived, or that the circle has been closed. As Martin Heidegger writes in 'Existence and Being' the foreword to *Being and Time* (1949), 'even with his arrival, the returning one has not yet reached home'.[33]

30. Ibid., p. 10.
31. Marian Nur Goni, 'Bruno Boudjelal: de la photographie en mouvement', interview with Bruno Boudjelal (January 2010) < http://www.africultures.com/php/?nav=article&no= 9578> [accessed 12 June 2013].
32. Bruno Boudjelal, Skype interview with the author, 23 April 2013.
33. Quoted in Mella, 'Derrida's Detour'.

This paper has presented *Jours intranquilles* as a complex account of loss and of Boudjelal's search for new forms of stability following the traumatic disclosure of his fractured family history and the discovery of his own Algerian origins. Rather than discovering any healing sense of recovery, recognition or reconnection, his early journeys to Algeria induce instead disorientation, loss, dispersal and fragmentation. Equally, the photographs he makes during these journeys, in their opacity and interiority, ostensibly 'fail' to represent the dirty war that frames his personal experience of the country in which his father was born. And yet, these 'failures' are transformed into a detour that will have creative, ethical and political valence for Boudjelal in terms of disrupting normative perceptions of the primacy of filial or national relations, and what constitutes also the indexical 'authenticity' of the photographic image. The detour thereby functions as a kind of creative estrangement, in which a space is opened up both for political agency and subjectivation, and a reappraisal of what constitutes the 'real' in a context where the real is a construct manipulated for ideological reasons by means of censorship and spectacle. Creative practice, political agency (in the sense of an active interpretive engagement with and attention to the enfoldedness of past, present and future) and autopoeisis are articulated and performed through the obliquity and resistance of a plastic present, in which the stakes of the past and future are perpetually (re)negotiated.

Nottingham French Studies 53.2 (2014): 216–231
DOI: 10.3366/nfs.2014.0087
© University of Nottingham
www.euppublishing.com/nfs

DE LA « NOTATION » À LA « FICTIONALISATION » DE LA VIE: PANORAMA DES TENDANCES PHOTOBIOGRAPHIQUES DANS LA LITTÉRATURE FRANÇAISE DES ANNÉES 1970 À NOS JOURS

FABIEN ARRIBERT-NARCE

Comme de nombreux travaux critiques l'ont récemment montré, le recours à la photographie s'est progressivement imposé comme l'un des principaux vecteurs d'innovation formelle et esthétique dans la littérature des vingtième et vingt-et-unième siècles[1]. Ce phénomène, que l'on peut situer dans le cadre plus large d'un véritable tournant visuel (ou *visual turn*) contemporain, est à la fois transnational – que l'on songe par exemple aux œuvres d'auteurs mondialement reconnus comme W.G. Sebald, Robert Frank, Daniel Mendelsohn ou Orhan Pamuk, parmi tant d'autres – et transgénérique, concernant aussi bien les champs du roman, de l'essai, de la poésie, du reportage que des écrits personnels (*life writing*), cette liste n'étant aucunement exhaustive. Dans ces derniers, qui retiendront plus particulièrement mon attention dans cet article, l'image photographique a également été utilisée dans des contextes et configurations fort variés allant du récit de vie traditionnel au journal intime en passant par l'autofiction et l'album de photographies légendé (ces structures pouvant d'ailleurs se superposer dans les limites d'un même volume) – là encore, il s'agit d'une liste ouverte qui nécessiterait d'être complétée. Afin d'esquisser un rapide panorama reflétant cette grande diversité, on peut par exemple citer ici les noms de Georges Perec, Alix Cléo Roubaud, Hervé Guibert, Marguerite Duras, Hélène Cixous, Hubert Lucot, Anne Brochet, Christian Boltanski ou encore Sophie Calle, chacun de ces auteurs occupant une place singulière dans le spectre

1. On peut entre autres citer ici les ouvrages suivants: Philippe Ortel, *La Littérature à l'ère de la photographie: enquête sur une révolution invisible* (Nîmes: Chambon, 2002); Daniel Grojnowski, *Photographie et langage* (Paris: Corti, 2002); Jérôme Thélot, *Les Inventions littéraires de la photographie* (Paris: Presses Universitaires de France, 2003).

des écrits de vie avec photos post-1945 (de langue française)[2]. Ce corpus d'œuvres de plus en plus fourni se compose ainsi de travaux d'artistes, de photographes et d'écrivains, et englobe logiquement différents types d'utilisation de la photo, qu'elle soit effectivement reproduite ou non dans le corps du livre, extraite d'archives personnelles ou seulement imaginée, furtivement évoquée ou décrite en détail, contemplée avec fascination ou méticuleusement analysée – sans parler des innombrables manières de la combiner au texte.

Comme le titre de cet article le suggère, je propose d'utiliser le terme de « photobiographie » – apparu en France dans les années 1980[3] – pour qualifier l'ensemble de ces assemblages phototextuels qui constituent donc un genre ou sous-genre littéraire réunissant tous les ouvrages ayant un projet autobiographique manifeste et recourant d'une façon ou d'une autre à l'image photographique; ce néologisme me paraît en effet bien correspondre au type d'œuvres concerné, et a en outre été relativement peu utilisé à ce jour dans le monde critique et universitaire, conservant par conséquent une certaine neutralité conceptuelle. Si l'on suit la définition assez générale et flexible que je viens d'en donner, on peut sans doute faire remonter les origines du genre au moins jusqu'aux phototextes d'André Breton des années 1920 et 1930, à savoir *Nadja* (1928), *Les Vases communicants* (1932) et *L'Amour fou* (1936) – même si la photobiographie a véritablement pris son essor en France à partir des années 1970 avec par exemple la publication par Barthes du *Roland Barthes par Roland Barthes* (1975) et de *La Chambre claire* (1980) qui ont eu beaucoup d'influence sur les contemporains, et qui ont marqué un tournant en renouvelant l'approche de l'écriture de soi et de la représentation du moi. Cette récente montée en puissance, qui a eu pour toile de fond plusieurs tendances et évolutions lourdes dans le monde des arts et des lettres et la société – dont entre autres l'émergence des paradigmes contemporains de « l'archive » et du « quotidien », le développement du livre d'art (ou illustré) ou encore l'apparition de nouvelles technologies comme le numérique –, n'a naturellement pas été uniforme et s'est faite en

2. Pour un tour d'horizon plus complet du genre photobiographique (en langue française) des origines jusqu'à nos jours, voir en particulier les études suivantes: *Traces photographiques, traces autobiographiques*, éd. par Danièle Méaux et Jean-Bernard Vray (Saint-Étienne: Publications de l'Université de Saint-Étienne, 2004); Magali Nachtergael, *Les Mythologies individuelles: récit de soi et photographie au 20ᵉ siècle* (Amsterdam: Rodopi, 2012); *Textual and Visual Selves: Photography, Film, and Comic Art in French Autobiography*, éd. par Natalie Edwards, Amy L. Hubbell et Ann Miller (Lincoln: The University of Nebraska Press, 2011).

3. Gilles Mora et Claude Nori ont été – à ma connaissance – les premiers à utiliser ce néologisme dans *L'Été dernier: manifeste photobiographique* (Paris: Éditions de l'Étoile, 1983), mais aussi dans plusieurs numéros des *Cahiers de la photographie* qu'ils ont co-fondés en 1980 avec Bernard Plossu et Denis Roche.

suivant des voies différentes. À cet égard, il me semble que l'on peut schématiquement distinguer deux catégories ou tendances principales dans la photobiographie depuis le tournant des années 1970 jusqu'à nos jours, à savoir une tendance que je nommerais à la suite du Barthes des Cours au Collège de France une « écriture de notation de la vie » (1978), utilisant la photo comme un moyen (à la fois technique mais également métaphorique) de capter la matière autobiographique aussi objectivement que possible, en s'en tenant aux faits, et à l'inverse, une tendance fictionalisante, insistant bien plutôt sur le jeu identitaire et la mise en scène dans toutes ses formes. Ces deux orientations, que je m'efforcerai de cerner et de présenter dans cet article en m'appuyant sur un ensemble de projets photobiographiques à mes yeux emblématiques, incarnent en fait deux démarches et deux éthiques autobiographiques bien distinctes, et dont l'écart même signale d'une certaine façon l'éclatement de ce genre littéraire en remettant par exemple en cause de diverses manières la célèbre définition de l'autobiographie proposée par Philippe Lejeune dans son *Pacte autobiographique* publié en 1975: « récit rétrospectif en prose qu'une personne réelle fait de sa propre existence, lorsqu'elle met l'accent sur sa vie individuelle, en particulier sur l'histoire de sa personnalité »[4]. Ainsi, l'écriture de notation de la vie remet notamment en question la dimension rétrospective évoquée dans cette définition dans la mesure où elle vise, comme la photo, à saisir le présent (le vivant) sur le vif, alors que l'autobiographie considère habituellement le passé *a posteriori* (et comme étant déjà passé, tandis que l'archive photographique, la *note* constituent des documents renseignant sur le passé mais ayant été *écrits* sur un mode instantané). Comme nous le verrons, les auteurs suivant une telle démarche ont également tendance à rejeter le récit auquel ils reprochent de reconstituer, de recomposer la réalité passée après coup au lieu de se contenter de rassembler des traces photobiographiques. Quant à la tendance fictionalisante dans ce genre littéraire, elle court-circuite le pacte référentiel qui constitue la clé de voûte de l'analyse lejeunienne, en se servant par exemple de la photo (réelle ou fictive) comme d'un support pour raconter toutes sortes d'histoires et en jouant volontiers avec la frontière séparant faits et fiction, réalité et légende; sans surprise, c'est alors souvent un pacte de lecture auto-fictionnel que l'on retrouve dans ce type d'œuvres. Comme on le voit, plus que le type d'images et la configuration formelle employés par le photobiographe, c'est donc bien plutôt son projet global et le mode d'utilisation de la photo auquel il décide de recourir qui doivent retenir notre attention ici, car c'est eux qui déterminent en fin de compte notre manière d'interagir avec l'œuvre photobiographique.

Précisons d'emblée qu'il ne s'agit bien évidemment pas de prétendre que tous les livres combinant d'une façon ou d'une autre autobiographie et photographie

4. Philippe Lejeune, *Le Pacte autobiographique* (Paris: Seuil, 1996), p. 14.

relèvent forcément de l'une ou l'autre de ces « catégories », entre lesquelles il existe d'ailleurs de nombreux recoupements et qui rompent *de facto* le binarisme primaire que mon analyse risquerait de constituer – sans compter que d'autres « tendances » peuvent très certainement être recensées. Mon intention est bien plutôt d'établir une cartographie générale permettant de mieux comprendre les lignes de fracture d'un genre singulier, en esquissant à grands traits des orientations importantes qui me paraissent être pertinentes pour situer un grand nombre de projets photobiographiques contemporains.

La photobiographie comme écriture de notation de la vie

À défaut de pouvoir être exhaustif dans cet article, je voudrais commencer par évoquer ici ce que j'ai appelé la tendance notationnelle de la photobiographie en me concentrant sur quelques exemples frappants qui me permettront d'identifier un certain nombre de caractéristiques et de traits convergents, à savoir: Barthes, incontournable dans ce contexte, J.M.G. Le Clézio, récent prix Nobel de littérature qui a confirmé avec *L'Africain* la popularisation du genre photobiographique, et enfin Denis Roche, figure essentielle et pourtant peu connue et étudiée[5]. Il me paraît en effet que ces auteurs ont en commun de se servir de l'image photographique à la fois comme d'un outil et d'un modèle de notation de la vie, celle-ci étant captée au moment même où elle se déroule, et les fragments de réel prélevés étant assemblés dans divers dispositifs intermédiaux que je souhaiterais maintenant présenter.

L'ayant déjà étudié plus en détail dans d'autres travaux interrogeant également son aspect photobiographique, je ne reviendrai que brièvement ici sur l'exemple de Barthes que l'on peut considérer à bien des égards comme un précurseur (à la fin des années 1970) du mode d'expression notationnel tant au niveau d'une certaine pratique d'écriture qu'à un niveau conceptuel et théorique[6] – et ce même s'il a utilisé la photo de manière plus conventionnelle et parodique dans le *Roland Barthes par Roland Barthes*, dont l'album liminaire déconstruit avant tout le mythe du roman familial, et n'est donc pas véritablement représentatif d'une écriture de notation[7]. Pour l'auteur de *La Chambre claire* et des Cours au Collège de France des années 1978–80 publiés en 2003 sous le titre *La Préparation du*

5. J'ai eu l'occasion d'étudier cette tendance de la photobiographie contemporaine en détail dans mon livre *Photobiographies: pour une écriture de notation de la vie (Roland Barthes, Denis Roche, Annie Ernaux)* (Paris: Honoré Champion, 2014).

6. Voir notamment les deux articles suivants: Fabien Arribert-Narce, « Roland Barthes's Photobiographies: Towards an "Exemption from Meaning" », *Colloquy*, 18 (2009), 238–53; « De la Photobiographie comme anti-récit (Roland Barthes, Denis Roche, Annie Ernaux) », dans *L'Autobiographie entre autres: écrire la vie aujourd'hui*, éd. par Fabien Arribert-Narce et Alain Ausoni (Oxford: Peter Lang, 2013), pp. 87–104.

7. Rappelons que l'album liminaire du *Roland Barthes par Roland Barthes* – qui n'en annonce pas moins une nouvelle tendance à venir dans l'œuvre de l'auteur – correspond

roman I et II, le modèle d'enregistrement photographique permet surtout d'éviter les écueils de l'autobiographie traditionnelle que sont pour lui la distorsion des faits vécus et l'enfermement dans une trame chronologique rigide et artificielle – qu'il a appelée « bio-chronographie »[8]. Ce modèle d'enregistrement (notationnel) photographique, il le pense en particulier par le biais d'un rapprochement avec le haïku japonais, forme poétique brève composée de trois vers de cinq, sept et cinq syllabes; ainsi peut-on lire dans *La Préparation du roman I*: « Ma proposition est que le haïku s'approche au plus près du noème de la photo: "ça a été" »[9]. Comme on le sait, ce « noème » sera fameusement repris dans *La Chambre claire*, le dernier livre publié du vivant de Barthes dans lequel il poursuit sa réflexion sur le sujet:

> on dit « développer une photo »; mais ce que l'action chimique développe, c'est l'indéveloppable, une essence (de blessure), ce qui ne peut se transformer, mais seulement se répéter [...]. Ceci rapproche la Photographie (certaines photographies) du Haïku. Car la notation d'un haïku, elle aussi, est indéveloppable: tout est donné, sans provoquer l'envie ou même la possibilité d'une expansion rhétorique. Dans les deux cas, on pourrait, on devrait parler d'une *immobilité vive*: liée à un détail (à un détonateur), une explosion fait une petite étoile à la vitre du texte ou de la photo.[10]

À travers cette comparaison, Barthes fixe les contours de l'écriture de vie qu'il désire et fantasme, c'est-à-dire une sorte de notation *dans l'absolu*, forcément fragmentaire et construite autour d'un ensemble de détails poignants, fulgurants (c'est pourquoi seules « certaines photographies » sont concernées: seules les images contenant des détails *remarquables* ou *punctum* sont associées au modèle notationnel, ce qui n'est par exemple pas le cas des clichés reproduits au début du *Roland Barthes par Roland Barthes*). Ce mode d'écriture a la particularité de ne pas être

> un acte de souvenir à la Proust, c'est-à-dire destiné à « retrouver » le Temps (perdu) *ensuite, après coup* [...], par l'action souveraine de la mémoire involontaire, mais au contraire: *trouver* (et non retrouver) le Temps *tout de suite, sur-le-champ*; le Temps est sauvé *tout de suite* = concomitance de la note (de l'écriture) et de l'incitation [...]. Donc une écriture (une philosophie) de l'instant.[11]

en fait à un impératif de la collection « Écrivains de toujours » alors dirigée au Seuil par Denis Roche qui a d'ailleurs été le commanditaire de ce projet.

8. Roland Barthes, *La Préparation du roman I et II: cours et séminaires au Collège de France (1978–1979 et 1979–1980)*, éd. par Nathalie Léger (Paris: Seuil/IMEC, 2003), p. 278.

9. Ibid., p. 115.

10. Roland Barthes, *La Chambre claire: note sur la photographie*, dans *Œuvres complètes*, 5 vols., dir. par Éric Marty (Paris: Seuil, 2002), pp. 785–892 (V, p. 828).

11. Barthes, *La Préparation du roman*, p. 85.

C'est dans cette perspective que Barthes oppose (toujours dans *La Préparation du roman I*) le registre temporel de l'aoriste – qu'il associe à la notation – à celui de l'autobiographie traditionnelle: « Parfait à la première personne = temps autobiographique par excellence → *Parfait*: le repère est le moment de l'énonciation ≠ *Aoriste*: le repère est le moment de l'événement »[12]. L'aoriste permet d'exprimer « quelque chose qui est restitué par la notation en produisant un effet de *"C'est ça!"* (= Tilt) », celui-ci – le Tilt – étant « évidemment anti-interprétatif: il bloque l'interprétation. Dire "Ah, la violette" signifie qu'il n'y a rien à dire de la violette: son être repousse l'adjectif »[13]. Ce dernier aspect est essentiel pour la réflexion que Barthes développe autour du haïku, de la photographie et de l'écriture de notation[14]: ce qu'il souhaite par dessus tout, c'est échapper dans le cadre de l'écrit de vie à l'auto-analyse, à toute forme de métalangage et méta-commentaire, quitte à se situer, même sur un mode utopique, en dehors du domaine de la signification (comme on le sait, le thème de « l'exemption de sens » est prédominant dans bon nombre de ses derniers textes). Ces *notes*, détails ou encore « biographèmes », ne prêtant pas à discussion à ses yeux, sont ainsi conçus par lui comme autant de « moments de vérité »:

> Je me le [le Roman] représente comme [...] une vaste et longue toile peinte d'illusions, de leurres, de choses inventées, de « faux » [...], ponctuée, clairsemée de Moments de vérité qui en sont la justification absolue [...]; quand je produis des *Notations*, elles sont toutes « vraies »: je ne mens jamais (je n'invente jamais), mais précisément je n'accède pas au Roman; le roman commencerait non au *faux*, mais quand on mêle sans prévenir le vrai et le faux [...]. En définitive, alors, la résistance au roman, l'impuissance au roman (à sa pratique) serait une résistance *morale*.[15]

On retrouve ici la ligne de partage éthique que j'évoquais plus tôt, décisive quant il s'agit de distinguer les différentes pratiques photobiographiques. Il me semble en effet que tous les auteurs qui s'inscrivent dans la lignée de cette écriture notationnelle barthésienne – même s'ils ne reprennent pas forcément à leur compte tous les paramètres du fantasme d'écriture de Barthes – ont recours à la photo (qu'il s'agisse de l'image produite ou du modèle d'enregistrement technique et graphique dans son ensemble, parfois convoqué de façon

12. Ibid., p. 118. On rejoint ici ce que j'évoquais dans mon introduction concernant la rupture qu'un certain nombre de photobiographes ont établie avec le récit rétrospectif auto-biographique précisément par l'intermédiaire de la photo ou du modèle photographique.

13. Ibid., pp. 86 et 125.

14. Cette réflexion tient à la fois d'une sorte de fantasme régressif (on peut par exemple lire dans *La Chambre claire*: « face à certaines photos, je me voulais sauvage, sans culture » [V, p. 794]) et d'une méditation sur le hors-sens, le hors-culture, trouvant à la fois sa source d'inspiration et sa justification dans le bouddhisme zen (du moins tel qu'il fut reçu et compris par Barthes).

15. Barthes, *La Préparation du roman*, p. 161.

métaphorique) pour rechercher une forme de vérité autobiographique; et suivant cette logique, ils partagent tous la fascination de l'auteur de *La Chambre claire* pour le référent photographique, pour la matérialité organique de l'objet qu'est en définitive une photo.

C'est par exemple le cas de Le Clézio dans *L'Africain* (2004), livre dans lequel il revient sur son enfance passée en partie en Afrique coloniale française avec ses parents et son frère – son père (« l'Africain » du titre) ayant été médecin dans plusieurs pays des empires français et anglais durant les années 1930 et 1940 – et dans lequel sont reproduites une quinzaine de photographies (en noir et blanc) provenant des archives personnelles de l'écrivain comme l'indique une note à la fin de l'ouvrage. À vrai dire, Le Clézio ne semble pas s'appuyer directement sur ces images pour construire son récit qui ne fait pas clairement référence à elles et ne les commentent pas véritablement – leur présence dans le livre est du reste liée à un impératif de la collection « Traits et portraits » dans laquelle il est publié (au Mercure de France); elles n'ont ainsi dans la plupart des cas pas de lien évident avec les textes qui les accompagnent et les entourent, et leurs légendes (lapidaires et factuelles) ne sont données qu'à la fin du volume, ce qui évite de les réduire à une simple fonction illustrative[16]. Pour autant, ces clichés qui ont tous été pris par son père lorsqu'il séjournait en Afrique sont quasiment les seules traces restantes (en dehors des carnets retrouvés et des souvenirs racontés) rattachant ce dernier à l'auteur, dont l'un des buts principaux est précisément de retracer la vie de cette figure centrale et pourtant fondamentalement absente dans sa propre existence, et qu'il estime donc mal connaître – on comprend ici pourquoi ce livre-portrait oscille volontiers entre biographie et autobiographie. La seule présence de ces photos, qui sont justement des traces de présence et sur lesquelles « paraissent la solitude, l'abandon, l'impression d'avoir touché à la rive la plus lointaine du monde », permet dès lors à Le Clézio d'établir une forme d'interaction, un échange avec celui qui a toujours été pour lui un étranger (« l'Africain »), et avec lequel il a entretenu des rapports distendus[17]; on peut d'ailleurs remarquer qu'aucune représentation visuelle du père n'apparaît, les clichés reproduits ne montrant que des paysages et des habitants des contrées coloniales traversées, à l'exception de deux images sur lesquelles on aperçoit au loin la silhouette d'un homme blanc et en costume, flou et par conséquent impossible à identifier. Que ces deux photos représentent ou non le père de Le Clézio, le corpus iconographique choisi par ce dernier peut dans tous les cas être interprété comme une manière d'absenter « l'Africain » (ou plutôt de le ré-absenter), d'en faire une figure distante et énigmatique conforme à la place qu'il a occupée dans

16. On notera que certaines photos sont bien évoquées et parfois même décrites dans le texte, mais qu'elles ne sont alors pas montrées: Le Clézio a donc sciemment évité toute redondance entre textes et images dans le livre.

17. J.M.G. Le Clézio, *L'Africain* (Paris: Mercure de France, 2004), p. 51.

la vie de l'auteur qui le conçoit comme un objet en perpétuelle fuite; le fait d'avoir d'une certaine façon évacué son visage – qui est le grand absent du livre – revient également à le réduire à un stéréotype, celui du médecin colonial, derrière lequel il est bien difficile de discerner des traits individuels, idiosyncrasiques. On peut aussi considérer qu'il s'agit là d'un moyen de rendre hommage et justice à l'aventurier qu'a été son père, en suggérant que ce sont avant tout les territoires découverts et les hommes rencontrés qui ont compté pour cet explorateur – c'est sans doute ce que signale la carte géographique reproduite au seuil de l'ouvrage.

Les images d'archive insérées dans *L'Africain* jouent donc un rôle crucial, et ce à plus d'un titre, en ayant une incidence concrète sur la réception de l'œuvre, et en revêtant plus particulièrement une valeur symbolique. D'une part, elles prennent le contrepied des grandes épopées dynastiques, du culte du souvenir et des photos de famille qui sont au cœur d'un grand nombre de récits autobiographiques traditionnels, mais elles contribuent en outre à former le cadre du texte, à créer une atmosphère particulière propre aux terres coloniales lointaines, mystérieuses, et qui imprègne la lecture tout en offrant un support à l'imaginaire – sachant que ce livre cherche à la fois à dire le mystère et à le combler autant que possible en rassemblant les faits connus sur l'existence du père en Afrique. À cet égard, il est à noter que le traitement neutre de ces photographies par Le Clézio – qui, comme nous l'avons vu, ne les exploite pas *textuellement* – tient à distance leur charge d'exotisme en ne cherchant pas à créer un quelconque effet de carte postale, à *légender* à partir d'elles; c'est leur valeur documentaire qui est ainsi mise en avant, et elles contrebalancent en quelque sorte l'aspect légendaire des souvenirs d'enfance de l'écrivain qu'il mêle dans son texte à des évocations plus factuelles de la vie quotidienne de sa famille en Afrique.

Cette volonté de tenir à l'écart la dimension mythique voire exotique susceptible de se rattacher à la photographie se retrouve également dans l'œuvre photobiographique de Roche, ce dernier ayant toutefois la spécificité de ne pas être seulement un homme de lettres mais aussi un praticien de l'image. En effet, la photobiographie telle que la conçoit Roche consiste fondamentalement à recueillir des éclats de la (sa) vie telle qu'elle s'écrit, c'est-à-dire à accumuler des traces matérielles d'existence – qu'il appelle des « antéfixes » – qui peuvent être aussi bien des photographies (autoportraits ou autres, le plus souvent accompagnées de légendes minimalistes ne laissant pas de place au *légendaire*) que des extraits de lettres ou de journaux intimes, soit en d'autres termes des exemples d'écriture journalière qui font volontiers prévaloir une esthétique de la quotidienneté et de l'amateurisme (d'où, par exemple, le recours fréquent au déclencheur à retardement dans le travail photographique de Roche). Il s'agit plus précisément de « figurer le mode de vie et l'existence même d'un individu ou d'un couple » en rassemblant « tous les résidus écrits qu'on peut trouver chez une

personne, dans sa maison, dans ses tiroirs, dans ses livres, dans ses écrits ».[18] Au final, les dépôts (graphiques) de vie rochiens sont réunis dans divers livres hybrides – *Notre Antéfixe* (1978), *Dépôts de savoir et de technique* (1980), *La Disparition des lucioles* (1982), *Conversations avec le temps* (1985), *Photolalies* (1988) – et dans différentes formes d'agencements qui expriment une certaine densité temporelle et existentielle. Ces fragments ne sont cependant jamais l'objet d'une tentative d'interprétation ou d'analyse de la part de Roche qui refuse de les insérer dans la trame d'un récit leur faisant raconter une histoire (son histoire personnelle en l'occurrence).

C'est sans doute à cela que tient à la fois l'originalité et la radicalité du projet rochien qui s'efforce d'exploiter les caractéristiques propres à la photographie pour *écrire la vie*. Ces caractéristiques sont tout d'abord la mécanicité (de l'appareil) et la répétabilité, et de fait, Roche n'a de cesse dans son travail de mettre en scène la nature technologique du processus photographique, en insérant par exemple dans le champ de l'image un ou plusieurs appareils photos, procédé de dédoublement visuel qui est aussi un moyen de souligner la reproductibilité technique propre à ce type d'images. Cette logique est poussée à ses limites extrêmes dans un cliché pris en 1989 à Waterville, en Irlande (Figure 1), et qui selon Roche pourrait être qualifié d'« absolu », d'ultime[19]. L'appareil représenté obstrue en effet complètement le paysage, couvrant la moitié de la surface de la photo, et attirant irrésistiblement le regard du spectateur. Commentant ce cliché, Roche a insisté sur le décalage dans la ligne de ce qui est sans doute un poteau apparaissant dans le viseur de l'appareil exhibé. Cette légère déviation, dont il ne peut d'ailleurs expliquer la cause physique, incarne parfaitement pour lui la spécificité de la représentation photographique, qui de par son caractère mécanique en particulier, diffère de la perception du sujet humain[20]. Quant à son entreprise photobiographique, il ne peut donc s'agir que d'une représentation techniquement médiée et donc biaisée de sa propre existence.

L'autre caractéristique principale de la photo argentique – du moins d'après Roche – est la sérialité, chaque cliché n'étant autre qu'un fragment de temps, un instantané prélevé dans le continuum temporel, et étant par la nature du dispositif photographique répétable à l'infini, d'où le principe de la série: chaque cliché s'insère d'une manière ou d'une autre dans un arrangement sériel, qu'il s'agisse par exemple de plusieurs images tirées à partir du même négatif ou d'un album-photo représentant les membres d'une même famille. Pour Roche, considérer une

18. Denis Roche, *La Photographie est interminable: entretien avec Gilles Mora* (Paris: Seuil, 2007), pp. 11–12.

19. Ibid., p. 102.

20. Voir ibid., pp. 105–6.

Figure 1. Denis Roche, 21 juillet 1989, Waterville, Irlande, Butler Arms Hotel, chambre 208 (1989). © Denis Roche. Courtesy Galerie Le Réverbère, Lyon (France).

photographie comme une pièce unique, comme un tableau exposé dans un musée est une erreur et une illusion certes largement répandues, ce qui s'explique entre autres par les habitudes culturelles et l'ombre portée de la peinture qui a longtemps plané sur le photographique. Le projet rochien, qui fait écho aux principes historiques présentés par Walter Benjamin dans son essai sur *L'Œuvre d'art à l'ère de sa reproductibilité technique*, diffère sur ce point de la pratique photobiographique de Barthes bien qu'il partage son attachement au modèle d'une écriture notationnelle inspiré par la photographie.

Ce « modèle » aurait pu être illustré ici par de nombreux autres exemples, dont *W ou le souvenir d'enfance* (1975) de Perec, *Le Voile noir* (1992) d'Annie Duperey, *Les Champs d'honneur* (1990) de Jean Rouaud, *La Ferme du Garet* (1995) de Raymond Depardon, *Daewoo* (2004) de François Bon, ou encore *Écrire la vie* (2011) d'Annie Ernaux pour n'en citer que quelques-uns. Pour tous ces auteurs, la photographie possède avant tout une fonction documentaire et de reportage – et c'est précisément cette fonction qui est remise en question dans la seconde catégorie de photobiographies que j'ai qualifiée de fictionalisante dans mon introduction, et qu'il est maintenant temps d'examiner.

Les tendances fictionalisantes dans la photobiographie française

Cette catégorie ou tendance photobiographique consiste donc à utiliser la photo comme un outil fictionnel voire même autofictionnel, qu'elle soit ou non matériellement reproduite dans l'espace du livre. Dans le premier cas, quand les images ne sont que décrites ou mentionnées, on remarque qu'elles tendent à être employées comme de simples pré-textes (au sens littéral du terme, c'est-à-dire ce qui vient avant le texte), amorçant le processus d'écriture de soi. C'est par exemple ce que l'on constate dans *L'Image fantôme* (1981) de Guibert, livre que celui-ci a décrit comme une « tentative de biographie par la photographie »[21], et qui est construit à partir d'une série d'images – certaines virtuelles, d'autres existant véritablement – ayant toutes un lien plus ou moins direct avec l'histoire personnelle de l'auteur. Ce dernier, malgré sa qualité de photographe ayant exposé et publié son travail en diverses occasions, a cependant toujours entretenu un rapport ambivalent à son objet d'expression, entre attirance et phobie, et il va même jusqu'à évoquer avec insistance son « incapacité à prendre des photos » dans *L'Image fantôme*[22] – c'est ce qui explique en partie l'absence dans cet ouvrage de clichés effectivement reproduits, les images (décrites) étant dès lors réduites au statut de simples « négatifs », de « fantômes » (conformément au titre), dont la fonction principale est d'autoriser le développement du texte; celui-ci est précisément défini par Guibert comme étant « le désespoir de l'image, et pire qu'une image floue ou voilée: une image fantôme »[23]. Et d'ajouter: « le texte n'aurait pas été si l'image avait été prise. L'image serait devant moi, probablement encadrée, parfaite et fausse, irréelle »[24]. On comprend bien dans ces conditions que l'écrivain ne cherche pas à s'appuyer sur la photo pour se souvenir ou pour s'ancrer dans la réalité passée. Il s'agit au contraire pour lui de projeter ses désirs et de révéler ses attachements affectifs les plus importants via le medium photographique, en exposant notamment son « moi » par le biais de ses relations aux autres. L'absence des images, ou plutôt leur caractère virtuel, permet à Guibert de les faire passer par un filtre – le négatif du texte –, grâce auquel il peut réécrire une (son) histoire en fonction de ses fantasmes: il les redéveloppe en quelque sorte, en les piratant volontiers, c'est-à-dire en court-circuitant leur message manifeste, voire en leur ajoutant un supplément de sens. Il s'insurge en particulier contre les photos de famille qui sont toutes interchangeables, anecdotiques (« plates ») à ses yeux, et les réinvestit subjectivement en recherchant par exemple le sexe de sa mère dans une photo

21. Hervé Guibert, *L'Image fantôme* (Paris: Minuit, 1981), p. 124.
22. Ibid., p. 114.
23. Ibid., p. 17.
24. Ibid.

de vacances ou en imaginant une relation homosexuelle entre son père et son oncle à partir d'un autre cliché[25].

On retrouve un traitement similaire de la photographie dans *L'Amant* de Duras, texte autobiographique qui devait être à l'origine un album-photo familial commenté par l'auteure et dans lequel est plus particulièrement racontée l'histoire de sa relation passionnelle et tourmentée avec un riche amant chinois rencontré en Indochine, pays où Duras a passé toute son enfance. Dans ce livre, toutes les images ayant inspiré le projet ont là aussi finalement disparu; seules certaines sont décrites et jouent un rôle central dans l'économie de l'œuvre, à commencer par un cliché qui n'a en fait jamais été pris et dont l'écrivaine (ou plus exactement la narratrice) se rend compte qu'il est le plus cher à ses yeux, à savoir « l'image absolue » comme elle le désigne dans l'ouvrage, qui l'aurait représentée à l'âge de quinze ans et demi, sur un bac traversant le fleuve Mékong, juste avant sa première rencontre avec « l'amant »[26]. Tout le texte, caractérisé au niveau stylistique par une grande fragmentation et une prédominance du registre visuel signalant une écriture d'inspiration photographique, ne semble faire que développer le négatif de cette image absente qui joue en quelque sorte le rôle d'une métaphore, symbolisant le moment de la seconde naissance de Duras, son entrée dans l'âge adulte. En effet, ce qu'elle veut voir dans cette photo, qui n'est en fait rien d'autre qu'une image mentale, mémorielle, c'est la séparation d'avec sa mère et le début de son désir sexuel et de sa vie d'écrivaine. Au niveau du texte, cette photographie absolue, dont la description maintes fois reprise libère ce que l'auteure appelle « une écriture courante »[27], offre également un cadre dans lequel son histoire personnelle peut être racontée et ré-imaginée, recomposée. Comme l'a souligné Susan D. Cohen,

> [a]s such, a non-existent photograph becomes an agent of literature, the « absolute » of a memory not confined to a single representation. Memory of a « real » event – the river crossing – merges with imagination in a literary projection of what the writer says that snapshot would have reflected had it been made.[28]

Et comme Guibert, Duras explique clairement que si cette photo avait vraiment existé et avait été montrée dans le livre, le processus d'écriture ainsi que celui du souvenir (les deux étant inséparables) s'en seraient trouvés bloqués.

Dans cette perspective, on voit que la factualité traditionnellement associée à la photographie est perçue et présentée comme un obstacle, et que l'image doit

25. Voir ibid., pp. 43–4.

26. Marguerite Duras, *L'Amant* (Paris: Minuit, 1984), pp. 15–17.

27. Ibid., p. 38.

28. Susan D. Cohen, *Women and Discourse in the Fiction of Marguerite Duras* (Houndmills, Basingstoke: Macmillan, 1993), p. 92.

être en quelque sorte textualisée – mise en texte – pour pouvoir reconstruire le passé, même d'une façon en partie fictionnelle et imaginaire. En tout état de cause, Guibert et Duras n'ont pas recours à l'image photographique pour prouver que ce qu'ils disent dans leurs textes est vrai ni pour renforcer le statut référentiel de leurs entreprises autobiographiques respectives. Et quand ils ne les réduisent pas à de simples images latentes, ces deux auteurs s'intéressent bien plutôt à tout ce qui n'est pas montré par les photos, à leur hors champ, et n'hésitent pas à explorer les histoires subversives et invisibles qui s'inscrivent en creux dans les albums de famille, en grattant la surface souvent trop lisse et donc trompeuse des clichés qu'ils contiennent.

Cette caractéristique n'est cependant pas spécifique aux livres dans lesquels les photos ne sont pas montrées aux lecteurs, et concerne également le travail d'autres photobiographes contemporains tels Sophie Calle et Christian Boltanski. Ainsi ces deux artistes jouent constamment dans leurs œuvres avec la frontière entre référence et fiction, en utilisant notamment de diverses manières des archives photographiques (personnelles, familiales, mais aussi dans bien des cas des clichés représentant de parfaits inconnus) pour construire et illustrer des versions fictives ou fictionalisées de leurs propres existences. Par exemple, dans *Des Histoires vraies* (publié pour la première fois en 1994), Calle combine de courts textes d'inspiration autobiographique, racontant le plus souvent des histoires improbables et amusantes, à toutes sortes d'images photographiques qui sont explicitement présentées comme des reconstitutions et des illustrations et non comme des preuves ou des documents. Même lorsqu'elle donne à voir des archives personnelles plus traditionnelles (comme des clichés la représentant enfant), elle tend à les utiliser de façon ironique et détachée, en les associant par exemple à des récits peu vraisemblables, ce qui est une manière de pratiquer avec dérision le jeu autobiographique[29]. Suivant la même logique, elle souligne souvent la nature construite et artificielle de bon nombre de ses photos, comme c'est le cas avec le cliché intitulé *Chambre avec vue*, réalisé en haut de la tour Eiffel en 2002 comme le révèle le texte d'accompagnement rédigé par Calle (celle-ci affirme avoir passé une nuit au quatrième étage de cet endroit incongru), et qui se présente ouvertement comme une mise en scène[30]. Ce faisant, elle problématise la croyance dans le pouvoir référentiel de l'image photographique et

29. Concernant l'ironie qui caractérise le travail de Calle, voir l'article de Johnnie Gratton, « Sophie Calle's *Des Histoires vraies*: Irony and Beyond », dans *Phototextualities: Intersections of Photography and Narrative*, éd. par Alex Hughes et Andrea Noble (Albuquerque: University of New Mexico Press, 2003), pp. 182–97.

30. *Chambre avec vue* est le titre d'une installation de Sophie Calle créée dans le cadre de la « Nuit Blanche » organisée par la ville de Paris du 5 au 6 octobre 2002. L'artiste s'était alors fait installer une chambre au quatrième étage de la tour Eiffel pour y recevoir, allongée dans un lit, toute personne désireuse de lui raconter des histoires pour la tenir en éveil jusqu'au matin.

invite son lecteur/spectateur à prendre en compte la dimension fictionnelle inhérente à tout projet autobiographique: comme l'indique déjà assez malicieusement le titre de l'ouvrage, il est illusoire de parler d'« une » histoire vraie, ou même de « la » vérité autobiographique, tout ce que Calle peut proposer étant « des » histoires vraies, qui expriment une part de vérité mêlée d'invention – le pluriel renvoie en l'occurrence à une mise en question de la notion de vérité dans ce contexte mais aussi à la fragmentation du sujet autobiographique. L'image mystérieuse montrant un œil fermé au cœur du livre symbolise finalement assez bien l'ambiguïté et l'entre-deux qui caractérisent l'ensemble du projet: s'agit-il d'une simple paupière close ou plutôt d'un clin d'œil qui ferait appel une nouvelle fois à la complicité du lecteur-spectateur? Cette idée a par exemple été formulée par Johnnie Gratton dans l'un de ses articles consacrés à Calle:

> The image of a closed eyelid on both the front and back covers of the 1994 Actes Sud edition of Calle's book, ironically cropped to form a spyhole-like circle, might well be taken initially to represent a wink of complicity encouraging healthy scepticism about the capacity of either photographic or autobiographical representation to pin down anything as definitive as « the » truth or even « a » truth of the represented subject.[31]

Pour finir, le travail de Calle se signale par sa propension à exploiter le potentiel narratif de ses images (comme nous l'avons déjà observé chez Duras et Guibert), en montrant précisément qu'une pluralité d'histoires – toutes plus ou moins vraies – peuvent être tirées du même contenu visuel. Par exemple, lorsqu'elle montre la photo d'une chaussure rouge assez banale sur le côté gauche d'une double page, son lecteur/spectateur peut vraiment se demander quelle sera la nature du texte d'accompagnement reproduit sur la page de droite, d'autant plus s'il a déjà lu les autres histoires racontées dans le livre, toutes plus surprenantes les unes que les autres. Calle joue ici manifestement avec les attentes du lecteur occidental, habitué à lire de gauche à droite et qui peut se demander en l'occurrence si ce n'est pas le texte qui illustre l'image plutôt que l'inverse. De fait, il s'avère que l'histoire de cette chaussure était particulièrement difficile à deviner, celle-ci ayant été volée dans un magasin par l'auteure alors qu'elle était encore une adolescente. *Des Histoires vraies* offre de nombreux autres exemples fonctionnant sur le même principe dont on peut voir à quel point il est éloigné de la démarche photobiographique de Le Clézio, Barthes et Roche.

31. Johnnie Gratton, « Sophie Calle's True Stories: More of the Same? », *Paragraph*, 26:3 (2003), 108–22 (p. 112). Cette image montrant un œil fermé se trouve non plus sur la couverture mais au cœur du livre dans sa version remaniée et augmentée publiée en 2002, toujours chez Actes Sud.

Conclusion

Au terme de ce parcours, on peut tout d'abord souligner la remarquable diversité des productions intermédiales évoquées ici, qui proposent des utilisations autobiographiques plus ou moins novatrices de la photo (correspondant à des contraintes des éditeurs ou à des démarches originales), et qui oscillent toutes entre une volonté de rapporter les faits de vie tels quels ou au contraire de les recomposer, de les mettre en fiction. Dans un cas, c'est un excès de littérarité et d'artificialité qui est refusé, de même que l'insertion des fragments photobiographiques dans la trame d'une histoire, et dans l'autre, un attachement jugé trop contraignant à la notion de vérité autobiographique. Bien entendu, ces perspectives d'ordre général doivent être nuancées et précisées en fonction de la singularité de chaque œuvre. Quoi qu'il en soit, on peut remarquer que le modèle de l'album-photo – qui est peut-être la matrice même du genre littéraire considéré dans cet article, de nombreux livres reprenant de manière plus ou moins inconsciente et manifeste cette structure paradigmatique – apparaît être au carrefour de ces diverses tendances et influences, entre narration et énumération, continu et discontinu, archives et légendes (personnelles, familiales), mais aussi entre l'individuel et le collectif. Si *L'Amant* (de Duras) et les *Légendes* (de Roche) sont par exemple tous deux tissés sur la trame d'un album de photos de famille, il est ainsi indéniable que les projets respectifs des deux auteurs ont des buts tout à fait différents. De même, bien que ces ouvrages soient parus dans la même collection « Traits et Portraits » au Mercure de France, la visée et le parti pris esthétique de Le Clézio dans *L'Africain* diffèrent en tous points d'un livre comme *L'Autoportrait en vert* (2005) de Marie NDiaye, qui exploite le caractère mystérieux et légendaire d'un certain nombre de clichés anonymes trouvés par l'écrivaine et reproduits en noir et blanc. De fait, la nature et la structure de l'album-photo compliquent la distinction entre fait et fiction, notation et mise en scène – distinction qui comme on le sait n'est jamais parfaitement nette. Se pose en particulier à cet égard la question du statut des légendes (dans le sens de *caption*, de texte d'accompagnement), qui semblent indispensables pour faire parler les images, pour en faire autre chose que de simples « clichés », mais qui en même temps risquent de faire verser l'ensemble photo-textuel créé dans le « légendaire », l'imaginaire – d'où la volonté d'un artiste comme Roche de s'en tenir à des légendes très brèves aussi objectives que possible, et à l'inverse la tentation chez d'autres photobiographes tels Duras ou Guibert de libérer l'espace textuel (narratif) de tout ancrage visuel direct, la description et/ou le commentaire ayant en quelque sorte phagocyté l'image.

Finalement, il tient lieu de préciser que la quasi totalité des œuvres qui ont été traitées ici s'appuient sur des photographies argentiques et non numériques; en ce sens, elles participent d'un paradigme esthétique ancré dans la fin du vingtième siècle, et en partie bouleversé au début du vingt-et-unième par l'avènement des divers moyens de communication et technologies qui ont révolutionné le domaine

de l'archive personnelle. Il serait ainsi pertinent de prolonger la réflexion engagée dans cet article en étudiant les nouvelles formes photobiographiques qui sont apparues à l'ère de l'Internet, des blogs et des réseaux sociaux (entre autres), ces plateformes et interfaces étant toutes basées sur une exploitation intensive de l'image représentant le sujet et ayant forcément à ce titre un impact sur les pratiques contemporaines d'écriture de soi (littéraires, mais pas seulement).

Nottingham French Studies 53.2 (2014): 232–246
DOI: 10.3366/nfs.2014.0088
© University of Nottingham
www.euppublishing.com/nfs

ANNIE ERNAUX, 1989: DIARIES, PHOTOGRAPHIC WRITING AND SELF-VIVISECTION

AKANE KAWAKAMI

Regular readers of Annie Ernaux will know that diary-writing has always been important to her, and to her sense of her self: 'rien ne rend autant la permanence du moi que le journal.'[1] To date, she has shared with her readers at least four different kinds of diary: her 'journaux intimes', 'journaux extimes', and in 2011, a photodiary of sorts in *Écrire la vie*, whose prefatory section contains excerpts from her 'journal intime' alongside a collection of family photographs, and a pre-writing diary called *L'Atelier noir*. In this essay, I want first to consider briefly how diary-writing can be seen as a photographic act for Ernaux, resulting in a collection of verbal 'snapshots' which constitute the raw material from which her more constructed narratives are built. I then intend to focus on Ernaux's acts of self-portrayal in 1989, through an analysis of the different diaries she kept that year as well as of a related non-diary work, to create a synoptic view of Ernaux's self in that twelve-month period. 1989 was the year during which Ernaux was having a passionate affair with a Russian diplomat, the affair that gave birth to *Passion simple*. But at the same time, she was recording her internal turmoil in *Se perdre*, her impressions of the external world in *Journal du dehors*, and making notes for various literary projects in *L'Atelier noir*. My aim will be to bring together the entries from these three diaries, as well as the more sustained account from *Passion simple*, to create a composite portrait – or rather, a composite photograph – of Ernaux's self at that point in time. Composite photographs, popular towards the end of the nineteenth and the beginning of the twentieth century, were made up of separate semi-transparent images of a group of individuals which were superimposed on one another to produce a single image, with the aim of revealing the 'type' to which the individuals belonged.[2] The practice was used to detect family resemblances and shared traits, and is an apt metaphor, in my view, for Ernaux's multiple and synoptic

1. Annie Ernaux, *Écrire la vie* (Paris: Gallimard, 2011), p. 37.
2. See Peter Hamilton and Roger Hargreaves, *The Beautiful and The Damned: The Creation of Identity in Nineteenth Century Photography* (London: Lund Humphries/National Portrait Gallery, 2001), pp. 63–75.

self-portraits which become superimposed upon one another in the consciousness of her reader.

By contrasting the differing images of her 'self' in 1989 obtained from these separate sources, I ultimately hope to show that all of these writings are connected if not pre-prepared elements of Ernaux's long-term auto-ethnological project, and that the most complete – and most formally innovative – version of her 'self' is the collective impression that emerges from considering all of these different and at times contradictory portraits. Philippe Lejeune, speaking in 2004 after the publication of *Se perdre*, describes the co-existence of her diaries and *récits* in the public sphere as a new genre of self-writing: 'c'est presque comme une "installation" – qui dépasse la notion d'œuvre fermée ou de texte'.[3] I will show how, with the further addition of *Journal du dehors* and *L'Atelier noir* to the collection, the 'installation' becomes even more multifaceted, and sheds further light on Ernaux's use of photography in writing about the self.

Diaries and Photography

Hervé Guibert characterizes diaries as a photographic form of writing: he describes both Goethe's *Voyage en Italie* and Kafka's diaries as 'une écriture photographique': 'la trace la plus récente de la mémoire, [...] comme quelque chose qui semble encore vibrer sur la rétine, c'est de l'impression, presque de l'instantané.'[4] Guibert's description almost dispenses with the diarist as transcriber of the impression, inasmuch as the 'trace' seems to appear of itself – as would be the case in photography – as an already visible print on a photosensitive surface, analogous to the retina.

Ernaux's diary entries – both internal and external – similarly ignore, on the whole, the extradiegetic role played by the diarist: the writer is relegated to the background whilst her emotions, observations and impressions take centre stage.[5] In her external diaries, Ernaux explicitly sees her role as that of a photographer, more specifically of the kind who practises 'straight photography': a transcriber of impressions who attempts to remain as invisible and non-interventionist as possible. Accordingly, these diaries contain scenes which are clearly of the 'outside': from the city's supermarkets, its streets, its RER carriages. In her 1996 preface to the second edition of *Journal du dehors* (the first edition had contained

3. 'Entretien d'Annie Ernaux avec Philippe Lejeune', in *Annie Ernaux: une œuvre de l'entre-deux*, ed. by Fabrice Thumerel (Arras: Artois Presses Université, 2004), pp. 253–8 (p. 255).

4. Hervé Guibert, *L'Image fantôme* (Paris: Minuit, 1981), p. 74.

5. In *Journal du dehors*, 'the subjective component in the event' is never made explicit, and can only be inferred. Michael Sheringham, *Everyday Life: Theories and Practices from Surrealism to the Present* (Oxford: Oxford University Press, 2006), pp. 321–2.

no preface), Ernaux wrote that her aim in the book had been to practise a 'photographic' writing:

> j'ai cherché à pratiquer une sorte d'écriture photographique du réel, dans laquelle les existences croisées conserveraient leur opacité et leur énigme. (Plus tard, en voyant les photographies que Paul Strand a faites [...] – les êtres sont là, seulement là –, je penserai me trouver devant un idéal, inaccessible, de l'écriture.[6]

I will show later that this is indeed an impossible ideal, and that her 'self' still remains faintly – but crucially – visible in these entries.

In her 'internal' diaries, Ernaux does not use the term 'photographique' to describe her style or aims, but makes use of related metaphors, all suggesting that her diary entries are actual traces of her passage through time. In *Se perdre*, she refers to the type of writing contained in it as an 'écriture immédiate'.[7] Her description suggests that the words which make up her entries are not so much a result of an act of composition as dictations from reality, almost like material deposits on the paper: 'Les mots qui se sont déposés sur le papier pour saisir des pensées, des sensations à un moment donné ont pour moi un caractère aussi irréversible que le temps' (*SP*, p. 14). Elsewhere too, Ernaux declares that she would never change a word in her diaries, let alone consider rewriting them; they are the raw material of her experience. This attitude is especially prevalent in the works in which photography plays an important role. In *L'Usage de la photo*, Ernaux compares her writing to stains, and then links both to photography:

> Je m'aperçois que je suis fascinée par les photos comme je le suis depuis mon enfance par les taches de sang, de sperme, d'urine, déposées sur les draps ou les vieux matelas [...]. Les taches les plus matérielles, organiques. Je me rends compte que j'attends la même chose de l'écriture. Je voudrais que les mots soient comme des taches auxquelles on ne parvient pas à s'arracher.[8]

Like the series of images she created with a former lover, Philippe Vilain, composed of his sperm and her menstrual blood on pieces of paper,[9] one of her

6. Annie Ernaux, *Journal du dehors* (Paris: Gallimard, 1993), p. 9. Henceforth, all references to this work are abbreviated as *JD* and inserted parenthetically in the text. The reference to Paul Strand seems to confirm that her ideal photographer is one who practises straight photography, who sees him/herself not so much as an artist as a recorder of reality.

7. Annie Ernaux, *Se perdre* (Paris: Gallimard, 2001), p. 88. Henceforth, all references to this work are abbreviated as *SP* and inserted parenthetically in the text.

8. Annie Ernaux and Marc Marie, *L'Usage de la photo* (Paris: Gallimard, 2005), p. 74.

9. See Shirley Jordan, 'Improper Exposure: *L'Usage de la Photo* by Annie Ernaux and Marc Marie', *Journal of Romance Studies*, 7:2 (2007), 123–41 (p. 134); Philippe Vilain, *Défense de Narcisse* (Paris: Grasset, 2005), pp. 56–7. See also Annie Ernaux, 'Fragments autour de Philippe V.', *L'Infini*, 56 (1996), 25–6.

ideal models for writing is the indelible stain, an ungainsayable trace of '*ça-a-été*';[10] and this is the kind of writing contained, as we will see, in her diaries.

Se perdre and *Passion simple*

These two volumes give us the fullest account of what Ernaux, or at least a part of her, was going through in 1989: as mentioned earlier, *Se perdre* – although only published in 2001 – is the diary she kept from autumn 1988, throughout 1989 and into 1990, for the full length of the affair she was having with the unnamed Russian diplomat and its aftermath, another account of which she published subsequently as *Passion simple* in 1991. The preface to *Se perdre* tells us about the relationship between the diary and the 'book':

> Après son [S.'s] départ de France, j'ai entrepris un livre sur cette passion qui m'avait traversée et continuait de vivre en moi. Je l'ai poursuivi de façon discontinue, achevé en 1991 et publié en 1992: *Passion simple*. [...]
>
> En janvier ou février 2000, j'ai commencé de relire les cahiers de mon journal correspondant à l'année de ma passion pour S., que je n'avais pas ouverts depuis cinq ans. [...] Je me suis aperçue qu'il y avait dans ces pages une 'vérité' autre que celle contenue dans *Passion simple*. Quelque chose de cru et de noir, sans salut, quelque chose de l'oblation. J'ai pensé que cela aussi devait être porté au jour. (*SP*, pp. 13–14)

Se perdre, at first sight, is very much what one might expect the diary of an affair to be. The progress of the affair is chronicled through descriptions of their meetings, the long periods of her waiting, her feelings, dreams and imaginings, and passages of self-analysis. The style is concise, at times to the point of being telegraphic, often written in one-word sentences which are essentially notes, frequently dispensing with verbs and articles. The diarist is never to be found in the extradiegetic position which would offer some perspective on the external or psychological events taking place: the events are simply offered, seemingly unmediated and unedited, to the reader.

On the level of discourse rather than syntax, the prioritization of notation over narrative results in the inclusion of lists. There are numerous lists in *Se perdre*, sometimes numbered, sometimes not, but their abbreviated form always creates a sense that the items in question – be they 'external' or 'internal' – are being described objectively, presented as 'photographs':

> Début de cahier. Souhaits: avoir une relation de plus en plus forte avec S. – écrire comme je le désire un livre plus vaste à partir de début 89 – ne pas avoir de problèmes d'argent. (*SP*, p. 40)

> 20 h 45. L'appel. Chaque fois, le 'destin', l'appel téléphonique, le signe venu de l'au-delà, cette frayeur, ce bonheur aussitôt. Quand je décroche, la peur atroce que

10. Roland Barthes, *La Chambre claire: note sur la photographie* (Paris: Cahiers du cinéma/Gallimard/Seuil, 1980), p. 120.

ce soit un faux signe, une erreur du même destin. C'est lui. Pour demain, seize heures. Et c'est le ravageur bonheur, l'effacement instantané d'une angoisse qui, ce soir, était au paroxysme . . . (ibid., p. 55).

Both of these sequences are structurally reminiscent of various passages in the external diaries; their formal independence from the narrative, as lists, suggests an objectivity which associates them with Ernaux's view of photography. At times this quality of detachment results in a certain black humour:

Déceptions aujourd'hui:
1) il ne m'a toujours pas dit les mots tendres attendus
2) après la rencontre à France-URSS, il est reparti avec les filles de l'ambassade sans me raccompagner à Cergy.
3) Et je m'aperçois que mon article sur la Révolution est d'une nullité glaçante. (*SP*, p. 53)

Another narrative mode frequently employed by Ernaux in her diary is the brief description, which she refers to as 'scènes'; these are verbal 'snapshots' of her memories or inner states, distinctly photographic or cinematographic in character. The beginning of the affair in Leningrad is introduced retrospectively in this mode:

Trois scènes se détachent. Le soir (dimanche) dans sa chambre, lorsque nous étions assis l'un près de l'autre [...]. [...] Puis les autres s'en vont (Marie R., Irène, R.V.P.) mais F. s'incruste, il m'attend pour partir aussi. [...]
Second moment, lundi après-midi. Quand j'ai fini de faire ma valise, il frappe à la porte de ma chambre. Dans l'entrée, nous nous caressons. [...]
Dernier moment, dans le train de nuit, pour Moscou. Nous nous embrassons au bout du wagon, ma tête près d'un extincteur. (Ibid., pp. 17–18)

Told in the present tense, these scenes are presented as three snapshots, as 'evidence' of the key moments summarizing the start of the affair.

Both the lists and photograph-like scenes ignore, by their very nature, the presence of the diarist: they are offered as material from her real experience, and not woven into a sense-making narrative.[11] Although patently emanating from a single consciousness, there is nothing in *Se perdre* that indicates the presence of

11. Of course, photographs presented as having a documentary function nevertheless contain the potential to create a reality rather than illustrate it, and Ernaux, as we will see, is aware of the biased status of her photographic 'evidence'. For a discussion of this issue see Johnnie Gratton, 'Illustration Revisited: Phototextual Exchange and Resistance in Sophie Calle's *Suite vénitienne*', in *Textual and Visual Selves: Photography Film and Comic Art in French Autobiography*, ed. by Natalie Edwards, Amy L. Hubbell and Ann Miller (Lincoln: University of Nebraska Press, 2011), pp. 139–66.

an extradiegetic narrator. Told in a mix of the present, *passé composé* and occasionally the future tenses, the entries fully occupy the narrator's present, with little or no perspective on the narratorial future. Quite frequently there are references to memories from the past – 'revu avec lui *César et Rosalie*, que j'avais été voir avec Philippe à Genève, l'été 72' (*SP*, p. 98) – but these usually point out repetitions, rather than developments, in her behaviour. The overall effect creates for the reader an overwhelming sense of living in, experiencing, Ernaux's present.

Because it is a diary, *Se perdre* does not – cannot, by definition – offer hindsight or perspective; what it does offer is a wealth of raw material which Ernaux appears to be collecting, at times consciously, for later use. In *Journal du dehors*, Ernaux wrote that

> il y deux démarches possibles face aux faits réels. Ou bien les relater avec précision, dans leur brutalité, leur caractère instantané, hors de tout récit, ou les mettre de côté pour les faire (éventuellement) 'servir', entrer dans un ensemble (roman par exemple). (*JD*, p. 85)

Here in *Se perdre*, Ernaux is carrying out the first of her 'démarches', collecting material for her auto-ethnological project. The ethnologist-diarist's position, if s/he is conscientious, should be that of a collector of material who is unable (as yet) to organize it into a story ('dans un ensemble'). This is why there is no extradiegetic narrator in this diary, no overarching vision guiding Ernaux's choice of material.

There are just a few self-reflexive moments in *Se perdre* which indicate Ernaux's awareness of her *lack* of awareness. At one point she muses that it would be better if her diary had two columns, 'l'un pour l'écriture immédiate, l'autre pour l'interprétation, quelques semaines après' (*SP*, p. 88). At other times, Ernaux redescribes the diarist's lack of perspective as an inability to write. She is of course writing in her diary throughout 1989, but what she means is that she is unable to write a book for the public. On two consecutive days in 1989, she explains why she needs to, but cannot, write such a book:

> *Samedi 8*
> Je ne sais pas ce que je vais commencer d'écrire, ni si même j'écrirai. [...] Nuit où le désir de mort était si fort [...]. [...] La raison n'en est pas vraiment S. – la lucidité étant maintenant un peu plus acquise sur notre relation – mais la *nécessité absolue d'écrire*, que je distingue mal de la douleur de vivre apparue depuis la fin avril. C'est-à-dire que je suis dans le creux où fusionnent mort, écriture, sexe, voyant leur relation mais ne pouvant la surmonter. La dévider en *un livre*. (Ibid., p. 166)

The kind of writing she is unable to do at this stage involves the telling of truth, the kind of truth which can only come from perspective ('la surmonter'). But at

this stage in her affair, Ernaux cannot do this. Even if she has acquired some lucidity, as she says above, she still does not know the *truth*, as she explains to herself the next day:

> *Dimanche 9*
> [...] Il fallait que la vérité se fasse pour que j'écrive. Mais il n'y a pas plus de vérité qu'avant, simplement un changement de croyances. (Ibid., p. 167)

In her current state, truth is out of her reach; even when she feels lucid, she is aware that it may simply be 'un changement de croyances'. The only thing about which she is certain is that her lack of knowledge stops her from writing. In other words, Ernaux's need to write *is* her need for perspective, for an 'afterwards', which by definition is impossible to come by in the present. And she knows that becoming able to write in this 'truth-telling' way, understanding her experience in a language that others will understand, will mean that her affair will have to be over. This is evident from the entry of 9th November, in which she tentatively envisages such a project:

> Livre qui pourrait commencer par: 'Du tant au tant j'ai vécu une passion', etc. La décrire minutieusement. C'est alors renoncer à revoir S., définitivement [...]. Le désespoir, je l'entrevois. C'est de croire qu'il n'y aura aucun livre capable de m'aider à comprendre ce que je vis. Et surtout de croire que je ne pourrai, moi, écrire un tel livre. (Ibid., p. 234–5)

'C'est alors renoncer à revoir S., définitivement' may sound like a superstitious thought (especially because S. had told her, at one point, that she must not write a book about him), but it is also, proleptically, an acknowledgement that the affair will have to be over for her to become able to write 'truthfully' about it.

The book that she eventually does write, *Passion simple*, is much more structured than *Se perdre*. The object of the work is not to tell a *story* – 'je ne fais pas le récit d'une liaison, je ne raconte pas une histoire [...] avec une chronologie précise'[12] – but to describe her passion for her lover A., a state which certainly had a beginning and an end, but during which she had no sense of chronology: 'je ne connaissais que la présence ou l'absence'. The way in which she decides to evoke this state is by offering the reader material signs of it:

> Je ne fais pas le récit d'une liaison, je ne raconte pas une histoire [...]. J'accumule seulement les signes d'une passion, oscillant sans cesse entre 'toujours' et 'un jour', comme si cet inventaire allait me permettre d'atteindre la réalité de cette passion. [...]
> Je ne veux pas expliquer ma passion [...] mais simplement l'exposer. (*PS*, pp. 31–2)

12. Annie Ernaux, *Passion simple* (Paris: Gallimard, 1991), p. 31. Henceforth, all references to this work are abbreviated as *PS* and inserted parenthetically in the text.

Through these signs, she aims to recreate the reality of her passion.[13] At the same time, her use here of the verb 'exposer' creates a link with photography which allows us to imagine the whole of this book as a photographic image of her passion, the opposite of a narrative ('je ne raconte pas une histoire'); a metaphor which gains in validity when we begin to read the book and discover in it an absence of chronological development.

In *Passion simple*, Ernaux recounts the things she used to do during the period of her passion in the imperfect tense, with occasional list-like sections inserted into the narrative, as was the case in *Se perdre*:

> J'allais au supermarché, au cinéma, je portais des vêtements au pressing, je lisais, je corrigeais des copies, j'agissais exactement comme avant, mais sans une longue accoutumance de ces actes, cela m'aurait été impossible [...].
>
> Les seules actions où j'engageais ma volonté, mon désir et quelque chose qui doit être l'intelligence humaine (prévoir, évaluer le pour et le contre, les conséquences) avaient toutes un lien avec cet homme:
>> lire dans le journal les articles sur son pays (il était étranger)
>> choisir des toilettes et des maquillages
>> lui écrire des lettres
>> changer les draps du lit et mettre des fleurs dans la chambre [...].
>> (*PS*, pp. 13–14)

This use of the imperfect, which she describes later in the book in a metanarrative aside as 'celui d'une durée que je ne voulais pas finie, celui de "en ce temps-là la vie était plus belle", d'une répétition éternelle' (ibid., p. 61), creates – together with the infinitive tense for the listed activities – an impression of timelessness; that is, a sense that nothing progresses or develops during this circumscribed period of time, just the continuation of the affair in an ever-present state of passion. The effect is very much that of a photograph, a static image about which we learn more as the pages accumulate, but only because it takes us (and her) some time to describe its surface area. In *Se perdre*, the ebb and flow of her jealousy, for instance, is more clearly chronicled, as is the apparent diminishing of the lover's interest and his visits from spring 1989 onwards, but in *Passion simple* this latter development is described simply, and as an almost static state: 'au printemps, mon attente est devenue continuelle' (ibid., p. 43).

After the narrative has recounted the fact of A.'s departure from France in November 1989, the time of the narrative slowly catches up with the time of the narration, until they meet in the present: 'maintenant, c'est avril' (*PS*, p. 66). In a footnote, Ernaux notices the change from imperfect to present tense, assigns the former to the time of her passion and the latter to the time after it, before

13. Ernaux's goal, as a writer, of 'atteindre la réalité de cette passion' will return in *L'Usage de la photo* (p. 13).

reminding us again that all she can do in this text is to 'm'arrêter sur des images, isoler des signes d'une réalité' (ibid., p. 67). Like the objects she keeps as signs of his now past existence in her life, such as the bathrobe he used to put on after making love, the images and signs collected in her text might be said to resemble the photographic writing of her diaries. But there is a crucial difference between the 'raw material' in *Se perdre* and *Passion simple*; their arrangement, or rather, their framing. In *Se perdre* every entry is an image, a snapshot of Ernaux's inner state or an event in her present, with no context or frame except for a date and/or time; whereas in *Passion simple*, the single 'photograph' of her passion is framed by the narrative of her writing project, her self-conscious attempt to record her actions, rearranged as single enunciations of iterative gestures ('choisir des toilettes et des maquillages') repeated over a period of time which is now in the past. The extradiegetic presence of the narrator, although she is clearly still very close to her past story, creates a distance which both generalizes and fictionalizes the experience of the 'raw material' for the reader.

The coda-like account of A.'s brief return to Paris in January 1991 also adds perspective to the overall presentation of her passion in this book, as Ernaux herself acknowledges:

> J'ai l'impression que ce retour n'a pas eu lieu. Il n'est nulle part dans le temps de notre histoire, juste une date, 20 janvier. [...] Pourtant, c'est ce retour, irréel, presque inexistant, qui donne à ma passion tout son sens, qui est de ne pas en avoir, d'avoir été pendant deux ans la réalité la plus violente qui soit et la moins explicable. (*PS*, pp. 74–5)

It is simply – but powerfully – the existence of an 'afterwards', the passage of time which allows her to think of her passion as past that differentiates the two works: although they contain the same material, one remains purely photographic, containing 'quelque chose de cru et de noir, sans *salut*' (ibid., p. 14, my emphasis), whereas in the other, Ernaux is *saved* through writing. If redemption can be achieved through time, the writing of it as well as its simple passage, *Passion simple* achieves such redemption, whereas the lack of redemption in *Se perdre* comes from the writer's ignorance of the future, her imprisonment in the present. As Lejeune points out, 'ce qui a été écrit en 1988–90 l'a été, chaque jour, dans l'ignorance (et l'attente!) du lendemain, et dans l'ignorance du récit qui en serait fait.'[14]

And this is precisely what the diary entry shares with photography; an inability to know the future. In *La Chambre claire*, Barthes's account of this characteristic of photography is presented as a frightening experience because it is described

14. 'Entretien d'Annie Ernaux avec Philippe Lejeune', p. 255.

from the viewer's perspective, and focuses on the imminence of death in the future of the photograph:

> devant la photo de ma mère enfant, je me dis: elle va mourir: je frémis, tel le psychotique de Winnicott, *d'une catastrophe qui a déjà eu lieu.* Que le sujet en soit déjà mort ou non, toute photographie est cette catastrophe.[15]

Reading *Se perdre* and *Passion simple*, the reader can experience the perspectives of both the photographed subject and the later viewer's perspective, and the effects are different from those described by Barthes. The ignorance of the future in *Se perdre* – its subject's imprisonment in the present – is what makes it so difficult, although also so gripping, to read; whereas for the reader of *Passion simple*, the photograph-like raw material of Ernaux's passion is placed within the context of an 'afterwards' which is not death (unlike in Barthes's example) but life beyond passion. *Se perdre* shows us what it would be like to live inside a photograph; *Passion simple* shows us what it is like to look at one, knowing that its subject has survived the experience depicted therein.

Journal du dehors and *L'Atelier noir*

There are only a few pages dating from 1989 in *Journal du dehors*, and in none of them is there even a hint of a reference to Ernaux's affair with A. (or S.). Instead, most of the entries are observations of human behaviour in public spaces, snapshots like the one below: 'Une jeune fille déballe ses achats dans le RER, un chemisier, des boucles d'oreilles. Elles les regarde, les touche. Scène fréquente. Bonheur de posséder quelque chose de beau, désir de beauté réalisé' (*JD*, p. 87). There is one long entry made in Florence, and if we cross-reference the dates with those in *Se perdre* and *Passion simple* we realize that it must have been written on the occasion of an anguished trip during which she wandered through the streets and museums wishing she was back in France with her lover, but the entry in *Journal du dehors* is all about the middle-aged male attendant who supervises the ladies' toilets in the Palazzo Vecchio (ibid., pp. 88–9). The week spent in Florence is chronicled in great detail in *Se perdre*, which lists all the places Ernaux visits, and describes how she is accompanied everywhere by the thought of S.; the one place name that is not mentioned is the Palazzo Vecchio. This absence would seem to be a consequence of Ernaux's conscious decision, mentioned in the introductory section of this essay, to avoid inserting personal thoughts and feelings into these external diaries. Certainly at first and even second glance, the overall impression is that she has succeeded in doing so.

15. Barthes, *La Chambre claire*, p. 150.

However, in the preface added afterwards to *Journal du dehors*, Ernaux admits that it has been impossible to keep herself entirely out of her writing: 'Mais, finalement, j'ai mis de moi-même beaucoup plus que prévu dans ces textes: obsessions, souvenirs, déterminant inconsciemment le choix de la parole, de la scène à fixer' (*JD*, pp. 9–10). I have discussed in more detail elsewhere how the image of Ernaux's self which results from these details – her obsessions and memories which dictate the choice of her words and scenes – is similar to the shadow in a photograph cast by the photographer, a mark of the self left from its attempts to record scenes from the outside.[16] This 'mark' might be said to denote a structural position, in the sense that the photographer's shadow – to continue with the analogy – reveals his position vis-à-vis his material, the angle of his camera, his choice of light source, and so on: in narrative terms, the image would correspond roughly to Genette's description of the narrator, whom he breaks down into point of view and narrative voice.[17] Ernaux's own description of her 'je' in an essay matches this view of the narrator as a position rather than a person: 'le *je* que j'utilise me semble une forme impersonnelle'.[18]

But Ernaux is not only the shadowy photographer of the external diaries; she is also the photosensitive surface on which the images are recorded. I have suggested in another study that Genette's division of the narrator into voice and point of view, in *Figures III*, leads him to neglect the existence of the narrating consciousness, the space of the narrator's self-awareness.[19] It is this space Ernaux is referring to when, in her description of her transpersonal 'je', she speaks of 'un moyen [...] de saisir, *dans mon expérience*, les signes d'une réalité familiale, sociale ou passionnelle'.[20] In Ernaux's external diaries, her consciousness is the space in which the everyday scenes from her urban life are brought into existence, and across which they are free to trample. Unsurprisingly, it is an invasive experience, as she describes it: 'je suis traversée par les gens, leur existence, comme une putain' (*JD*, p. 69).

16. Akane Kawakami, *Photobiography: Photographic Self-Writing in Proust, Guibert, Ernaux, Macé* (Oxford: Legenda, 2013), ch. 3.

17. See Gérard Genette, *Figures III* (Paris: Seuil, 1972), pp. 203–24.

18. Ernaux, 'Vers un je transpersonnel', in *Autofictions et Cie*, ed. by Serge Doubrovsky, Jacques Lecarme and Philippe Lejeune (Paris: Université Paris X, RITM, 1993), pp. 219–21 (p. 221).

19. 'The narrator's world is the fictional world that the narrator inhabits, as distinct from the world of the story that he/she creates: it [...] is crucial to the organisation of the narrative.' Akane Kawakami, *A Self-Conscious Art: Patrick Modiano's Postmodern Fictions* (Liverpool: Liverpool University Press, 2000), p. 9.

20. Ernaux, 'Vers un je transpersonnel', p. 221 (my emphasis).

In both of these ways – both as the photographer's shadow which leaves a mark on her snapshot of the city, and as the photosensitive surface on which all these other existences can be played out – Ernaux's self is present in her external diaries. And it is in these ways also that she sees herself as existing not just within her own body, but in the bodies of others, dispersed throughout the city as we go about our business in the same urban space. At the very end of *Journal du dehors*, Ernaux describes how a random woman she notices on the RER reminds her of her own mother, then comments: 'c'est donc au-dehors, dans les passagers du métro ou du RER, [...] qu'est déposée mon existence passée [...], dans des individus anonymes qui ne soupçonnent pas qu'ils détiennent une part de mon histoire' (*JD*, pp. 106–7).[21] And the last entry of 1989 brings a flash of self-recognition:

> Dans le métro, un garçon et une fille se parlent avec violence et se caressent, alternativement, comme s'il n'y avait personne autour d'eux. Mais c'est faux: de temps en temps ils regardent les voyageurs avec défi. Impression terrible. Je me dis que la littérature est cela pour moi. (Ibid., p. 91)

The shadow of the photographer in this snapshot is particularly interesting because it is a *double* shadow: of Ernaux the passionate lover, constantly preoccupied with S. and therefore quick to notice lovers everywhere, but also of Ernaux the professional writer who recognizes, in the suburban adolescents, her own desire to expose her most intimate self in her writings. It is a moment in which one feature in the composite photograph suddenly gains in clarity, through the alignment of that feature in all of the verbal snapshots; the image of Ernaux the writer of intimacy surfaces through the layers of *Se perdre*, *Passion simple* and *Journal du dehors*, as it will do again in *L'Atelier noir*.

One might have thought that writing about her tumultuous love life in *Se perdre*, and 'photographing' the external world (and the self in it) in *Journal du dehors* would have been enough diary-writing for Ernaux in 1989: but we now know that she also kept a third diary. *L'Atelier noir* is a transcription of her notes on various writing projects, taken from a separate record that she has kept since 1982. The title is suggestive of the darkroom, and indeed the book contains the thoughts and ideas with which Ernaux experiments prior to their 'development', so to speak, into what she considers to be publishable writing, or to their metaphorical 'exposure' to the outside world. It is not exactly a 'journal d'écriture', as it does not contain her drafts or plans: it is a *pre*-writing diary, inasmuch as it stops each time she starts writing a book. Correspondingly, the entries for 1989, during which she did not write a book, are quite numerous.

21. This conclusion harks back to the book's epigraph: 'Notre *vrai* moi n'est pas tout entier en nous (Rousseau)'.

And in these entries it is possible to see glimpses of her affair, but the references to 'S.' in this diary are, without exception, completely professional. It is as material for her work – even during her affair – that her feelings about S. are being regarded, in spite of all the genuine heartache and crises of jealousy recorded in *Se perdre*: these are very clearly snapshots of her self as writing machine, not as passionate woman. It is not even the case, I believe, that writing about her affair in this clinical way is an attempt at distancing herself from her feelings, at self-protection: the situation seems rather to be the other way round, that she sees her own suffering as an opportunity to observe new patterns of behaviour in action. This is Ernaux at her auto-ethnological best, poised to gather raw material for her professional self from her personal one.[22]

So although *L'Atelier noir* reveals that in 1989 Ernaux considered writing, at various points, a book on the relationship between writing and sex, an erotic novel, the beauty of the male body and a book on the Soviet Union, these are all 'work' thoughts. Just once, she complains that 'actuellement, je "cherche" mais dans un tel état de douleur affective (à cause de S.) que je ne suis pas sûre de chercher réellement'.[23] But even this observation develops into a thought, by the end of the paragraph, about the advantages of the third-person pronoun: 'Est-ce que la solution, la libération, ne serait pas choisir "elle", la mise à distance? "Elle" qui, suivant Genette, permet plus que le "je"' (*AN*, p. 58).

There are numerous entries in 1989 about her long-term project, the book which would eventually be published as *Les Années* (in 2008); indeed, if one had not read *Se perdre*, one might be forgiven for thinking that this book project was her chief obsession during this year. For instance, in the 23rd July entry of *L'Atelier noir*, Ernaux sounds utterly absorbed by her structural problems: she complains that 'je sens que je manque de repères, cadres (savoir ce que je veux démontrer indirectement, c'est-à-dire le cadre idéologiquement conscient' (*AN*, p. 61). But her *Se perdre* entry of the same day, by contrast, shows her observing a depressing – or comforting? – continuity between her past and present selves, in an almost stereotypical posture of the languishing lover unable to concentrate on anything else: 'relu agenda 63, l'attente de Ph., à Rome. [...] le moi d'hier, à Rome, était celui d'aujourd'hui, et les deux hommes une ombre unique, celle de S. plus longue et plus douce' (*SP*, pp. 173–4).

Similarly, on the same date that the earlier quotation from *Se perdre* was written, 9 July 1989, and in which she analyses her acute emotional suffering,

22. This is similar to what Hervé Guibert does in *Cytomégalovirus*, his hospital diary: for an extensive discussion see Kawakami, *Photobiography*, ch. 2.

23. Annie Ernaux, *L'Atelier noir* (Paris: Éditions des Busclats, 2011), p. 58. Henceforth, all references to this work are abbreviated as *AN* and inserted parenthetically in the text.

Ernaux is jotting down – in her *L'Atelier noir* notebook – completely professional thoughts about the structure of *Les Années*:

> 9 juillet
> Il faut, en premier lieu, évidemment, déterminer le projet global: qui oscille entre la 'somme romanesque', objective, 'établie' avec 'personnages' et la quête, encore que les 2 ne soient pas incompatibles, Autant en emporte le vent et Proust ('je'?).
> La structure de 'géométrie variable' en fonction du projet, de la possibilité d'ajouter des choses extérieures (journal d'écriture, etc.). (*AN*, p. 60)

On 15 November 1989, Ernaux writes that one of her main aims is to achieve 'le réalisme le plus extrême, le moins de différence entre la vie et la littérature' (*AN*, p. 63). From then on into December of that year, that is to say immediately following the departure of S. from France, we see a few more entries in this 'writing diary' reminiscent of the ones from her actual diary: that is, entries in which she seems to be expressing her feelings for him. But on closer inspection it becomes clear that they are attempts to turn her life almost directly into writing, perhaps to achieve the 'extreme realism' she was aiming at in November. The following are instances of such life-into-writing entries:

> 19 novembre
> Je pense à ma façon d'aimer S.: 'Aimer, c'est passer le doigt sur cette courbe des hanches', etc.
> Elle ne peut que s'inscrire dans une histoire, mon histoire et l'Histoire.
> [...]
> Toutes les nuits, je refais son corps, etc.
> 'J'ai cessé d'écrire au mois de ... De toute façon ce n'était pas fameux, absence de nécessité. Il faisait chaud.' (Ibid., pp. 64–5)

At first glance these may seem to be evocations of longing, descriptions of how she is missing S.; and in a sense, of course, they are, except that she is – by using quotation marks, and the abrupt and self-aware 'etc.' – immediately channelling her emotion into an act of creation, fuelling her writing. 'Je pense à ma façon d'aimer S.' might, arguably, be the 'real' Ernaux thinking back to her time with her lover, but what follows is put into quotation marks, and thereby transferred into the world of writing: ' "Aimer, c'est passer le doigt sur cette courbe des hanches", etc.' The 'etc.' is particularly effective as a demystifying device, reminding us (and herself) that her 'façon d'aimer S.' is now reserved purely for narrative use: 'Elle ne peut que s'inscrire dans une histoire, mon histoire et l'Histoire.'

The second part of the quotation occupies an even more beguiling position between lived memory and writing, partly because it seems to describe something she is doing in the present, and partly because of the subtle use of quotation

marks. 'Toutes les nuits, je refais son corps' sounds like something she is 'really' doing, and indeed it may be that she is. However, the quiet 'etc.' added to the end of the sentence inserts the possibility of self-reflexivity; is she writing about something she is doing, a Proustian iterative, or is she trying the sentence out for her book? Is it an intra- or extradiegetic sentence? ' "J'ai cessé d'écrire au mois de ..." ' is clearly an incipit, with the ellipsis indicating a date to be filled in, but the self-reflexive-sounding ' "De toute façon ce n'était pas fameux, absence de nécessité. Il faisait chaud" ' casts some doubt on its status. Is the whole sentence a trial incipit for her book? Or is the 'de toute façon ce n'était pas fameux' a metanarrative aside?

I want to call these attempts by Ernaux to work on her own feelings even as she is still feeling them – to create a story out of her living emotions – attempts at self-vivisection: a writer first and foremost, she dissects herself in her diary entries, but in her 'writing' diary the process is at its most complicated and dangerous. These attempts to work on her living flesh, so to speak, give us these fascinating moments in which Ernaux is both observer and observed, writing as an objective and subjective self at the same time. They encapsulate the uneasy mix of private and public life, personal conviction and public truth that characterize Ernaux's best work: her aim, as she has said in various books, is to 'écrire dangereusement' (*AN*, p. 57),[24] to carry out in writing what the adolescent couple, 'photographed' in 1989 in *Journal du dehors*, were doing on the metro.

My attempt in this essay to create a 'portrait of Ernaux in 1989' by bringing together fragmented images from various sources may not be what Ernaux would wish her readers to do, given that these sources are dispersed throughout her œuvre, and published at different times. Yet all of these works, apart from *L'Atelier noir* which was published in the same year, are collected in *Écrire la vie*. Any *œuvres complètes* project must (by definition) unite an author's separate works, but in the case of an auto-ethnological writer like Ernaux, such a bringing together of self-writings – especially with the prefatory collection of photographs and diary entries – both challenges the notion of the completeness of each individual work and reconstructs a blurred but fascinating vision of multiple images of the same person. Like a cubist portrait which defies the laws of perspective to show different and irreconcilable aspects of the same person at the same time, or a moving portrait that shows the painter at work at the same time as the painter as sitter, Ernaux's diaries track her self in and through her writing, which both divides and unites her, makes her both subject and object, adding ever more layers to her composite photograph.

24. See also Annie Ernaux, *L'Écriture comme un couteau. Entretien avec Frédéric-Yves Jeannet* (Paris: Stock, 2002).

Nottingham French Studies 53.2 (2014): 247–248
DOI: 10.3366/nfs.2014.0089
© University of Nottingham
www.euppublishing.com/nfs

NOTES ON CONTRIBUTORS

FABIEN ARRIBERT-NARCE is Associate Professor in French at Aoyama Gakuin University, Tokyo, Japan. His publications include *L'Autobiographie entre autres. Écrire la vie aujourd'hui* (Peter Lang, 2013; co-edited with Alain Ausoni) and *Photobiographies: pour une écriture de notation de la vie (Roland Barthes, Denis Roche, Annie Ernaux)* (Honoré Champion, 2014).

AMANDA CRAWLEY JACKSON is a curator and Senior Lecturer in French Studies at the University of Sheffield. Her current research focuses on the ways in which contemporary visual arts from France and Algeria represent and re-cast urban landscapes and the spaces of migration. She is the director of Furnace Park, Sheffield.

SHIRLEY JORDAN is Professor of French Literature and Visual Culture at Queen Mary University of London. She works on three areas: contemporary French women's writing (with a current emphasis on inhospitality in Marie NDiaye); intimacy and excess in women's experimental autobiography across media; and city photography. She has published chapters and articles on the poetics of scale in urban photography, on city photography as interruption and on street photography, focussing on practitioners such as Stéphane Couturier, Valérie Jouve and Denis Darzacq. She is currently co-investigator of an AHRC-NWO network (2012–14) dedicated to exploring visual cultures as interruption in global cities.

AKANE KAWAKAMI is Senior Lecturer in French at Birkbeck, University of London, and the author of three monographs: *A Self-Conscious Art: Patrick Modiano's Postmodern Fictions* (Liverpool University Press, 2000), *Travellers' Visions: French Literary Encounters with Japan, 1881–2004* (Liverpool University Press, 2005), and *Photobiography: Photographic Self-Writing in Proust, Guibert, Ernaux, Macé* (Legenda, 2013). She has also published numerous articles in refereed journals on a wide range of twentieth- and twenty-first-century writers. She teaches and researches in areas such as contemporary francophone fiction, travel narratives and exoticism, photography, and interactions between literary and visual culture.

MAGALI NACHTERGAEL is Maître de conférences in Literature and Contemporary Arts at the Université Paris 13 Sorbonne Paris Cité, and the author of *Les Mythologies individuelles. Récit de soi et photographie au 20ᵉ siècle*

(Rodopi, 2012). She is founder and co-coordinator of the inter-disciplinary research programme *Les Contemporains* on literature, visual arts and theory in collaboration with the Université Paris 7 Diderot (http://contemporains. hypotheses.org). Her current research deals with Roland Barthes and the arts.

OLGA SMITH received her PhD from the University of Cambridge. Her research interests lie at the intersection of photography, its history and theory, and modern and contemporary French art and thought. She has published a number of articles on French contemporary artists and is co-editor of a collection of essays on the trope of memory in French culture, entitled *Anamnesia: Private and Public Memory in Modern French Culture* (Peter Lang, 2009). She taught at the universities of St Andrews and Cambridge, and currently occupies the post of Curator of public programmes at the Tate Gallery, London.

EDWARD WELCH is Carnegie Professor of French at the University of Aberdeen. His research is concerned with the literary and visual culture of post-war France, with particular interests in the relationship between France and Algeria, and the representation of modernization, spatial change and urban planning. He is the author of *François Mauriac: The Making of an Intellectual* (Rodopi, 2006) and (with Joseph McGonagle) *Contesting Views: The Visual Economy of France and Algeria* (Liverpool University Press, 2013).

KATHRIN YACAVONE is Lecturer in the Department of French and Francophone Studies at the University of Nottingham. Her research and teaching focus on the history and theory of photography in French and European cultures as well as on twentieth-century intellectual history. She has published articles on photography in the work of Barthes, Benjamin and Proust, and is the author of *Benjamin, Barthes and the Singularity of Photography* (Continuum/Bloomsbury, 2012 and 2013). She is currently preparing a monograph on portraits of the writer in French photography, literature and criticism from the 1840s to the present.

HISTORICAL REFLECTIONS / REFLEXIONS HISTORIQUES

Senior Editor: **Linda E. Mitchell**, *University of Missouri-Kansas City*

Coeditor: **Daniel Gordon**, *University of Massachusetts, Amherst*

Historical Reflections/Reflexions Historiques has established a well-deserved reputation for publishing high quality articles of wide-ranging interest for nearly forty years. The journal, which publishes articles in both English and French, is committed to exploring history in an interdisciplinary framework and with a comparative focus. Historical approaches to art, literature, and the social sciences; the history of mentalities and intellectual movements; the terrain where religion and history meet: these are the subjects to which *Historical Reflections/Reflexions Historiques* is devoted.

RECENT ARTICLES

The Charms of Paris...Yesterday
CHARLES REARICK

In Search of the Rescuer in the Holocaust
DORI LAUB

Legends of a Revolutionary: Nostalgia in the Imagined Lives of Auguste Blanqui
PATRICK H. HUTTON

The Tragic Nostalgia of Albert Camus
ROBERT ZARETSKY

"The Truth about the Mistake": Perpetrator Witness and the Intergenerational Transmission of Guilt
KATHARINA VON KELLENBACH

Nostalgia and the Myth of the Belle Époque in Franco-Russian Literature (1920s–1960s)
NATALIA STAROSTINA

Picturing Politics: Female Political Leaders in France and Norway
ANNE KROGSTAD AND AAGOTH STORVIK

Passions and Purposes: Acting Faith and Nostalgia in New Caledonia
MATT K. MATSUDA

Tropiques Nostalgiques: Fatal Homesickness in French Algeria
THOMAS DODMAN

Ruth Klüger: Reflections on Auschwitz
BIRGIT MAIER-KATKIN

journals.berghahnbooks.com/hrrh

berghahn

journals
NEW YORK · OXFORD

ISSN 0315-7997 (Print) • ISSN 1939-2419 (Online)
Volume 40/2014, 3 issues p.a.